the big book of
REALISTIC
DRAWING
SECRETS

Easy Techniques for Drawing People, Animals and More

NORTH LIGHT BOOKS
CINCINNATI, OHIO
www.artistsnetwork.com

CARRIE STUART PARKS
& RICK PARKS

 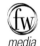
Other fine North Light Books are available from your local bookstore, art supply store or visit us at our website www.fwmedia.com.

22 21 20 19 22 21 20

DISTRIBUTED IN THE U.K. AND EUROPE BY DAVID & CHARLES
Brunel House, Newton Abbot, Devon, TQ12 4PU, England
Tel: (+44) 1626 323200, Fax: (+44) 1626 323319
Email: postmaster@davidandcharles.co.uk

Library of Congress Cataloguing-in-Publication data is available from the publisher upon request.

Edited by Kelly C. Messerly
Designed by Doug Mayfield
Production coordinated by Matt Wagner

ABOUT THE AUTHORS

Rick and Carrie Parks blend their love and friendship with their Christian faith, home and art careers. They team-teach forensic art classes throughout the nation, winning national awards for their outstanding instruction and for inspiring others to achieve artistic excellence. They are both forensic artists and have worked on major national and international cases. Their forensic art has appeared on multiple television shows, including *America's Most Wanted* and *20/20*.

In addition to teaching, Rick and Carrie create fine art in pencil, watercolor, pastel pencils and stone carvings. Carrie is a signature member of the Idaho Watercolor Society and has won numerous awards for her paintings.

To find out more about the Parks or to find a class near you, check out their website at www.stuartparks.com. Contact Rick at rick@stuartparks.com or Carrie at carrie@stuartparks.com.

Metric Conversion Chart

To convert	to	multiply by
Inches	Centimeters	2.54
Centimeters	Inches	0.4
Feet	Centimeters	30.5
Centimeters	Feet	0.03
Yards	Meters	0.9
Meters	Yards	1.1

The Big Book of Realistic Drawing Secrets

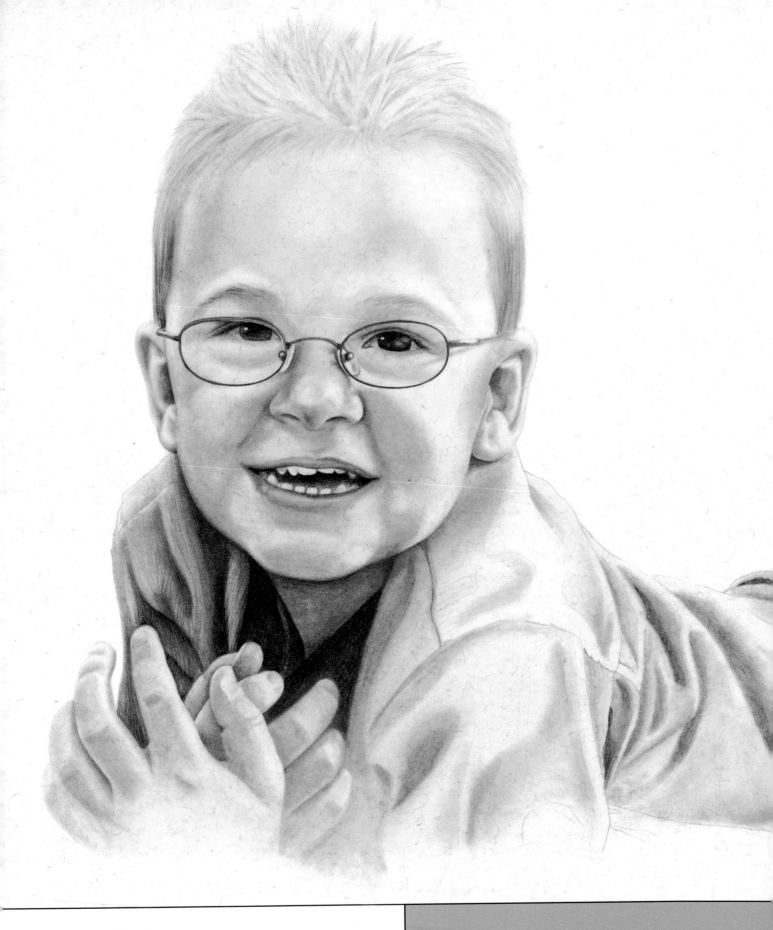

WILLIAM MAX IRWIN
Graphite pencil on smooth bristol board
12" × 14½" (30cm × 37cm)

APPLE BLOSSOMS
14" x 17" (36cm x 43cm)

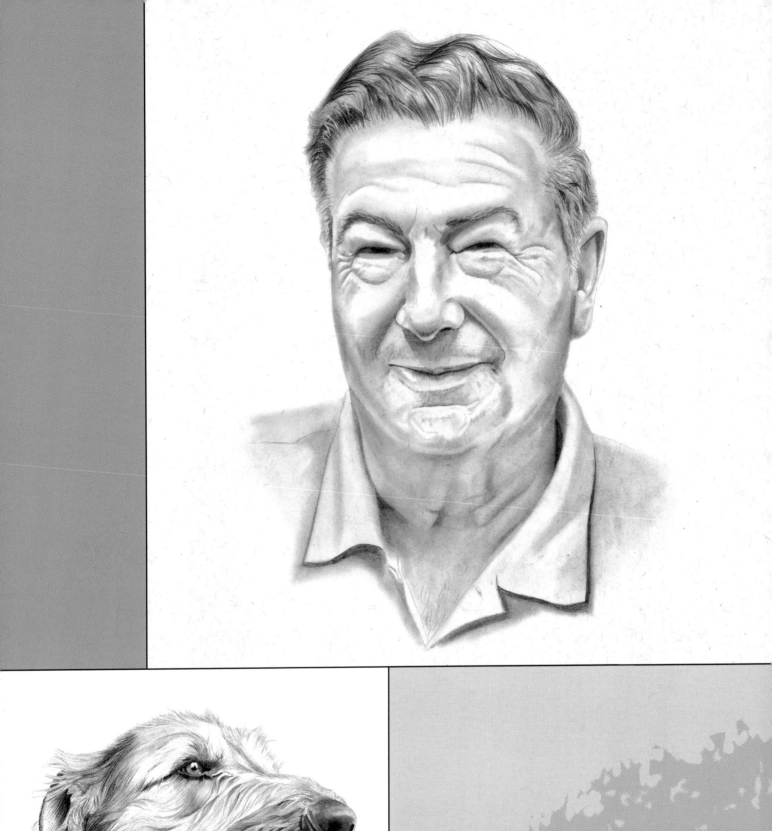
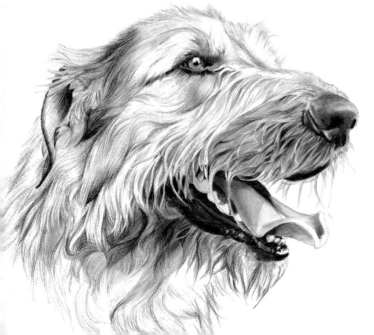

TABLE OF CONTENTS

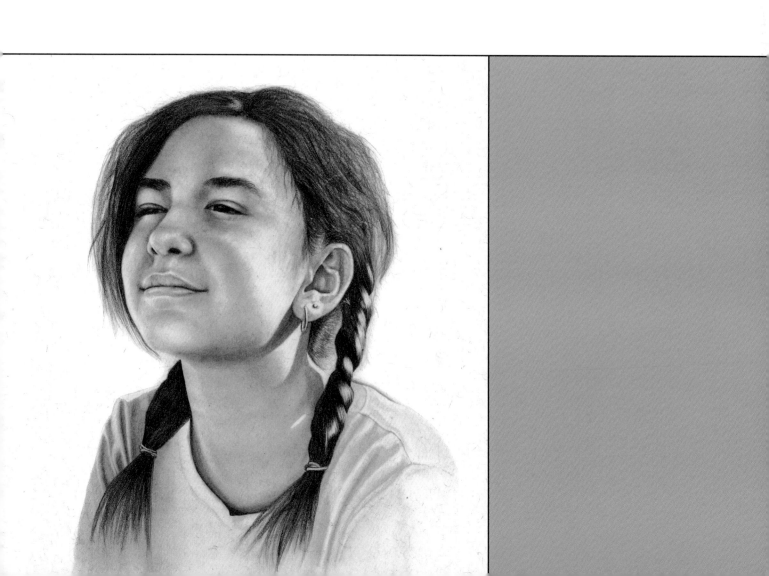

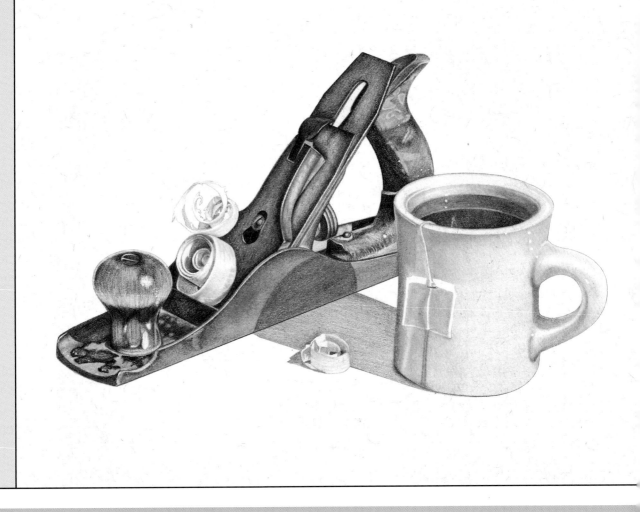

INTRODUCTION

So many times I have heard someone throw down the sword—make that the pencil—and issue this challenge to me: "Yeah, but you can't teach ME to draw!" Yes, I can teach you to draw, even if you can't draw a straight line—or draw blood with a knife. You're reading this book, which means you've met the only criteria I have: a desire to learn.

Drawing is a very learnable skill. If you haven't learned to draw, your drawings are weak or some art teacher told you to take up knitting instead, you just haven't had the right instruction. I'm not promising that you'll become Leonardo da Vinci by the end of this book, but I do believe you will draw better than you have ever hoped. All you must do is apply (and practice!) the drawing tools taught in this book. You'll

soon discover that learning to draw is less about talent and more about learning to perceive the world around you differently.

GETTING THERE

My own artistic journey is just colorful enough to make for a good, and hopefully inspirational, story.

I'd always found certain types of art easy. That is, I could look at some things and somehow draw them fairly accurately. I grew up in a small mining town in northern Idaho where the public school system could barely afford textbooks, let alone an arts curriculum. My parents did the best they could to encourage my talent, but when I announced that I was going to be a professional artist, they could barely mask their horror.

Art was fine as a hobby, but a career? After much soul-searching, they bravely sent me off to a nearby community college to study commercial art.

I soon found myself floundering. Lessons consisted of the professors placing a mess of white shapes on a table and having us draw them. White balls, white shoes, white drapery and, well, more white stuff. I could never figure out the point. What is so special about white? Then we got to paint. We did paintings of the white stuff in the primary colors of red, blue and yellow. Egads! I just wanted to draw something that really *looked* like something.

After a year of not getting it, I changed majors and figured my art career was probably going to become a hobby after all. I envisioned myself as a gray-haired

lady puttering with bad oil paints on Saturday mornings. For several years I drifted from college to college and major to major. I became the consummate professional student.

Then one day I attended a gallery opening of watercolor paintings. As I wandered around the room studying the paintings, it hit me: I can do this! I can paint at least this well. So what was the difference between this artist and me? How did she get her own art show and not me? My husband dryly provided the answer: "She *did* it." She took the time and effort to actually create enough art for a one-woman show. I made up my mind then and there that I was going to be an artist, too, despite my collegiate setbacks.

THE STORY CONTINUES

After some time as a watercolorist, I found myself developing a fascinating use for my drawing skills: I started working at a crime lab as a forensic artist. Part of my job was sketching crime scenes. I would love to tell you that I was originally hired to work there because I was a brilliant artist with the crime-solving ability of Sherlock Holmes, but that would be stretching it. In 1985, I attended a short course on composite drawing at the FBI Academy in Quantico, Virginia. Composite drawings are the "Wanted" drawings you see of criminal suspects on the nightly news. They are usually created by combining separate facial features that the victim or witness of a crime selects from a book of faces. The composite is used to identify an unknown suspect. I was invited to the course only because the FBI wanted participants from a variety of regions throughout the United States. My face-drawing skills were still dreadful at this point, but I was inspired to improve.

I worked hard and paid attention to what it would take to do a good job. I became Carrie Parks, Pencil Sleuth.

I loved drawing faces and became addicted to forensic art. I finally finished my college degree with a double major in social science and art—with honors, no less. My motto was, "I have a pencil, and I'm not afraid to use it!"

Now my husband and I travel across the nation teaching composite drawing and forensic art courses. We have taught all kinds of people of varying skill levels, from FBI and Secret Service agents to civilian adults and children. We have won awards for our teaching methods, and I've even written a book exclusively on drawing faces. And to think, at one point I thought art could only be a hobby!

SO, THE POINT OF THIS IS …

You, too, can realize your dream of becoming an artist if you set your mind to it. This book aims to teach you what it takes to do just that. I'm not going to set a bunch of stuff in front of you and expect miracles. Instead, I'll cover all the essentials, teaching you the secrets of realistic drawing one step at a time. Before you know it, you'll be turning out picturesque landscapes, stellar portraits—any subject that you like!

In my many years of teaching art, I've discovered that there are certain characteristics that define success as an artist. My short list is as follows:

Desire. Desire doesn't just mean wanting something, but wanting it badly enough that you're willing to try a different approach to get it. At first, you might not like it, might not do well trying it, or might not find it useful, but still you are willing to try. This characteristic is what will allow you to grow and improve your artistic skills.

Interest. It's hard to whip up a fascination for drawing Harley-Davidson motor-cycles when you love to ride horses. You need to draw what interests you,

and practice your drawing on the things that interest you.

Good instruction. This is my role. Good instruction is not up to the student, it is up to the teacher. If you've ever taken a class where you were told to draw something in a particular way but were never told why or how, you haven't failed—your teacher has. If it's meaningless to you, you'll never learn. Art needs to be stepped out, explained and demonstrated. If it were as simple as just drawing something, you would already be doing it!

Focus. The artists who develop the best drawing skills usually have the best observational skills. This means having an eye for the details as well as the overall picture. This takes concentration and training but is well worth the effort.

Practice. To be good at anything, you need practice. One of my students was so thrilled by his new skills that he started drawing everybody, everywhere. I believe he had a sketchbook firmly in hand wherever he went. Of course, he is a fantastic artist now because he practiced his skill.

Talent. Some artists may have it, but you *don't* have to have natural talent to draw well. In my opinion, it takes far more training and skill develop-ment than actual talent to become a successful artist. Anyone can learn to draw by applying her desire and interest. I'll supply the good instruc-tion if you focus on and practice what you're learning. Everyone will then be convinced that you had talent all along!

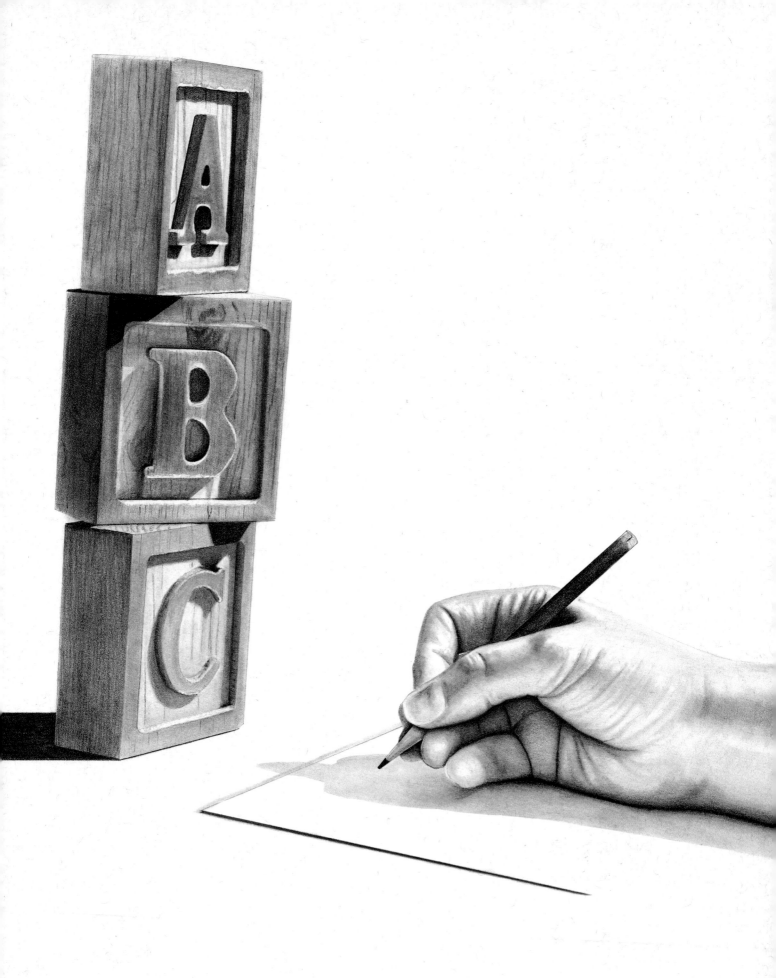

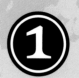

The Right Stuff:
Materials and References

BUILDING BLOCKS
16" x 20" (41cm x 51cm)

Y ou want to know the first secret to drawing? Find the best tools available! You have to have the right toys. Having the proper pencils, paper, erasers and other tools can make a big difference in your art. I'll show you what I prefer, but I fully expect you to develop an addiction to trying out new drawing supplies on your own. Think of it as the chocolate in your art life.

In addition to the right supplies, you need something to draw from. Whether it's a photograph, still life setup, live model or a trip to the great outdoors for some plein air sketching (and maybe a little bug-slapping), the inspiration for your artwork can come in many different forms.

Pencils

Your cheerful yellow No. 2 pencil usually contains an HB lead. It would perform just fine as a drawing pencil, but ask yourself, is it really cool? No, buying a sparkly version doesn't make it better. You need stuff, remember? There are quite a few pencil choices to consider:

- **Mechanical pencils** come in a variety of colors and are easily found in most art stores. They usually consist of a plastic holder and a fine HB lead that advances by clicking on an end or side button. They create consistent lines of equal width.
- **Lead holders** are available in the drafting section of most office supply stores and come with an HB lead. Various grades of 2mm lead can be purchased and easily placed into the holder. The main difference between lead holders and mechanical pencils is that a mechanical pencil cannot be sharpened. Unlike a lead holder, its tip is very small and will break if you apply too much pressure.
- **Graphite and charcoal pencils** differ in several ways. Graphite pencils, often called lead pencils, consist of ground graphite mixed with clay and placed in a wooden holder. They are available in many grades, although there is a slight difference in the darkness

among brands. They often create a shine in the drawing as light hits the surface. Charcoal pencils have more "drag" when you use them, may be more difficult to erase, and create a different appearance in your drawing. They often come in only three or four degrees of darkness.

- **Carbon pencils** combine the darkness of charcoal with the smoothness of graphite and may be combined with either graphite or charcoal in a single drawing.
- **Ebony pencils** are very dark, smooth graphite pencils. Many artists love these pencils, but they may limit your ability to build subtle tones.
- **Wash pencils** are water-soluble graphite pencils. They may be applied to wet or dry watercolor paper. You can also apply a wash of clean water for different effects.

Pencil Grades

There are about twenty grades of graphite available, ranging from the lightest and hardest at one end of the scale (9H), to the softest and darkest at the other end (9B). The HB lead in your yellow pencil is medium-grade, workable lead (or, technically, graphite). Your choice of pencil is determined by your drawing style and paper choice.

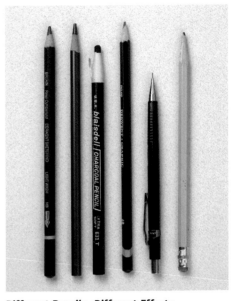

Different Pencils, Different Effects
The standard No. 2 pencil works just fine for drawing, but other grades of lead will be needed for some of the effects found in this book. From left to right are wash pencils, ebony, charcoal, graphite, mechanical and basic yellow.

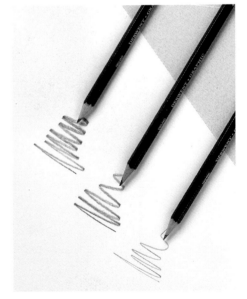

Pencil Grades
Hard pencil grades make lighter lines, while softer grades make darker lines.

Psssssst!

We will be using only four types of graphite in this book: 2H, HB, 4B and 6B. Purchase several 6B pencils; they wear out fast.

Fancy Stuff

Drawing sets are very nice and make wonderful gifts, but they're not necessary for drawing. If you purchase a kit, be sure it looks like you'll try most of its supplies, because some contain pencils you may never use.

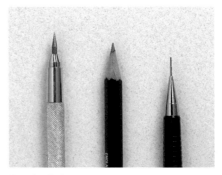

Get the Point

Compare the point on a lead holder with the point on a regular drawing pencil and a mechanical pencil.

Special Note: Pencils

Soft-leaded pencils will break inside their wooden hold-

HOW TO USE LEAD HOLDERS

Lead holders are our choice for drawing because they form a sharp point.

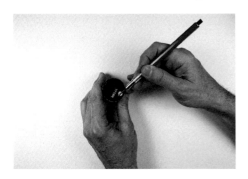

1 Expose the Correct Amount of Lead

The top of the lead pointer has two small holes. Release some of the lead from the holder and place it into one of the holes.

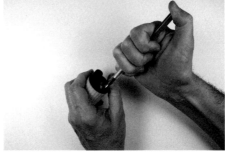

2 Correct Length

The size of the hole is the exact amount of lead you will need to sharpen. Slide the extra lead back into your pencil until the metal tip rests on the sharpener.

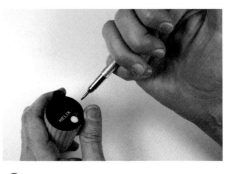

3 Ready to Go

You now have the exact amount of graphite exposed.

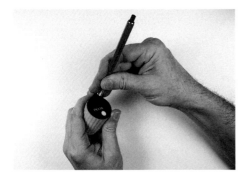

4 Sharpen

Place the lead holder into the larger opening. Jiggle it so it's correctly positioned. The entire top will rotate in a circle, sharpening all sides. Don't worry if you don't do well the first time. This takes a bit of practice.

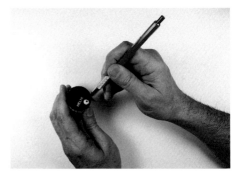

5 Clean Up

Push your sharpened tip into the small white area on your lead pointer filled with soft-rolled paper to clean off the excess graphite.

Erasers

Most people have the idea that erasers are used only for boo-boos. Make a mark, erase it. Make another mark, erase again. Erasers are far more useful than that. They can lighten areas, create textures and add a variety of different effects to your drawing.

Unlike pencils, erasers are not lined up and clearly labeled for the shopper's convenience, so you'll need to investigate your options before making a purchase. There is a wide selection of erasers available, each varying in hardness (or firmness) and messiness (how much eraser residue is left behind). The upside, though, is that with so many options you're guaranteed to find an eraser that suits your needs.

Types of Erasers
- **Pink Pearl** is a common eraser with attitude. It gets into your drawing and really tears up the graphite. But be cautious: The same aggression this eraser applies to graphite is also applied to your paper. There's a possibility that your paper will be roughened up as well.
- **Kneaded erasers** made from rubber are soft and pliable. You can wad them into a point to lift graphite out of tight places or use them to lighten an area that's too dark by pushing them straight down on the art, then lifting. Clean them by stretching them back on themselves.
- **White plastic** or vinyl erasers are your best choice for general cleanup. They are nonabrasive, tend to be gentle on your work and leave behind no residue.
- **Gum erasers** are useful but terribly messy. They shed worse than a collie in spring.

- **Electric erasers** are great, especially the smaller, battery-operated versions.

I use the white plastic and kneaded erasers the most. I like the way the white plastic eraser handles the paper—gently yet efficiently. The kneaded eraser lifts out the graphite without destroying the underlying pencil lines.

Going Electric
Drawing supplies are inexpensive compared to other mediums. Think about the money you'll save! Because you have all that extra money, you're now going to spend it on your first big purchase: a portable electric eraser.

There are several brands of portable electric erasers on the market, but I find the Sakura brand works best. Some brands spin too fast, grinding into the paper and leaving rough spots. Some brands stop spinning as soon as you touch the paper. The Sakura eraser has the right spin to erase, can be sharpened to a fine point by using a sanding block and is easy to hold.

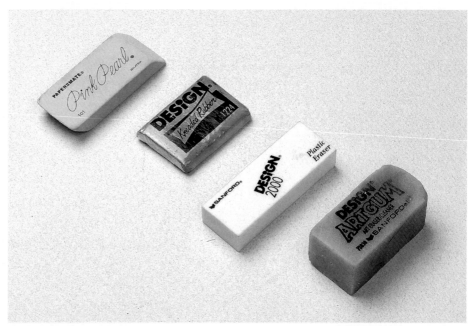

Rounding Up the Usual Suspects
From left to right are the Pink Pearl, kneaded, white plastic and gum erasers.

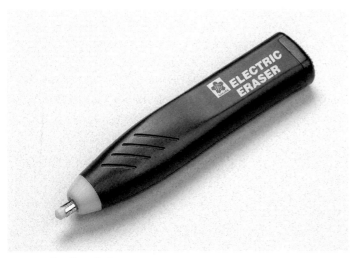

My Favorite Electric Eraser
I like the Sakura portable electric because it handles like a pencil and erases cleanly without tearing up the paper.

My Favorite Kneaded Erasers
Colored kneaded erasers by Faber–Castell don't stain your work and come in red, yellow and blue. Blue's my favorite; it matches my eyes.

Drawing White Lines
An electric eraser with a sharpened tip allows you to accurately draw white lines through your shaded areas.

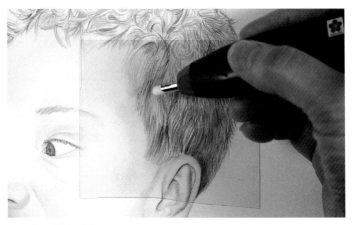

Creating White Lines
You can't draw white lines on white paper, but you can lift them out of your shading using the electric eraser. Practice creating the effect of white hairs, eyebrows or highlights in the eyes and hair.

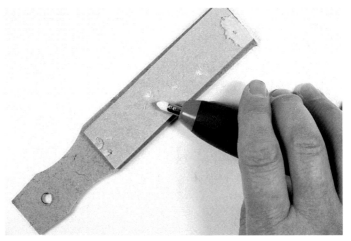

Sharpening Your Electric Eraser Tip
In order to "draw with white," that is, make fine lines with your eraser, you'll need to sharpen the tip. An old piece of sandpaper works fine, as does a sanding block created for artists. Turn on your eraser and angle it so that the spinning eraser forms a sharp point.

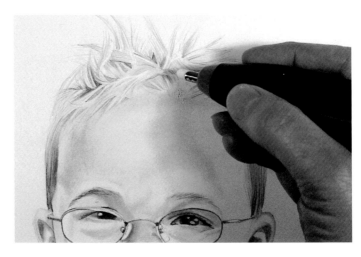

Other Absolutely Necessary Toys

I once handed my five-year-old nephew a toy catalog and asked him what he wanted for Christmas. He opened the book and studied the first page intently, then said, "everything on this page." He looked at the facing page, waved his hand over it and declared, "everything on this page, too." He went through the entire book like that, asking for everything but the dolls.

No, you don't need to buy everything on every page of the art supply catalog, but you do need to add a few more items to your shopping cart.

Ruler

We'll use a ruler for a variety of different projects, and the best one by far is the C-Thru plastic ruler. The C-Thru ruler has a centering section so you can find the middle of anything. The interior lines make it easy to create 90-degree angles (trust me, you'll need that). I prefer the 12" × 2" (30cm × 5cm) version.

Circle Template

Certain things are a given. Chocolates have calories. You'll run into the most people you know at the grocery store when you look your worst. And drawing perfectly round circles is impossible without help. The next item for your drawing kit is a circle template. You can find it in most drafting areas of office supply stores as well as general art stores. You will absolutely need it. Find one with a variety of small holes.

Erasing Shields

Erasing shields are inexpensive tools made of thin metal that you erase over top of to create different effects. You can create a custom template by cutting through a piece of acetate with a hobby knife. The best acetate to use is clear plastic report covers.

Blending Tools

Many artists use their pencils to create shading, smudging and blending without resorting to some form of a blending device. It can make for a beautiful drawing, but requires skillful handling of the pencil. You may also take the other route and create nice shading with tools.

A short list of blending tools includes a paper stump, tortillion, chamois and a cosmetic sponge. Don't even *think* of using your finger because the oils will transfer to your paper. The paper stump is used on its side; the tortillion is used on its tip.

Proportional Divider

A handy (albeit expensive) tool is the proportional divider. It allows you to measure between your drawing and your art. There are several art suppliers on the Internet that carry this item. I'll demonstrate how to use one in a later chapter (see "Using a Proportional Divider" on page 54).

Horsehair Brush

My final toy is a horsehair brush to remove the erasing dandruff. A bird feather, soft-complexion brush or soft paint brush also work well. You don't want to use your hand because that will smear the drawing, and if you try to blow the debris off, there's a good chance that you might include some spit. Take it from me, spit doesn't add to your drawing.

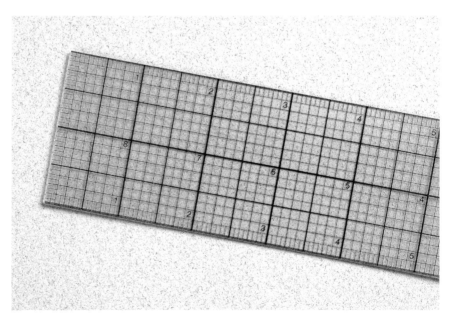

Ruler With a Grid
I use the C-Thru plastic ruler for precise measurement.

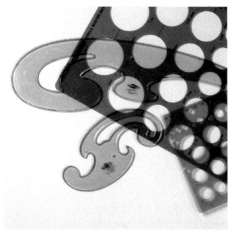

Circles and Curves
Circle templates and French curves allow you to draw perfect circles and curved edges.

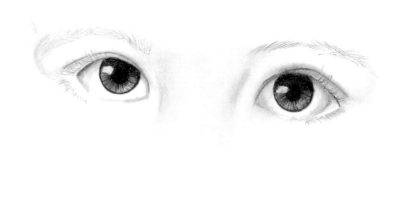

Round Is Beautiful
The only way you'll achieve eyes this nice is with a circle template.

Erasing Shields
I use the erasing shield to clean up edges.

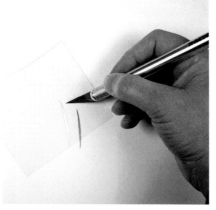

Creating a Custom Template
By cutting through a template, you can shade a particular shape that may otherwise be difficult to do.

Subtracting Using a Template
That same template allows you to customize the area you want to erase.

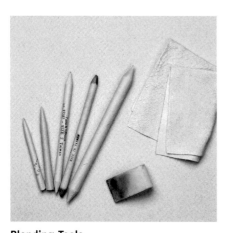

Blending Tools
From left to right are tortillions, paper stump, chamois and a cosmetic sponge.

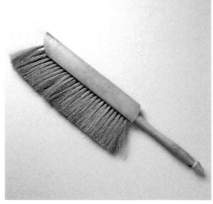

Art Brush
Find a soft brush to clean up your debris, and make your drawing easier.

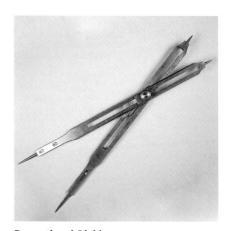

Proportional Divider
Use this handy tool to measure between your drawing and art.

Paper

Drawing paper is sold as individual sheets, in bound pads, in various shades of white to cream, in different weights (thickness), acid content (from newsprint to acid-free) and with finishes ranging from very smooth to quite textured. There isn't a right or wrong choice, except for newsprint, which yellows over time—only what works best for your pencil style and desired results.

I've tried a lot of different papers over the years. Because of the style of drawing I do, I like a very specific type. That's not to say it's the ultimate paper for you—I firmly believe you should experiment. However, to get the effects you'll see in this book, you'll need to use plate-finish (smooth) bristol board. Why bristol board? Surfaces that have more texture than bristol board don't blend the same—the graphite bounces across the top of the rough surface and doesn't easily get into the "valleys." You might have problems getting a smooth finish. In addition, rougher surfaces "grab" the pencil lead and require you to maintain good, even strokes—which can be difficult for a beginner.

Keep several spiral-bound sketch pads handy for travel. Sketching from life is a challenge, but it develops the eye. We'll cover more about this on pages 24–25.

And finally, an often overlooked but necessary type of paper is tracing paper. It's useful for tracing (of course) and transferring drawings, and also as a barrier to protect your drawings from the oils on your hand.

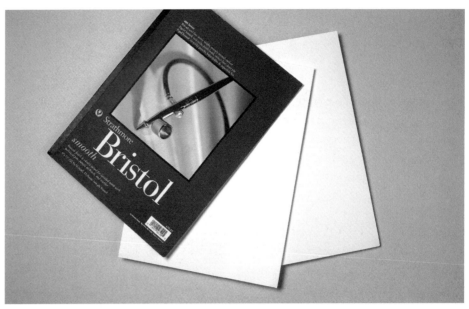

Smooth, Heavyweight Paper
A smooth, heavyweight paper makes blending easier.

Tracing Paper Serves as an Oil Barrier
Place a piece of tracing paper under your hand as you shade to keep from transferring the oils from your hand to the paper and to keep from inadvertently smudging the wrong part of your drawing.

Sometimes You Have to Trace
Objects such as glasses, when viewed straight on, must be the same size and shape because they're mechanical. Trace one side of the glasses, then turn the tracing paper over and check the other side for symmetry.

Pssssst!

I buy my paper from an online supplier once I've determined what paper I need. It hasn't been touched by oily hands like in an art store. When I buy from a store, I purchase sealed pads.

Drawing Table

You need a place to lay your supplies and your drawing paper that allows you enough room to draw comfortably. A full-size drawing table provides a firm, steady surface and enough room to rest your arm as you draw. The table should angle so that your drawing paper is parallel to your eyes, which minimizes the chance for visual distortion as you work.

I always remove my drawing paper from the pad and place it on a drawing table unless I'm working in my sketchbook. In that case, I'll place a piece of cardboard between the pages to prevent transfer.

If you have limited space or want to carry your studio with you, consider a portable drawing table. I have a dandy one that has a handle for easy transport and whose angle is somewhat adjustable (though not as much as a larger drawing table). Homemade drawing surfaces work just as well, as long as they are firm and steady. Use a clipboard or a piece of smooth material such as Masonite or plywood with the addition of bulldog clips or drafting tape to hold your work in place.

No Distractions
I have a wonderful drawing table with matching light, chair, tray and taboret (set of portable drawers). I have several thingamajigs that twirl around and hold a variety of nifty pencils and erasers. Needless to say, I look major cool when I draw.

I've faced my table away from the window to avoid distractions while drawing. I can think of all kinds of things to do outside if given the stimulus of a window.

Back to the Drawing Board
This portable model can make any place your art studio.

Reference Photos

Step one in drawing is to take a photo. We'll talk about contour drawings and life drawings later; for now you'll want to start with photos.

Going Digital

I mostly use film photography, but digital cameras are progressing at a fast rate and are easy to use. Just be sure your photos are clear and have enough detail. Some digitals look great on the computer but terrible when printed. If that's the case, you can draw while looking at your computer screen. It's easy to transfer a digital color photo to black and white for drawing purposes.

Lighting

I prefer a strong light source because I like the play of light and shadows on my subject. The problem may be, however, that too much sunlight can make for squinty eyes, black shadows or not enough contrast. One way to solve the problem is to photograph your subjects on an overcast day. You'll get some light patterns without the blasting sunlight. You can also photograph in the shade on a sunny day. You'll achieve contrast without the bright sun. Select photos that describe the contours of the subject rather than those that look like something spilled on the picture (the effect you might get when drawing a face dappled with sunlight through a tree). I've discovered that unless you also draw the tree, you'll end up with a blotted face. Direct light may place the subject in total darkness, making drawing it almost impossible. If this happens, you might try to lighten the face using a photo manipulation computer program.

Size

I realize it seems like the most obvious thing in the world to make your photo as large as possible, but I still have many students bring in snapshots where their darling child's face is smaller than my fingernail. Size does matter in drawing, because if we can't see, we can't draw.

Copyright

It is important to address the issue of copyright. Photographers work hard to improve and grow in their craft, and their photos are their art. If you get the photographer's permission to draw from his or her image, go ahead. Don't assume, however, that because your darling grandson is in the photo that you can draw from it. Play it safe and ask.

Places to Find Photos

I can't think of a better resource for drawing than the wonderful antique photos you have in your old family albums. Start by scanning the photo (if you have the ability to do so; if not you can have it done for you). Enlarge the scanned photo so that it's easier to see and keep the original nearby. Antique stores, garage and estate sales and other such locations may also provide a treasure trove of photos to draw from. Also, some books and magazines have great photos for practice, but remember these are just for practice, not publication or sale.

That's the Ticket!
Try photographing your subjects on an overcast day to achieve good contrast without squinty eyes or dappled shadow.

Bigger Is Better

The photo above left is nice, but the full figure is too small to see facial details. Above right is the size you need for details.

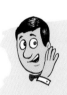

Pssssst!

The secret to good photos? Big. Clear. Interesting angles.

Antiques

Antique photos, unless from a book that may have copyright protection, make fine drawings because they are often very clear and in black and white. Think about drawing your grandmother as a child.

Shopping List

- *2H, HB, 2B and 6B pencils*
- *Pencil sharpener or lead pointer*
- *12-inch (30cm) C-Thru ruler*
- *Circle template*
- *Kneaded and white plastic erasers*
- *Electric eraser (if you can afford it)*
- *Bristol board*

- *Tracing paper*
- *Soft brush*
- *Drawing board*
- *Set of paper stumps*
- *Set of tortillions*
- *Reference photos*
- *French curves (for drawing glasses)*

Combining Photo References

Not only do you have the ability to change what you find in a single photograph, you can combine several photos for a single drawing. After all, trying to photograph a litter of puppies, four little children, or both sets of in-laws who live two thousand miles apart is waaaay too much work. You can also create a composite drawing of family members who have passed away, every dog you've ever owned, or other things that could never be grouped together for a photo. Composite drawings can enhance reality or make the impossible possible.

Let's look at how the drawing on page 23 was created using a number of different photos.

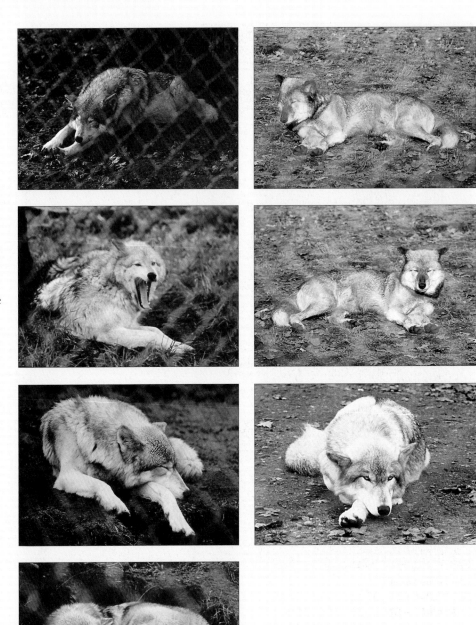

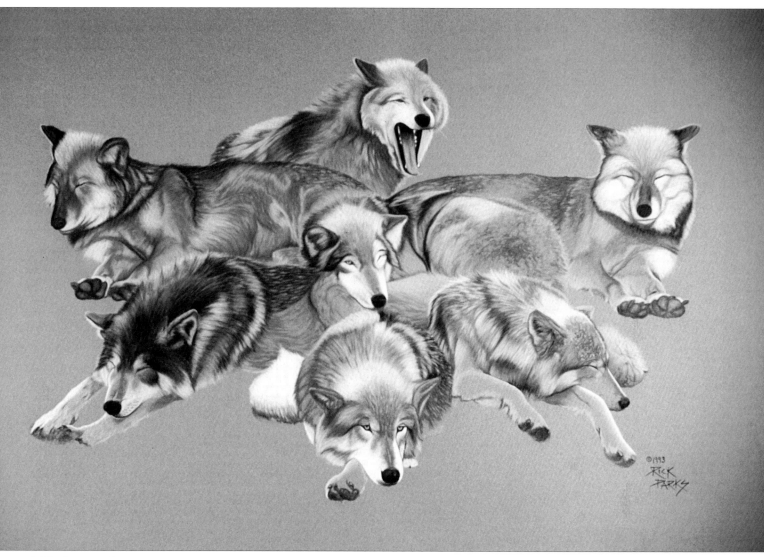

Finished Composite

This composite drawing was derived from seven photos taken at Wolf Haven in Tenino, Washington. The wolves were arranged in an interesting pattern, and the ground was implied, not drawn. Rick named it *Monday Morning* because he thought the body language of these wolves resembled the appearance of his fellow workers around the watercooler after too short of a weekend.

MONDAY MORNING

24" x 36" (61cm x 91cm)
Collection of Frank and Barbara Peretti

Pssssst!

There are two tricks to making good composite drawings. The first is getting the proportions of the combined elements correct so that everything looks like it naturally goes together. The second is a consistent light source, especially when the lighting is different in every photo. You may need to do a bit of research or ask questions when combining images.

Drawing From Life

I used to do most of my drawing from life—rendering the subjects in front of me rather than working from a photo. I wasn't attempting to be artsy, I just didn't own a good camera. One way to draw from life is to draw on location, which the French refer to as plein air drawing. The idea is to hike somewhere with your drawing equipment, sit on the wet ground, swat at bugs, unwittingly find poison ivy, get sunburned and draw a so-so sketch which gets soaked in a sudden monsoon on the way back to your car. Sounds fun, huh?

Why Bother?

You might think I'm not too fond of plein air sketching. That's not entirely true; drawing on location does have its benefits, and I've been known to take advantage of them occasionally. Plein air sketching, along with general drawing from life (which doesn't necessarily have to occur outdoors), allows you to register the mood of a location and the immediacy of the scene. However, it also forces you to deal with unwanted movement and ever-changing lighting conditions. For these reasons, it can be a lot harder than drawing from a photo.

One time I sketched a black Labrador retriever for a lady. He was a very nice dog, holding still for long periods of time and moving only very slowly. Unfortunately, because he moved so slowly, I didn't catch the fact that his head was slightly turned to the left when I started drawing the top of his head, facing me straight on when I drew his eyes, and slightly turned to the right by the time I finished his nose. Not my best work, believe me!

The best of both worlds is to tote your camera, sketchbook and notebook on location when you draw. Photograph the scene or subject from several angles, then sketch and make notes about your feelings, the colors (if you plan on eventually turning this into a painting) and your ideas for incorporating what you see into a finished work. Think of the possibilities! You can take that great old photo of Grandpa McCandless and place him in front of the antique car on display at a car show. Keep a collection of your sketches, photos and notes, which will come in especially handy on those rainy days when you'd rather make a drawing than watch another rerun on television.

Psssssst!

Always carry a camera with you when heading outside to draw. That way if the experience is not all it's cracked up to be, you can at least get some good reference photos out of it.

Drawing on location can be both exciting and beneficial to the artist, but it's not as easy as working from photo references. It's more challenging because the wind tosses the leaves, critters wander off and people don't hold still. Drawing from photos in the comfort of your studio or workspace means you can take your time, a luxury you usually don't have when you draw from life. Give drawing from life a try, but don't beat yourself up if you find it to be difficult.

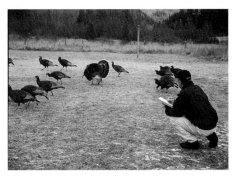

Hold Still!
Rick and I have a herd of turkeys that has taken a shine to our land, so naturally we photograph, sketch and paint them. Turkeys, being, well, turkeys, do not hold still. This is one of the many challenges of drawing from life.

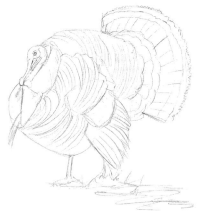

A Plein Air Sketch
Rick couldn't capture all the feathers or the shading, but he did try to get the feeling of movement and the roundness of the turkey.

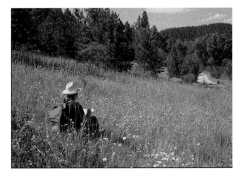

Taking It All In
It can be exhilarating to take in a scene first-hand, as it provides you with an opportunity to use all of your senses. Choose a comfortable spot with a good view. And be sure to check the weather forecast before heading out!

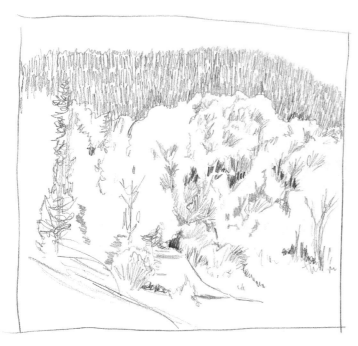

A Plein Air Sketch
This is a sketch of our upper field and the dirt road that leads to our house. The hillside was covered in flowers, which in turn were covered with bees. Rick quickly sketched the scene, seeking the various shapes, shades and textures of the vegetation on a summer day.

Cheat Sheet

When first starting to draw, you will need:

- *an HB graphite pencil (a yellow No. 2 will do)*
- *a pencil sharpener*
- *a white plastic eraser*
- *makeshift blending tools—facial tissue, a makeup sponge, etc.*
- *a ruler or other straightedge*
- *drawing paper or a sketchpad*
- *a steady, firm drawing surface*
- *a place to store your supplies*
- *photo references or live inspiration*

It would be nice to have:

- *a variety of pencils ranging from 2H (hard) to 6B (soft), or the same size leads with a lead holder (plus the special sharpener it requires)*
- *additional erasers—kneaded, portable electric*
- *paper stumps and tortillions for blending (plus sandpaper for cleaning the stumps)*
- *bristol board*
- *French curves and circle templates*
- *erasing shields*

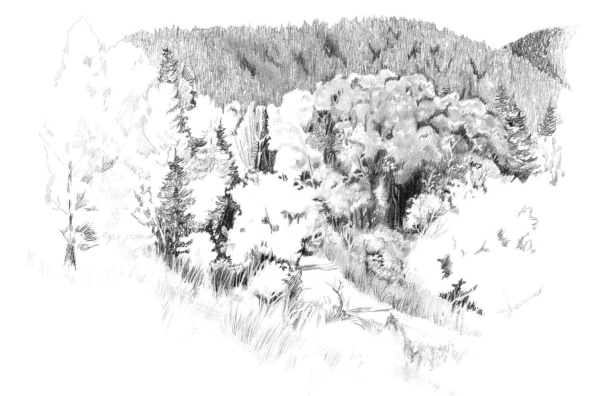

Finished Drawing
Plein air drawings capture a freshness, spontaneity, action and movement that is unique to the art. This finished drawing was created mostly from the rough sketch with a few more details added from a photo taken the same day. It is deliberately loose in execution.

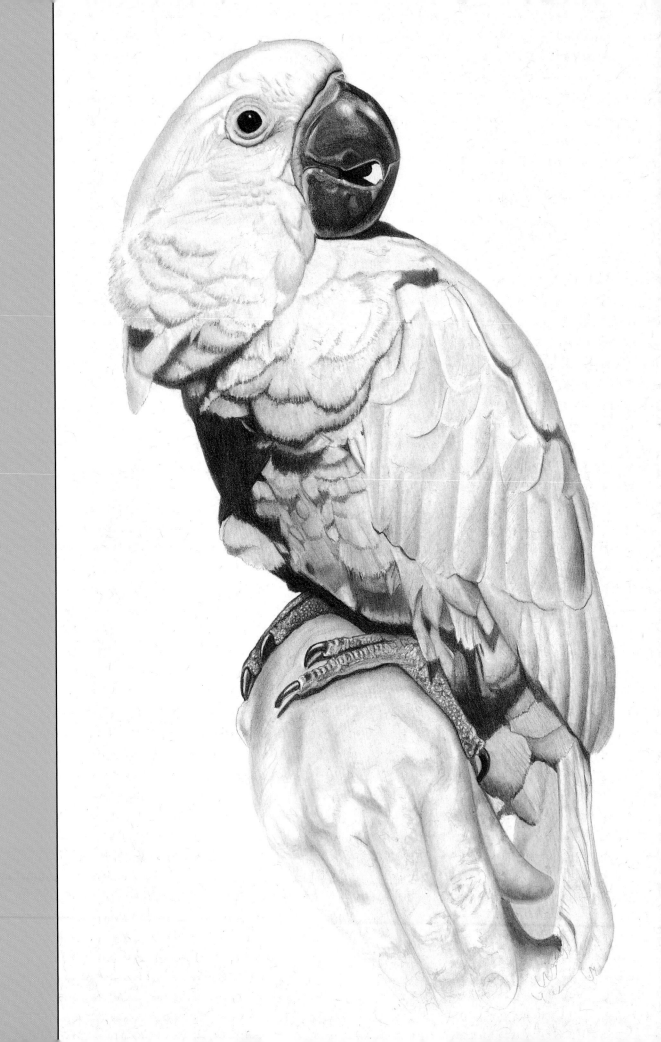

Realistic Drawing Techniques

HOGAN
17" x 14" (43cm x 36cm)

Chances are you've already tried to draw your favorite subject on your own. If you didn't get the results you were hoping for—and you most likely didn't if you bought this book!—your inaccurate (or incomplete) perception of your subject may not be the only culprit. Your technique of putting pencil to paper may take some of the blame. Maybe your rendering was close, but not quite right. That's OK! The first step is to actually get off your duff and give it a try. From there it's all about practice.

Before ballet dancers start dancing, they practice their positions. Singers go through pre-concert vocal warm-ups. A writer might start the day with some journaling or maybe a cup of coffee. As an artist, you're in the same boat—you need to warm up before you cut loose. Consider this chapter your pre-drawing warm-up. It's designed to get you drawing and using your tools correctly. All the tools, techniques, secrets and ideas won't help you without some practice, so grab your box of drawing goodies and let's get going.

The ABCs of Drawing

You first learned the alphabet as a series of shapes. You committed to memory the shapes of twenty-six letters (actually, fifty-two when you count both lowercase and uppercase). You memorized the letters and the sounds they made. You might have even learned by placing the alphabet into a song: "A-B-C-D …" and so on (although the letter "ellameno" took some time to figure out!). Then you combined the letters to form simple words like cat, dog, run and see.

In drawing, there are really only two kinds of shapes to learn: straight and curved. These simple shapes can be combined to form simple, recognizable images. All of us are able to combine straight and curved lines to create the simplest of drawings.

In reading, you eventually progressed to more and bigger words. With each passing day, you acquired more and more words for your memorized dictionary. Then you strung the words together to form sentences. In art, you might have taken a turn at drawing a more complex critter or car.

Here's where the natural artists and the rest of the world part. The natural artists develop a few skills to move on and draw more accurately. Everybody else figures there's no hope and throws down their pencils in disgust.

So what's the problem then? Why can't your drawings progress past this most basic stage? Understanding how your mind works can help you overcome this roadblock.

 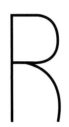

A B C D E F G H I J K L M N

O P Q R S T U V W X Y Z

Mastering the Shapes
Learning how to read demanded that you memorize the shapes that made up each letter. Learning the letter R, for example, required you to learn the series of curved and straight shapes that combined to form the letter.

Duplicating the Shapes
After a bit of practice, you were able to recognize all letters of the alphabet and the series of curved and straight shapes needed to duplicate or write each letter.

cat ran see the look

Combining the Shapes
Once you memorized the entire alphabet, you could then combine letters to make words. Likewise in art, you can combine basic straight and curved shapes to form simple drawings like this cat. You've gotten this far in your drawing skills already. The goal is to move forward.

Thinking in Patterns

The human brain is very efficient. It processes information at an astounding rate, then places that information into a memorized pattern so it makes sense to us in the future. For instance, we learn to recognize letters of the alphabet by memorizing their shapes. Once memorized, these shapes are stored in the brain and recalled when necessary. It is this ability to recall information that prevents you from having to relearn the alphabet every time you sit down to read.

The same process applies to objects around us. Your brain records a recognizable pattern for each object and recalls that pattern when necessary. So why doesn't the object in your drawing look like it does in real life? The answer is simple: When you draw, it is the memorized pattern that you usually reproduce on paper, not the reality of the object in front of you. Anything unique about the object you see may be lost when your brain recalls the pattern on file.

Along with stubbornly adhering to memorized patterns, your brain records only essential visual information, not every single detail. To prove this point, try drawing a one dollar bill without looking at it, and then compare it to the real thing. Notice any differences? Even though you've seen the dollar bill countless times, your brain hasn't recorded the exact details. In fact, you've likely only stored enough information to distinguish this piece of currency from any other piece of paper.

This means our mental patterns of most objects we want to draw are missing the details necessary to make the object appear realistic. You may be wondering, then, how veteran artists are able to crank out realistic drawings without even breaking a sweat. This is because our brains continually add shapes and images to our dictionary of patterns. For example, you have learned to read a sentence regardless of the font or handwriting style used. The same happens with drawing: Artists who have been drawing for some time have a large dictionary of patterns that they have been adding to over time. They have probably sketched them many times as well.

So how do you build your dictionary of patterns and ultimately improve your drawings? It's all about understanding perception, which we'll talk about next.

The Problem of Primitive Patterns
When we write, we rely on our memorized shapes to communicate. That's fine for writing but lousy for drawing. Memorized patterns seldom help us create realistic drawings when we're starting out. This is the case with each of the objects pictured here. Sure you can recognize the objects, but they are a far cry from realistic representations. You must expand your mental dictionary of patterns if you want your drawings to improve.

Perception

Seeing as an artist is not about vision, the function of the eyes. It's about perception, the mind's ability to interpret what we see. A good definition of perception is the process by which people gather, process, organize and understand the world through their five senses. With this in mind, there are two important points that every artist should know about perception.

First, each of us has a filter that affects our perceptions. By shaping your filter to meet your interests, you can build upon your dictionary of patterns and develop your artistic skills. However, it can be a challenge to alter your perception without study and practice.

This brings us to the second point: Perceptions are powerful—so powerful that they don't change unless a significant event occurs. In drawing, this significant event is training. The goal is to give you tools to bypass that filter and train your mind.

Filters

Perception filters exist solely to keep us from overloading on too much information. If we didn't have filters in place, we would suffer from sensory surplus. As handy as your filters may be in everyday life, they must be shaped and altered for you to become a proficient artist.

One filter I'd like to bypass right away is edges. I became aware of this when teaching children to paint, and it is the same filter still firmly in place in adulthood. Our perceptions dictate that objects must have strong outlines and defining edges.

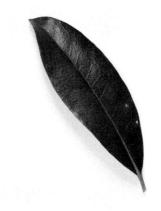

The Reality
When children (and many adults) are shown a subject such as a leaf, all the information they need to draw is present. It has a shape and color.

The Perception
Although all the details are present in the photograph, the filter of perception means the aspiring artist draws what is present in their mind—the outline of the leaf. There are no thick, dark edges present in reality.

The Reality
The reality of a face is that the nose begins in the forehead and is shorter in length than we tend to see it.

The Perception
We perceive the nose as originating somewhere around the eye area and as longer than in reality. The perception of the nose as overly long is so prevalent that many drawing books have incorrect proportions.

Pssssst!

The secret to drawing? Learning to see by using tools to overcome the filters of perception.

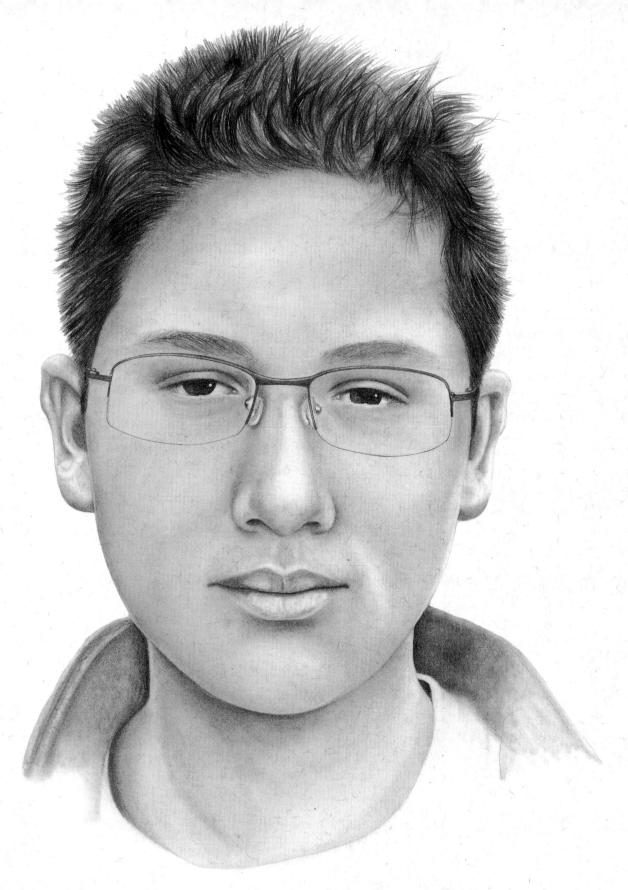

Capturing a Likeness

Understanding how your filters work, and then turning them off, will allow you to draw what you see, not what you think you see using memorized patterns of facial features.

NICHOLAS GONZALES

Graphite pencil on smooth bristol board

16" × 13" (41cm × 33cm)

Contour Drawing Warm-Up

One excellent warm-up practice is to do a contour drawing. There are two kinds of contour drawings: regular and blind. Both types involve placing your pencil on a piece of paper and not lifting it until the drawing is complete. The idea is that as your eyes are moving across the subject you have chosen, your pencil is moving across the paper in the same manner.

How do these two types of contour drawings differ? The answer lies in whether or not you look at your hand while in the process of drawing. In a regular contour drawing you have the freedom to look at both the subject and your drawing as you work. But a blind contour drawing, as the name suggests, requires that you lock your gaze on the subject entirely, never looking down at your hand as you draw.

Now, contour drawing may sound like a waste of your time, but the point is to train your eye and hand to move together at the same time and at the same pace. This ultimately forces your eye to slow down and more carefully observe the object so your hand can keep up. Just give contour drawing a shot—it'll be fun, I promise!

Pssssssst!

Contour drawings don't always have to be of a lone object. You can do a contour drawing of an entire scene or landscape. Though your pencil shouldn't leave the surface of your paper when you are drawing just one object, it is OK to quickly lift your pencil when drawing multiple objects if there is dead space between them. Only do this when necessary, though: The space between the objects should be significant enough to justify lifting your pencil.

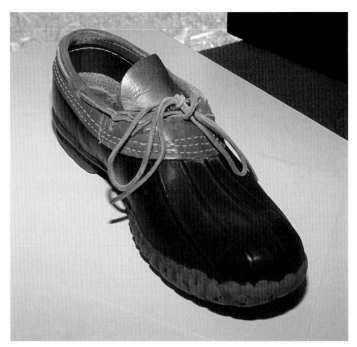
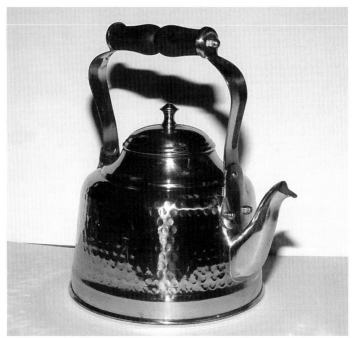

Reference Photos
I used this shoe and copper teakettle to complete the contour drawings on the next page. You can practice contour drawing with just about anything you have laying around the house.

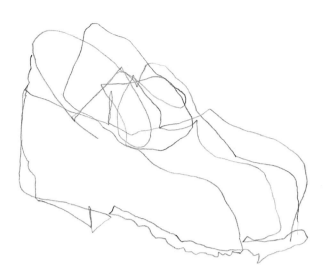

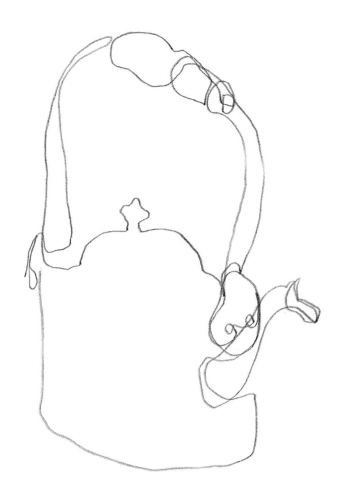

Blind Contour Drawing

Choose a starting point on the object, then place a piece of paper under your drawing hand and put the pencil down on the paper. Turn your body so you can't peek back at your hand. As you start drawing, your eyes and your hand should be in sync. That is, as your eye moves slowly around the object, your hand should record the exact part of the image on which your eyes are focusing at any given time. Let your eye explore each shape and area of the object as your hand does the same. Don't lift your pencil from the paper until the drawing is complete—and no peeking at your paper! When you're finished, you should end up with a scribble that kind of resembles your subject.

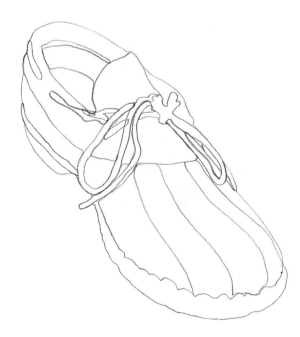

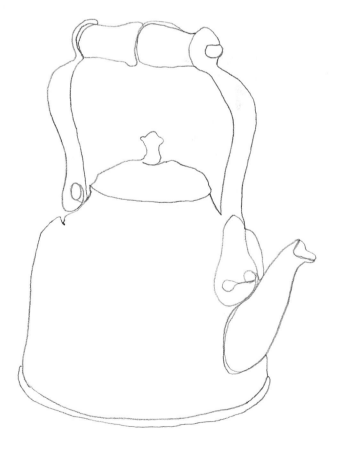

Regular Contour Drawing

Begin this drawing in the same way, only don't bother turning your body so that you can't see your hand. This time, you can freely look back and forth from your paper to the subject, but you still can't lift your pencil from the paper until the drawing is complete. No cheating! Your regular contour drawing will more closely resemble the actual subject.

Pencilling Techniques

Three pencilling techniques to try are hatching, crosshatching and circulism. You can usually choose one of these techniques to use throughout your drawing.

Hatching

Hatching involves drawing parallel lines on your paper. These lines should be varied at the points where they begin and end to prevent unwanted hard edges from occurring. Vary the distance between the lines to create lighter or darker areas. I think Paul Calle is the finest artist using this skill, and have just about worn out his book *The Pencil*.

Hatching may also be an interesting effect if all the lines go in the same direction, giving the drawing a more stylized image.

Crosshatching

Crosshatching is lines, um, crossing the hatching. Very clever name. Crosshatching starts the same way as hatching does, with parallel lines. Once the first set of lines is drawn, a second set is placed over it at an angle. If more depth is needed, a third or fourth layer (or as many layers as necessary) may be added to create the desired darkness.

Hatching and crosshatching are considered useful styles for creating shadows when drawing in pen and ink, although they may also be used in drawing.

Circulism

The third technique I'd like to touch on is circulism (sometimes called scumbling). This stroke is a series of interlocking circles that may or may not be blended later. You must keep your strokes even and your pencil on the paper. Many colored pencil artists use circulism on their work to build up the layers of color.

Hatching

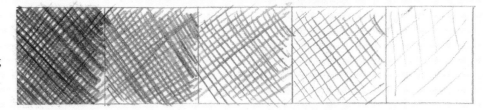

Crosshatching

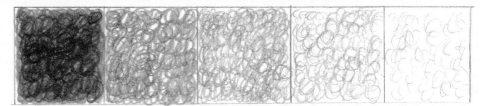

Circulism

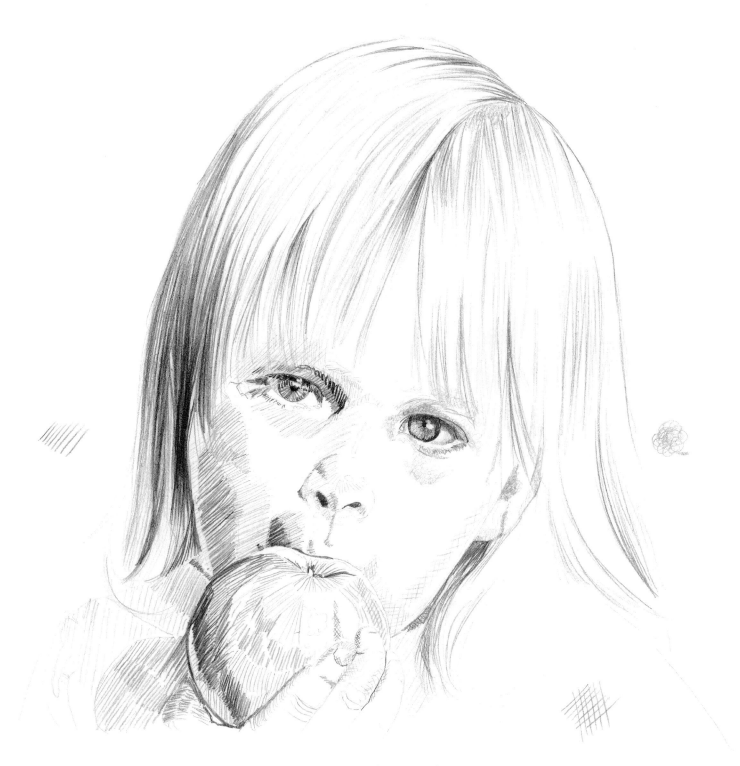

Choose a Style

Many artists choose one technique for their
drawings rather than mix styles within the
same piece of art. Experiment with your art
by trying out each style.

Smudging Techniques

To make your drawings look more life-like, you'll want to blend your pencil strokes for realistic shading. I call this technique *smudging*.

I remember taking a composite drawing class a number of years ago with an accomplished and well-known instructor. He paused at my desk and stared in horror as I smudged my drawing, finally grabbing the offending tool from my hand.

"Don't smudge!" he said. "You're grinding the graphite into your paper and you'll never be able to erase it!" He then walked away, taking my stump with him.

He was right. Smudging your drawing does indeed grind the lead into the paper, making it difficult if not impossible to "clean back out" to create the lights. I pondered his reasoning for the rest of the day before seeing the flaw in his point. Then it dawned on me that he was an oil painter, and oil painters work from dark to light. I am a watercolorist, and since watercolorists work from light to dark, we are used to preserving our whites or lightest areas beforehand. It's not a problem to use the technique of smudging for shading if you remember to keep away from the areas you wish to remain light.

I smudge my shading with some form of blending tool. These tools could be a paper stump, tortillion, chamois cloth or even a makeup sponge or facial tissue. Never, never smudge with your finger. Fingers contain oils that will contaminate your drawing and mess it up.

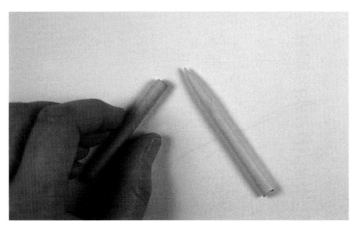

Small Smudging
Made of rolled paper, a tortillion is designed to be used on its tip, which will mash down if pressed too hard. This tool is meant to be used in small areas. It does not blend larger areas well because too much pressure is placed on too small a tip, creating a streaky appearance.

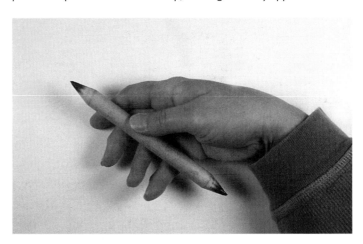

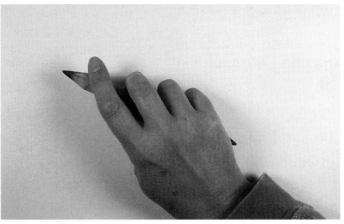

Large Smudging
A paper stump is typically used on its side, although you can use the tip for smaller areas. Don't hold it as you would a pencil, however, when blending large areas. Place the stump across your hand, as shown in the first picture, then turn your hand over to use the tool correctly. This spreads the graphite over a larger area without placing too much pressure on a small area.

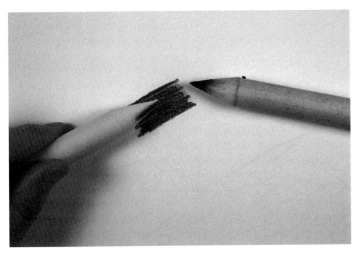

Getting Dirty

When you smudge, you are blending your pencil strokes together. The blending tool starts off clean and picks up the graphite from your pencil, smoothing and blending the strokes. You can accelerate this process by scribbling with your 6B pencil on a scrap piece of paper and rubbing your paper stump in the graphite.

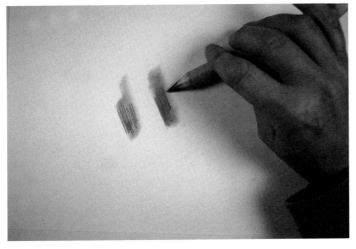

Start Neat

If your scribbles are sloppy to begin with, you will still see the sloppy strokes when you are done blending. Smooth, even strokes blend well together.

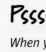 **Pssssst!**

When your paper stump gets dirty and dull from blending, you can clean it up and sharpen it with sandpaper. And if you accidentally mash down the tip of your tortillion, unbend a paper clip and use the wire to push the tip back out.

PRACTICE SMUDGING IN LAYERS

Using a paper stump involves shading in layers. Your goal is to go from darkest dark to light by blending in one direction. The darkest areas of your drawings will take numerous applications of pencil scribbles and smudging.

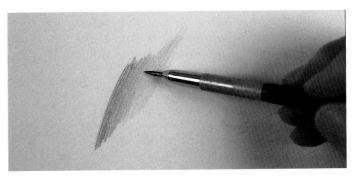

1 Gently Scribble

Draw a line on a piece of paper. Gently scribble with a soft 4B to 6B pencil next to the line, putting less pressure on your pencil for gradually lighter lines as you work to the right.

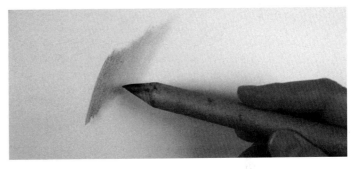

2 Smudge

Blend the scribble with your stump, using long strokes in the direction you drew in. Now draw your stump over an area that has no shading. The graphite on your stump will transfer to the drawing.

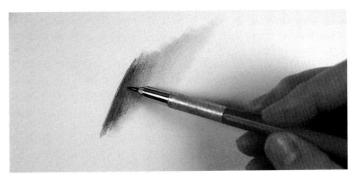

3 Repeat

It will take several applications of graphite and smudging to adequately develop the darks in your drawing.

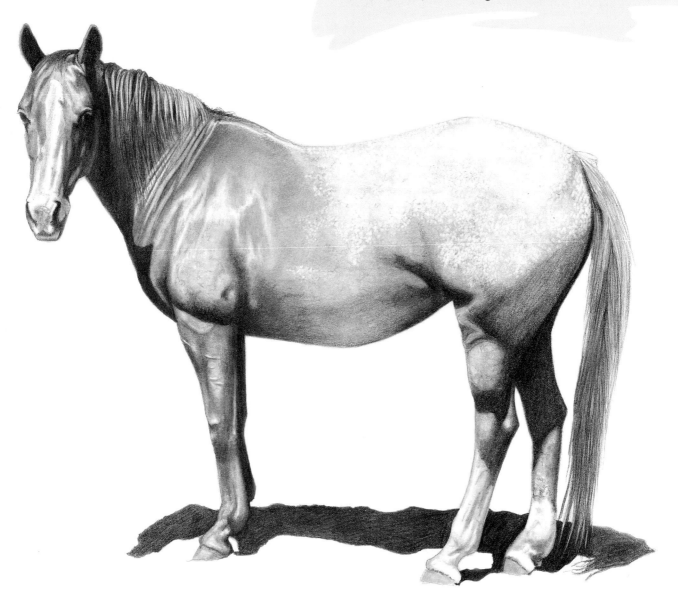

Putting It All Together

The darker areas of this horse were blended together with a paper stump. Several applications of graphite built up the desired level of darkness in the darkest areas. No pencil strokes were used on the midtones; the shading came entirely from the graphite residue on the paper stump. Some lines were deliberately left showing to indicate hair.

Erasing Techniques

Your eraser is a remarkable tool. Although you've been erasing things you have written since at least the first grade, you've probably never truly appreciated it. Sure it can correct mistakes, like lightening a too-dark area, but its use can be so much more deliberate than that. In taking away graphite, an eraser can add tremendous interest to your artwork.

My two favorite erasers are the kneaded rubber eraser and the portable electric. If you haven't yet succumbed to the benefits of the portable electric, I suppose you could use a standard white plastic eraser. We'll also practice erasing with the help of an eraser shield.

Psssssst!

As children, we tended to think of erasers as mistake-fixers. They're far more than that. In art, we erase as much as we draw, using the eraser to create lights, lighten midtones and make texture (think wispy white hairs or windblown grasses). Look closely and you'll see that erasers were used extensively in the drawings throughout this book and often share equal billing with the pencils.

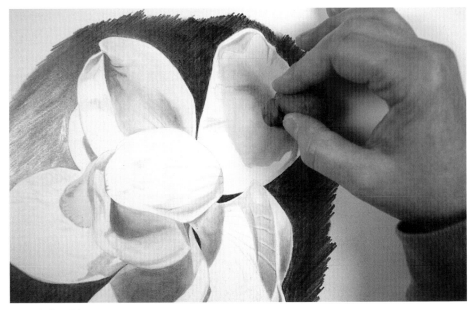

Kneaded Rubber Eraser
The kneaded rubber eraser will clean up mistakes just fine, but I love it because it will lift graphite from a drawing without leaving a harsh, unnatural edge. You use the eraser by dabbing—pushing it straight down, then lifting straight up—not by rubbing it side to side. The more you dab at a spot, the lighter it gets. This works wonderfully for developing the form of your subject (by creating light areas among darker ones) or for lifting out highlights.

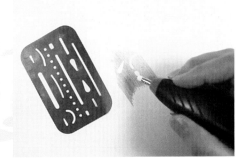

Erasing Shields
Erasing shields are best used as a way to clean up small areas on your drawing. You position the shield so the shape that will best correct the problem is over the troublesome part of your drawing, then erase through it. Erasing shields are also useful for creating new shapes.

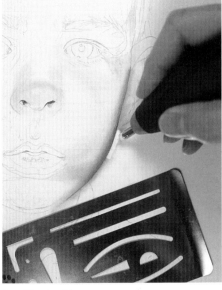

Outside the Lines
When I shade by smudging, I use a large erasing shield to clean up the outside edges of the subject. This allows me to make long sweeping strokes with the paper stump, which makes my drawing look smoother.

Give Templates a Try

You can create a variety of unique effects by making a custom template. Start with a piece of clear acetate, which you can find as transparency sheets or plastic report covers in just about any office supply store. Take a craft knife and cut out the shapes you desire in the sizes you want. Then you can lay the template on your paper and draw or erase the specific shapes through it. You can reuse these templates again and again for countless drawings.

Pssssst!

Custom templates are incredibly useful for the repetitious elements in a drawing. To avoid repetition that's too predictable (and therefore boring), change things up a little. Cut various sizes of the element on your template, or try flipping the template over and using the reverse image in areas.

❶ Create the Shape
With a craft knife, carefully cut the template into the desired shape. In this case, the shape had a sharp point, so the acetate was reinforced with a piece of tape so it wouldn't tear.

Draw or Erase With Templates
I used a small, curved custom template to draw in this blade of grass over a shaded area, then used the same template to erase a blade away.

❷ Draw Through It
The template may be used to draw through to create a small, sharply defined area. It also could be used to build up a darker area on an already shaded area.

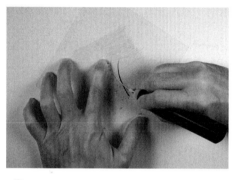

❸ Erase Through It
You could use the template like a custom erasing shield. It may be placed over areas that have been previously shaded to create layers of values (or lights and darks).

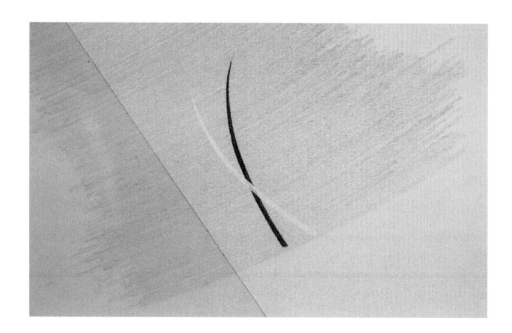

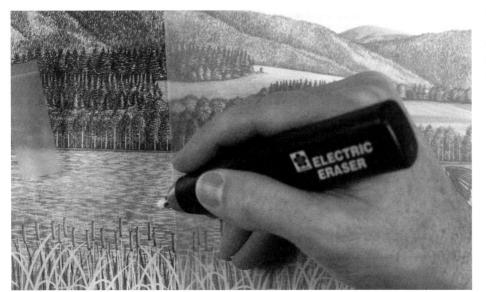

Putting It All Together

In this landscape drawing, the cattails, the tips and stems of the cattails and the trunks of the trees in the background were erased using custom templates. Some of the templates were reversed to create matching sides.

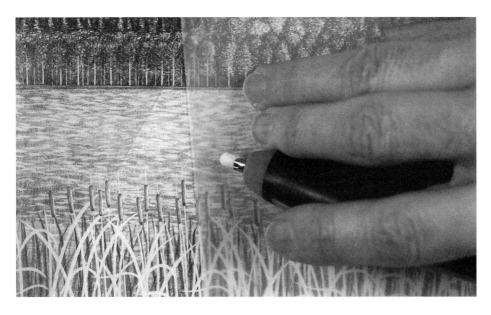

Look Closer

The ripples in the water were also erased through a custom template.

Cheat Sheet

- Contour drawing, in which you don't lift your pencil from your paper as you draw, trains your eyes and hand to move in sync and forces you to really observe your subject.

- Three common pencilling techniques for filling in your drawing are hatching, crosshatching and circulism.

- Hatching involves drawing parallel lines of varying lengths. Vary the distance between the lines to create lighter or darker areas.

- To crosshatch, layer sets of parallel lines over each other at different angles until you reach the desired darkness.

- Multiple pencils with different grades of graphite are required for building, a technique in which pencil tones are gradually layered.

- Blending or "smudging" makes your pencil strokes smooth and gives your drawings a finished look.

- You can blend using tortillions (ideal for small areas), paper stumps (best for large areas but usable in smaller ones) or household items like facial tissue, but never with your finger, which can deposit unwanted oils on your drawing.

- In drawing, erasers don't merely remove mistakes—they are used purposely to lift high-lights, soften hard edges and create realistic textures.

- Erasing shields and templates can give you greater control in pencilling in or erasing shapes.

A Lesson in a Jar

Among my regular activities I'm a professional speaker, and I sometimes use an illustration to make a point in my presentations. I'll take a clear glass jar and place four or five good-sized stones in it. Then I'll ask the audience if the jar is full. About half the group will say yes; the other half will stare at me as if I had sprouted horns.

Next I'll add smaller stones, filling the jar further. I'll ask the question again: "Is the jar full?" This time seventy-five percent will respond with no, anticipating another clever move on my part, and the remainder will fold their arms and stare at the ceiling. I'll pour sand into the jar next and repeat the question. Ninety percent will say no, and the remaining ten percent will check their wristwatches. Finally, I'll pour water into the jar. "Is the jar full?" I ask. By now the entire audience has been snagged by my antics. Yes, they all admit, the jar is finally full.

The point is this: If I don't put in the big rocks first, they'll never fit. As a budding artist, you need to get the big stuff down first. Work from the large, overall shapes to smaller, specific details. I can't emphasize this enough as you continue through the chapter: No amount of spectacular detail can "fix" a drawing whose main shapes aren't placed correctly.

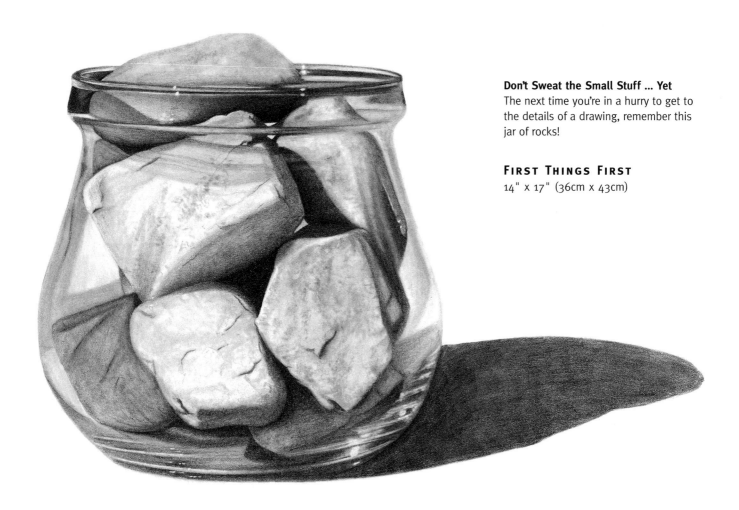

Don't Sweat the Small Stuff ... Yet
The next time you're in a hurry to get to the details of a drawing, remember this jar of rocks!

First Things First
14" x 17" (36cm x 43cm)

The Art of Measuring

You already have a basic knowledge of proportion and scale. You know about it because you learned it, and examples of it surround you in your everyday existence. You learned that a cocker spaniel is a very small dog when compared to an Irish wolfhound, but not so small compared to a chihuahua. You learned that you'd better measure the rooms of a new house and all the furniture you'd like to fill them with if you expect everything to fit. You learned that a large milkshake isn't that much bigger than a small one (that is, until your bathroom scale sets you straight).

So, what did you actually learn? You learned to compare things to other things through measurement, whether by eyeballing it or getting on your hands and knees with a tape measure. This is how we check proportion or scale—the size relationships between objects. In art, you will use measurement to put the proportions within your drawing to the test.

What Can Be Used as a Baseline?
Anything that is smaller than most of the objects in the drawing makes the best baseline. For example, the diameter of the quarter may be compared to the length of the key: The key is about twice a long as the quarter. The diameter of the quarter may also be used to measure the length of the screwdriver.

Baselines and Why You Need Them
In correctly drawing an object to scale, one technique is to establish a baseline and draw from that. A baseline is a common term used to describe the standard to which we compare something. After all, size is relative to what is being compared. A ruler is really a type of baseline, because we use it to measure linear objects.

In drawing, you will compare a baseline in the image in front of you to something else within the same image. For example, the width of a window in your reference photo might be a baseline. The building the window belongs to may then be considered about five windows wide, and the trees surrounding it about two windows wide each. Baselines are especially handy when drawing people. Drawing the width of the face, for instance, is much easier when you think in terms of how many "eyes wide" it is.

Wor d S

Early Lessons in Site
You've already had quite a bit of experience evaluating and adjusting proportion and scale. Think back to penmanship class in grade school: You learned there was an appropriate size and location for words on your lined paper.

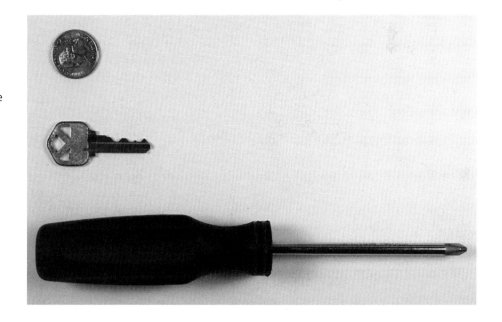

Measuring and Enlarging With Photos

The easiest way to measure objects with a baseline is to use a photo. Photos are two dimensional and easy to manipulate with your ruler or measuring tool. Measuring the proportions in your reference photo not only helps ensure that your drawing will be accurate, but it allows you to enlarge your drawing with ease.

A simple measuring system works best when the image is, well, simple and consists of mostly straight lines. Take the windows and door of a building, for instance. Since we are dealing with all fairly straight lines, a ruler works just fine for establishing proportions. We might find the window is $2\frac{7}{16}$ inches wide, so we draw a line on our paper that is $2\frac{7}{16}$ inches wide. The ruler measures it out for us. No big deal. Boring, but not hard.

But what if you wanted to make your drawing two and a half times bigger than the photo? You could do the math. Let's see, two and a half times $2\frac{7}{16}$ equals—well, maybe the math was a bad idea. Sure you could simply round your numbers up or down for easier arithmetic, but do you need to number crunch at all?

There is an easier way, minus the math. All you need besides your reference photo and drawing paper are a thin scrap of bristol board, an HB pencil and a ruler.

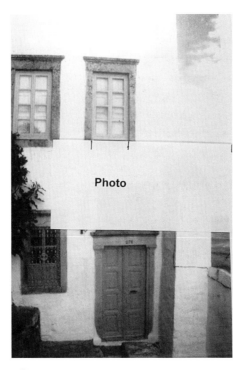

① Choose a Baseline From the Photo

Make a cheat sheet. On the scrap paper, write "photo" on one end and "drawing" on the other. This is to remind you to use the photo measurement to measure the photo and the drawing measurement to measure the drawing. You may think this is overstating the obvious, but you still keep forgetting where you left your car keys, so there's a remote chance you'll forget which side measures what. Select a short, straight part on the photo (we'll use the inner part of the window) and mark that width on the paper.

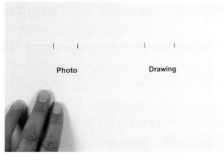

② Create a Baseline for the Drawing

You can choose any size for your drawing: a smidgen bigger, smaller, twice as big, whatever. Decide how big you want to draw the image and, on your cheat sheet, mark what will be the width of the window on your drawing.

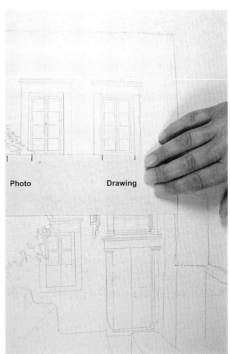

③ Compare and Measure as You Draw

Start your drawing using this as a baseline or standard of measurement. Everything in the picture is either the same size as, smaller than, or larger than your measurement. With your one baseline and piece of paper, it is possible to scale everything in the photo to the size you need it to be for your drawing.

Measuring Curved Subjects

Measuring objects with straight lines is fairly straightforward, but what happens when you must measure something with curves? In my experience I have found that many beginning artists, and a few experienced ones, have a consistent problem drawing curves correctly.

Curves can be tough to master. A curve that's too flattened will make something look incorrectly enlarged. Too rounded a curve will "squish" your drawing. Let's look at two subjects containing curves and use the same technique to measure both.

Psssssst!

A small confession here: I draw first and use the measuring system at the end or midway through to check how well I've scaled out the drawing. It's faster than measuring ahead of time and it trains my eye to pay attention to scale.

baselines

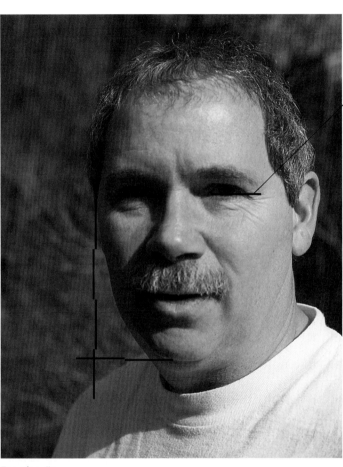

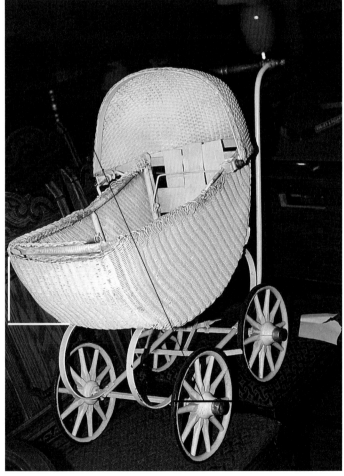

Exercise #1

My brother Scott was very unhappy that his mug didn't make it into my last book, so we'll use it in this one. To measure the curve of the side of his face, first select a baseline, which should be a fairly small shape on the face. In this case we'll use the width of his eye. Mark the width on a piece of paper, then see how many eye widths it takes to get to the side of his face from the curve of his chin (about one and a half eyes). Now turn the paper sideways and see how many "eyes" it takes to get to the widest point on the side of his face (three-and-a-smidgen eyes). The side of his face, therefore, will curve between these two points.

Exercise #2

This time we'll measure a baby carriage. Take a smaller measurement for the baseline—say, the width of the wheel—and compare it to where the carriage curves around in the front. It's one "wheel" out and one "wheel" down. That was easy!

Getting the Angles Right

This next measurement exercise is a bit more challenging. Our goal is to correctly proportion our drawing of a building structure and have it show the same angles as the reference photograph. It involves the same process of measuring that we used in the previous example, but we have added perspective, the idea that the structure has depth and parts of it appear closer to us or farther away.

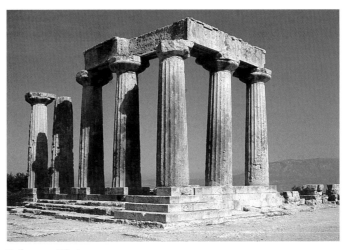

Reference Photo
Let's figure out how to accurately draw the angles of these ancient columns in Corinth, Greece. When doing this with one of your own photos, work on a photocopy instead of marking it up.

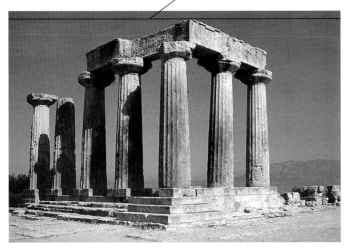

horizontal reference line

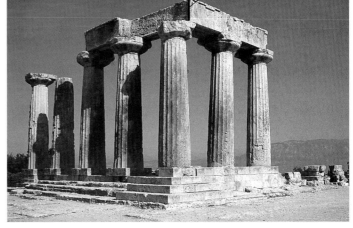

horizontal reference line photo baseline

① Draw a Reference Line

Using your ruler, draw a line across the top of the structure on the photo. This line touches the highest point of the columns and runs from one side of the photo to the other. This gives us a reference line from which to measure. Lightly draw a corresponding line across your drawing paper. We will be erasing this guideline later.

② Establish Your Baseline

We need to select a baseline measurement from the columns—a short, straight area that we can use to measure the entire drawing. I chose the height of the near corner. Mark a piece of scrap paper with this measurement.

Pssssst!

A straight line is an artist's best friend. It provides a concrete reference point that assists our eyes in recognizing even the most subtle angles and curves of our subject.

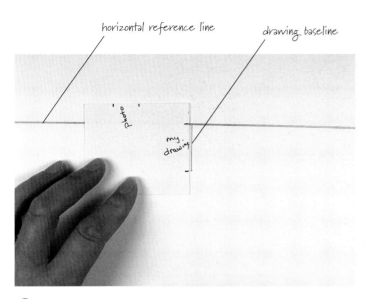

horizontal reference line drawing baseline

Photo

my drawing

③ Decide the Size of Your Drawing

If you want your drawing to be the same size as the photo, simply transfer the measurement to your paper. If you want it to be larger, make the baseline slightly larger when you transfer it, as I did here. If you want to make your drawing smaller … you get the drift.

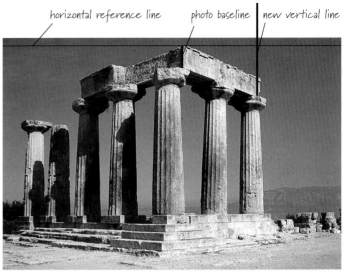

horizontal reference line photo baseline new vertical line

④ Add a New Vertical Line

Draw a vertical line at the end of the columns on the photo. Make sure it is parallel to the photo baseline. The correct angle of the columns is now bracketed between the lines. Measure the distance over and down on the photo; that is, from the top of the photo baseline (at the near corner of the structure) straight across to the new vertical line at the far corner, then from this point down to the top of the far corner. The horizontal distance is almost four baselines, and the vertical is about one and a half baselines.

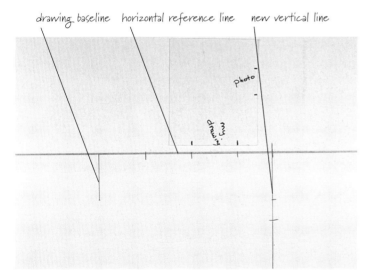

drawing baseline horizontal reference line new vertical line

photo

my drawing

⑤ Measure Your Drawing

Using the drawing baseline, measure the same amount of baselines over and down on your drawing. Make a mark at almost four baselines over and one and a half baselines down, and you have the correct reference point for your angle.

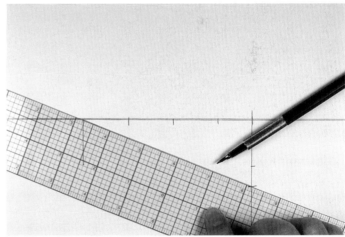

⑥ Transfer the Angle to Your Drawing

Use a ruler to connect the points and form the correct angle. The stone in the photo is not a perfectly straight line, but for now a ruler gets us in the ballpark.

47

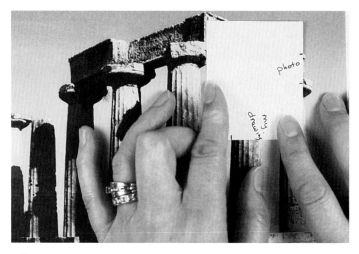

7 Don't Assume

Don't assume that the far corner of the entablature (the block held up by the columns) is the same height as the corner nearer to the camera. Measure. When I did a comparison measurement, the far corner was slightly smaller—which makes sense, since things appear to be smaller the farther they are from you.

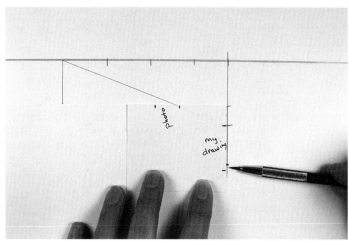

8 Compare and Mark

Measure your drawing with a slightly shorter mark than the drawing baseline to indicate the height of the block.

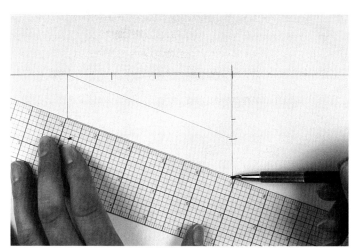

9 Finish the Angle

Connect the dots and voila! You have correctly recreated the angle in the picture for your drawing. Now the entire drawing may be scaled by using your baselines and measuring.

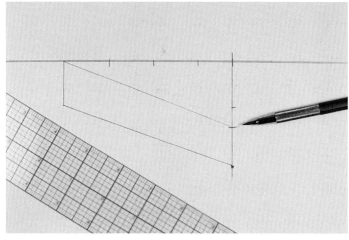

Pssssst!

Any baselines or other lines of reference should be drawn very lightly. Seeing these guidelines in your finished work is kind of like noticing someone's wearing a beautiful new shirt, then seeing that they forgot to remove the price tag!

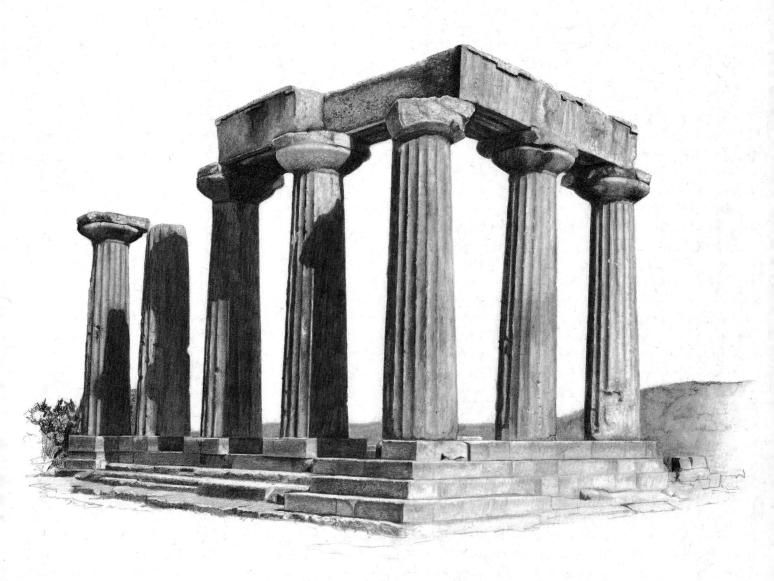

Then a Miracle Happens ...

OK, so a couple of lines on a piece of paper does not suddenly morph into a drawing like this. It's a good start, though. If you can get the angles and proportions correct, you've achieved the first step and laid an excellent foundation for your finished drawing. We'll work on honing your eye, clarifying your drawing and creating realistic shading as we progress through the rest of this book.

CORINTH, GREECE
Graphite on bristol board
14" x 17" (36cm x 43cm)

Flattening

Having just shown you how to measure something on a two-dimensional photo, let's touch on measuring something "on the hoof" as it were. The next site technique we'll look at is *flattening*.

What if a fantastic elk stepped out in front of you while you happened to be on a nature hike with your sketchbook? This very accommodating elk strikes a pose and holds it long enough for you to sketch him at your leisure. OK, this scenario may seem a little far-fetched, but you need to know how to work out the proportions in a three-dimensional situation no matter what your subject is.

Working out proportion in three dimensions is a lot like working in two dimensions. Two-dimensional objects have height and width. What is a three-dimensional object? One with depth. How do you perceive depth? By looking at something with both eyes. But when you are drawing something on a two-dimensional piece of paper, you don't want that depth perception. So what do you do?

Close one eye. One eye on its own will not perceive depth. Closing one eye will flatten the world around you and help you draw a three-dimensional object on your two-dimensional paper.

Don't believe me? Try this: Open both your eyes and place your finger in front of your face. Look beyond your finger at the background. Your eyes will actually see two fingers, and you can't see both your finger and the background at the same time. Now try the same thing with one eye closed. Aha! One finger and a background.

Let's look at how to establish a baseline on that three-dimensional, ever-so-patient elk.

1 Select a Baseline on the Subject

Choose a portion of the subject to use as your baseline. Remember, it should be a fairly small line, either vertical or horizontal, because a smaller line will be easier to compare to everything else in your drawing.

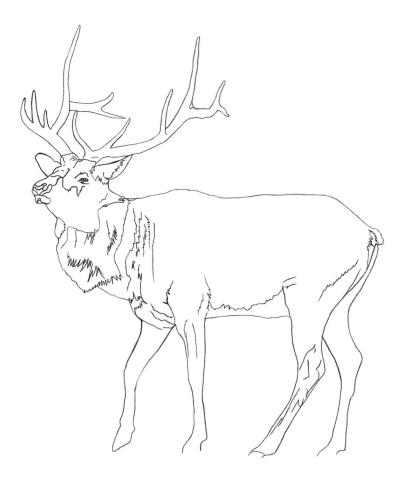

② Measure the Baseline

We'll select the height of one antler as our baseline. Extend your arm fully and straight out in front of you and close one eye. Hold your pencil so that it's parallel to your body. Use the tip of the pencil to mark the top of the antler. Use your thumb to mark the bottom of the antler. This measurement is your baseline.

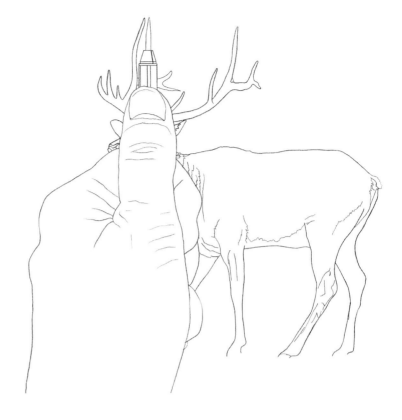

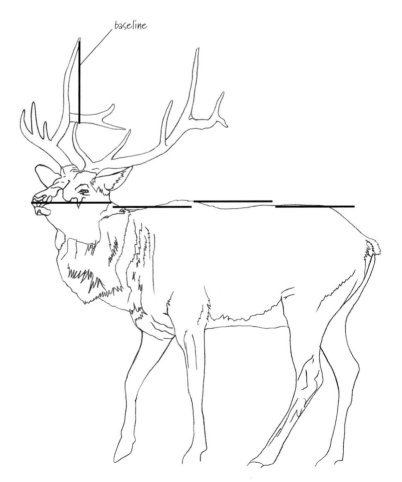

baseline

③ Compare the Baseline Measurement to the Subject

Using the measurement of the tip of the pencil to your thumb, you can now compare the antler baseline to any other part of the elk. For example, you may discover that, compared to the antler, the elk is about four baselines long.

Creating a Grid

A classic way to draw something with correct proportion is to create a grid and place it over your photo, then draw a grid on your paper. Let's explore different ways to make a reusable grid.

Computer Grid

Create a 1" (3cm) grid on your computer, then print it on clear acetate designed for a printer. (Hint: Be sure you buy the correct acetate for your printer type.) You can also draw a grid on a piece of paper and copy it onto acetate designed for use with a copier machine.

Low-Tech Grid

Using a ruler and a pen designed to mark on acetate (such as an ultrafine felt-tip marker), you can create a reusable grid. Any piece of acetate will do, both clear cover stock or sheet protector work well.

Make a Grid on Your Computer
There are a lot of programs you can use to make a simple grid on your computer. You can lay the grid right over your photo.

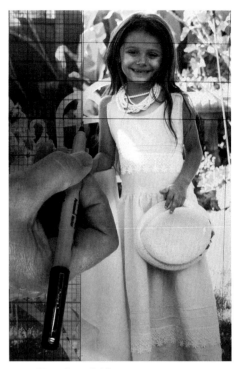

Draw Your Own Grid
If you prefer to keep it low-tech, a ruler, a felt-tip marker and a piece of acetate work very well.

Pssssst!

Drawing grid lines on your paper and then erasing them is a pain in the rear. A lightbox (or window on a sunny day) can be used instead. Place the grid on the lightbox, tape it down, then place your paper over the grid. You can see the grid through the paper and there's no erasing later.

Using a Grid

Draw a grid on a blank piece of paper. If you place a 1" (3cm) grid on your photo and draw 1" (3cm) squares on your paper, you will draw the same size as the photo. If you draw a 1" (3cm) grid on the photo and a 2" (5cm) grid on your piece of paper, you'll enlarge your drawing to twice the size of the photo. If you draw a 1" (3cm) grid on your photo and ½" (1cm) grid squares on your paper, the drawing will be half as large. You get the idea. You can either use one of your own pictures or base your drawing on the grid photo on the previous page.

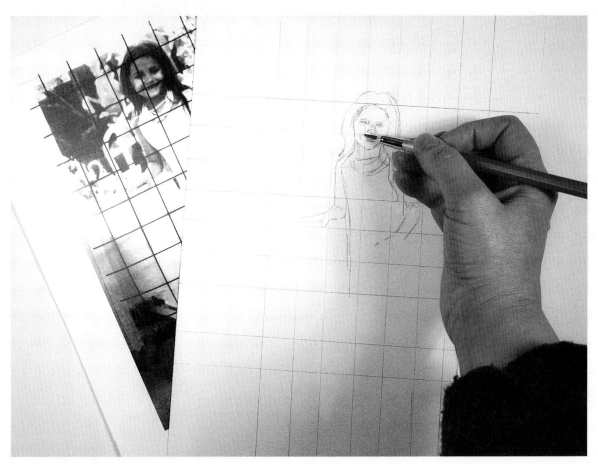

Number Your Grid Paper
You may get confused as to exactly where you are in your drawing compared to the photograph. To help you keep track of which square you're working in, number your grid on the photograph across the top and down the side, then do the same on your drawing.

Using a Proportional Divider

Proportional dividers can save a few steps, but are expensive. However, they last a lifetime. They are designed so that once you set the proportion, you can measure everything on the photo and scale it to your drawing.

On one side of the divider is a wheel that slides the divider up and down to increase or decrease the scale. If the wheel is in the middle of the divider, you are drawing the same size as the photo. The more you move the wheel toward one side or the other, the greater the scale. On some dividers, there is a second wheel that locks the scale in place so that when you open it to measure, for example, an eye on the photo, the other side scales it to your drawing.

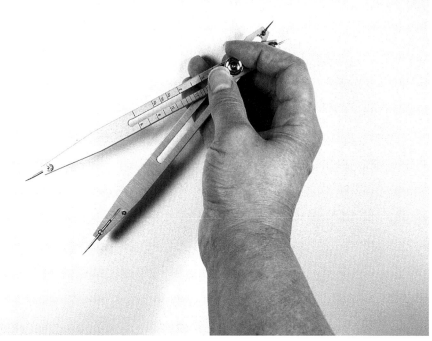

Proportional Divider
We need a few tools to help us see the correct proportions on a face. One tool is a ruler or straightedge. We're not measuring so much as using the line drawn by a ruler to provide reference points. The other tool is a proportional divider.

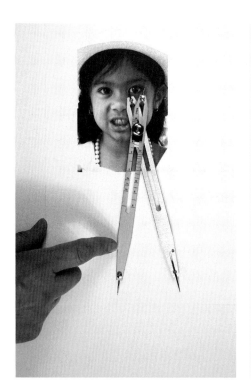

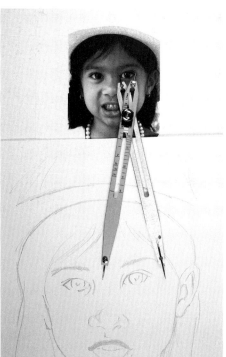

❶ Select a Feature to Set the Scale

Use the width of the eye again. Open the proportional divider so that one side measures the eye on the photo. The other side will be used to measure the eye on the sketch.

❷ Compare

Comparing the proportional divider to my sketch, I find it is too large. I need to move the wheel more toward the center.

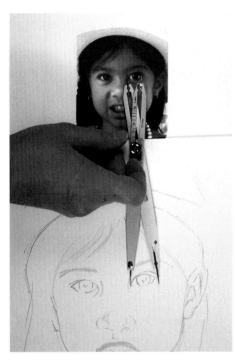

③ Check Again

Go back to the eye on the photograph. Check again and then compare it to your drawing. When the eyes are set, tighten the divider.

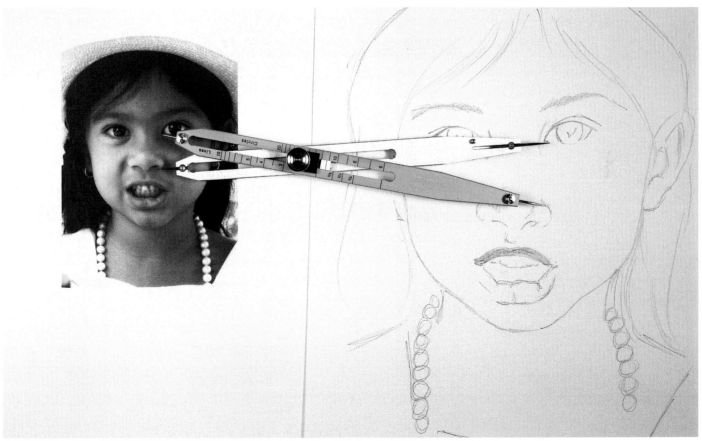

④ Ready to Roll

At this point, anything you measure on the photo with one side of the divider will correctly check the proportion of your drawing. You're in business!

Optical Indexing

Optical indexing is a fancy way of saying things line up. The idea is that if you have one object in your drawing placed correctly, you can use this as a point of reference to check the locations of everything else in your drawing. If certain parts of your drawing line up or are spaced appropriately according to your drawing reference, then you have a correctly proportioned piece of artwork.

Many artists use either a few simple horizontal or vertical lines or a more thorough grid system to check the alignment of the elements within their drawings. Both methods make it easy to spot mistakes in placement and proportion. Some artists begin their drawings with these guidelines to prevent problems from the get-go; others pull them out when they are in the middle of a line drawing that's not quite right. How you decide to use them is entirely up to you.

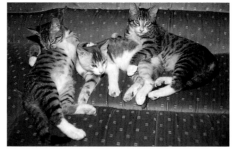

Bring On the Grid
Many artists use grids, but they are labor intensive and not needed unless it is a complex image you desire to draw. This pile of cats is a complicated series of shapes. This is a good time to use a grid system.

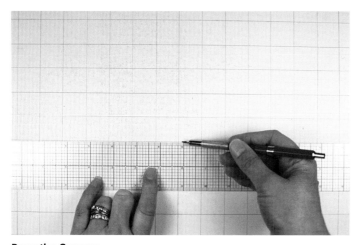

Draw the Squares
Place a grid of equal-size squares over the reference photo, or draw one directly on a copy of the photo. Then draw a grid of equal-size squares on your drawing paper. If you use a grid of 1" × 1" (3cm x 3cm) squares on your photo and the same on your drawing, the drawing will be the same size as your photo. For a larger drawing, make a larger grid on your paper.

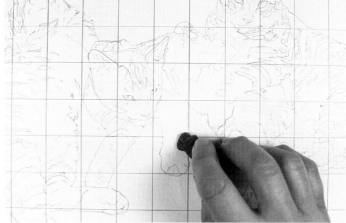

Fill In the Squares
Draw the shapes you see within each square. Keep your finger (or other marker of some kind) on the reference-photo square you're currently working on so you don't get lost. (It may sound silly, but there are kitty paws and tiger stripes going in all directions.) Once you have the shapes drawn in, carefully erase your grid. Looking at the various parts of a complex subject in this way makes drawing them much more manageable.

Pssssssst!
You can make a reusable grid in a variety of different ways:

- *Create a grid on a computer and print it on a sheet of clear acetate.*
- *Draw a grid with a permanent marker on a sheet of clear acetate.*
- *Draw a grid on regular paper, run it through a copier and make copies on acetate.*
- *Make a grid on a clear insert or folder, and slide your photo into the insert.*

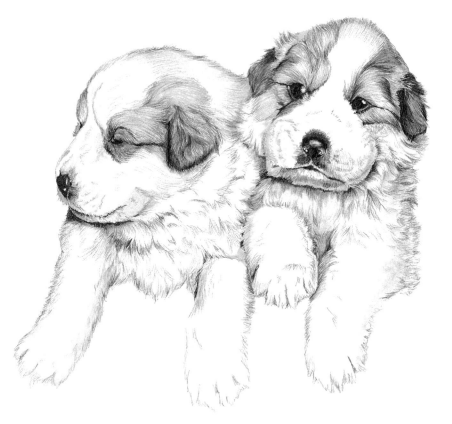

Check Locations

For example, when I place a horizontal ruler under the jaw of the puppy on the right, it lines up with the top of the left puppy's nose.

What Lines Up?

Here we find that the inside corner of the right puppy's eye lines up with the edge of his nose. Choosing a few different features or parts of your subject to spot check is usually enough measuring to make sure your drawing is in correct proportion.

Reading Between the Lines

These two Great Pyrenees puppies are much less complex than the pile of kittens. A grid could be used, but often just a few lines are necessary to measure the distances between elements to make sure you're in the ballpark. Try drawing these puppies first, then take a ruler and see what lines up in your drawing compared to mine.

Cheat Sheet

- *No amount of spectacular detail can "fix" a drawing whose site, or location of shapes, is incorrect.*

- *Every drawing needs a baseline or standard of measurement to which all the other parts of the drawing are compared. This ensures correct proportion.*

- *Measuring elements according to a baseline is easiest to do with a photo because it is two dimensional.*

- *Establishing two baselines—one for your reference and one for your drawing—makes it easy to enlarge or reduce the elements for a larger or smaller drawing.*

- *Make a horizontal reference line to help you check angles for accuracy.*

- *To measure a three-dimensional subject, "flatten" it by looking at it with one eye closed, extending your arm straight out in front of you, and measuring a baseline with your finger.*

- *If certain parts of your drawing line up or are spaced appropriately according to your drawing reference, then the drawing is in proportion.*

- *Use a complete grid or just a few horizontal and vertical guidelines to check how the elements in your drawing line up.*

Seek to Simplify

Most children find they have the ability to make simple drawings that satisfy them. Popular with this young set are cartoon characters. They often graduate from drawing such animated friends as the Little Mermaid to the exaggerated comic book superheroes. Then … nothing. Their art interest often drops off. What happened? It could be that football, girls, boys, dances, music and life in general takes over, and they simply move on

to other new and exciting pursuits. I suspect that is often the case, but I also think that once their interest in comic-strip characters wanes and the budding artist wants to try drawing something else, it proves to be difficult and they simply give up.

It was easy for the untrained eye to find the well-inked outlines of the cartoon characters and comic book images. The black-inked edges made the shapes

of objects easy to see. Unfortunately, the world around us is not outlined in black. It's more subtle and the shapes are harder to see. When something is more demanding, many move on to other subjects or interests.

Artists continue to seek those same simple shapes. It's really not so hard, because no matter how "decorated" they are, shapes are basically either straight or curved.

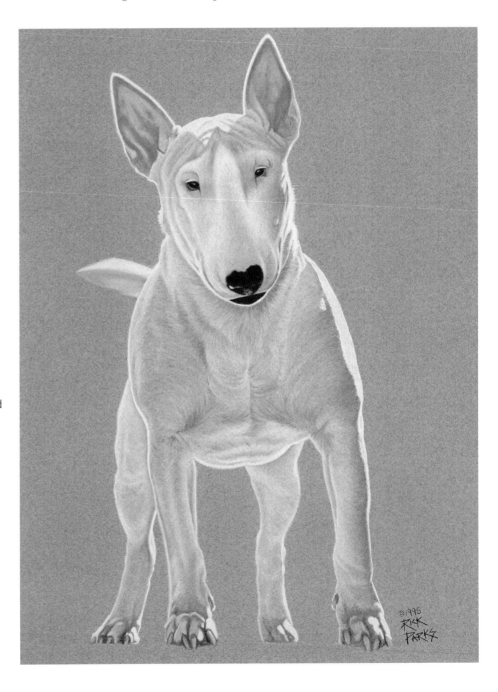

Humble Beginnings
When we were children, most of us at least made an attempt to draw our favorite cartoon characters. We grabbed a crayon or marker and started drawing lines, imitating what we saw.

Artistically Advanced
Winnie has no hard edges and certainly no black outlines. In fact, she's actually somewhat outlined in white. The basic shapes in both the cartoon drawing and this one are essentially the same, even though they aren't quite as obvious to the eye in *Winnie*.

WINNIE
Pastel pencil on toned paper
20" x 16" (51cm x 41cm)

Rename What You See

It's really not enough to say you see a shape such as those clearly shown in these pictures. Artists think of the objects they are drawing in terms of shape. They think about drawing circles, curves, straight lines and so on. If you asked them to say aloud what they were thinking as they drew, it would be phrased in terms of the shape, not the subject itself. Changing the way you think and name something will help you see it better for the purposes of drawing.

Take your camera out and record some of the shapes around you, or dig through your old pile of reference photos. Select a photo and draw its shapes—and *only* the main shapes, not all the details. The contour drawing exercises you learned on pages 32–33 are perfect for training you to see and draw the shapes of things.

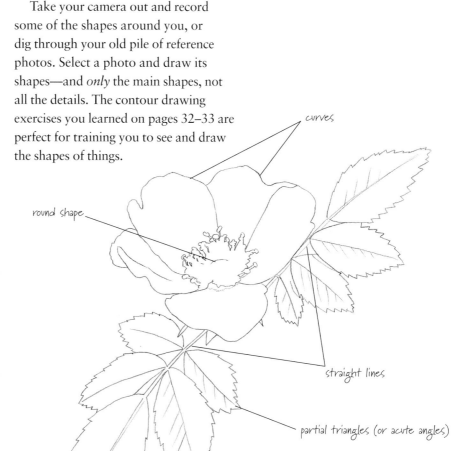

curves

round shape

straight lines

partial triangles (or acute angles)

Everyday Shapes
Look at the simple shapes found in this photo. Don't think "flower" as you draw; think straight and curvy lines, round and angular shapes.

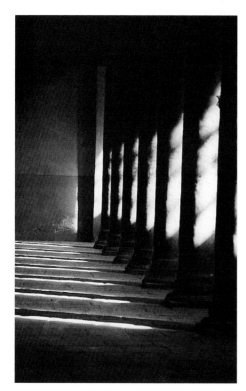

Seeing Patterns, Not Things
Photos like these are exceptionally good for helping you understand how to look past subject matter and see only shapes. An artist is more interested in the patterns in these pictures than the fact that they show columns and palm fronds.

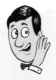

Pssssst!

Don't fall into the rut of drawing all trees, rocks, flowers and so on the same when they are not. To help avoid this, describe what you are drawing in terms of its shape. This will help you recognize the things that make it unique, which will in turn make for more realistic drawings.

Isolate Parts of the Whole

Just as a musician may practice a portion of a melody and a dancer may practice the same movement over and over, an artist often breaks up a subject such as a human figure and draws just the hands, feet or facial expression.

Isolating and studying shapes is very important. I don't know how many times I've looked at a drawing or painting that was well shaded and fairly well propor- tioned, but the trees were badly rendered on a landscape, the eyes were incorrectly drawn on a portrait or the nose of a dog looked like a double train tunnel. Take apart the subject you wish to draw and look at its parts. Separate them and draw them in individual sketches. Make it a habit to carry your sketchbook with you and work on these little studies to improve your overall drawing.

Pssssst!

Cut a square out of the center of a piece of white paper and place it over your reference photo. Move the paper around the photo to force your eyes to focus on the shapes in the particular area shown.

Where Do I Start?
One look at this cat and many beginning artists would be too overwhelmed to even consider drawing it.

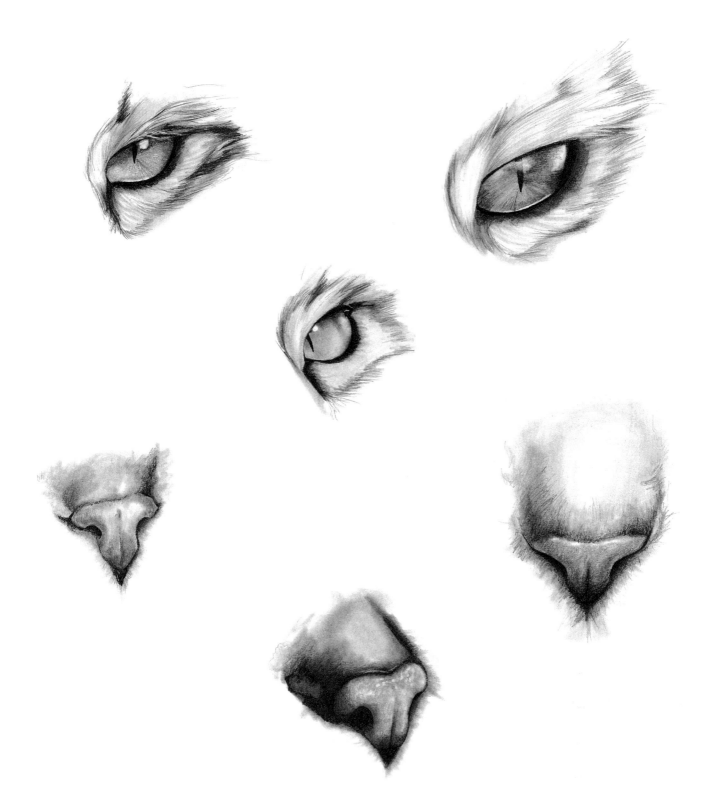

There, Now That's Not So Bad ...
The cat seems manageable when you try drawing just an eye or the nose before attempting to render the entire head with all its features and fur patterns. Along with the view shown in the full drawing are views of the cat's left eye and nose from slightly different angles. Isolating the cat's features like this helps you recognize the subtle differences these different points of view create.

Recognize How Shapes Relate

The dictionary defines "relate" as bringing into logical or natural association for a reference. We have been using a form of relating every time we draw a line next to the subject. We relate the subject to that line.

I came to realize that I was using another technique similar to drawing a line for reference—I was also using a circle for reference. A circle has certain properties that I can count on, much like a line. I can use these properties to help me see to draw.

You can use any circular shape in your subject to help you see the correct placement of other shapes. Using a circle as a point of reference can help you draw better.

Pssssst!

Any completely round shape may be used as a reference point to figure out the proper placement of other items in a drawing. For example, a tire, a wheel or an orange may be used to establish the location of the rest of the car, wagon or bowl of fruit.

Looking Round
It's pretty easy to determine the midpoint of a circle. If I were to fill in this circle to the halfway point, I would simply fill in to the fattest part.

Lines and Circles
Stay with me on this one—we're going somewhere. If I see a line that crosses the circle, I can determine where to place that line in a drawing by using the properties of the circle. A line through the center is easiest to duplicate because the line crosses at the fattest part. Lines in the top third area, bottom fifth area and so on cross the parts where the circle is getting smaller or larger, respectively.

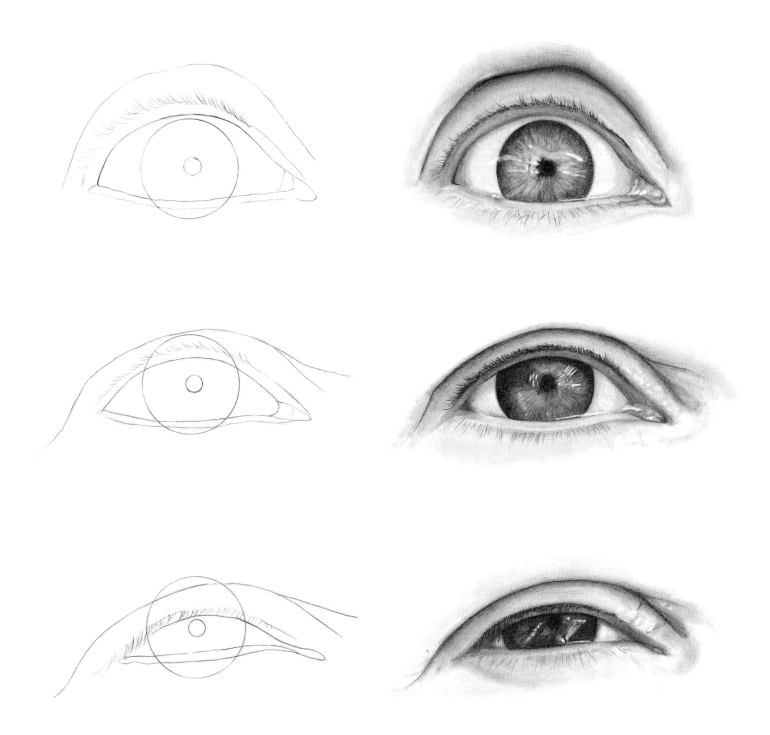

The Eyes Have It

Let's apply what we've learned to a familiar object. I find using a circle for reference most useful when drawing eyes. When I look at an eye, I look at the perfectly round iris (the colored part) to determine where the eyelid should go. The location of the lid gives the eyes their expression, and if it's located at the wrong spot, the look is off.

Be Aware of Negative Space

No, this is not a New Age reference to a place with bad vibes. Negative space is the area around and between the positive shapes that you tend to devote most of your attention to when you draw. If I'm drawing my hand, for example, the hand is the positive shape and the spaces between my fingers and around my hand are the negative spaces.

Negative space and positive space work together to form the whole of the image. I'll admit that sounds like the most obvious thing in the world. I stated it because what it means is that if I observe and draw the negative space, the positive shapes will be correct as a result. They don't have a choice. Aha! That means by concentrating on the negative space when I draw something complicated, the positive will be correctly drawn and properly proportioned.

 Psssssst!

One tool that helps artists more easily identify negative space is the viewfinder. A viewfinder is a square piece of cardboard with an open middle, or you can make an adjustable one with two L-shaped pieces. Viewfinders help you define edges and see relationships.

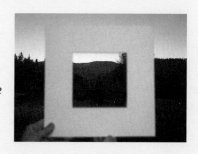

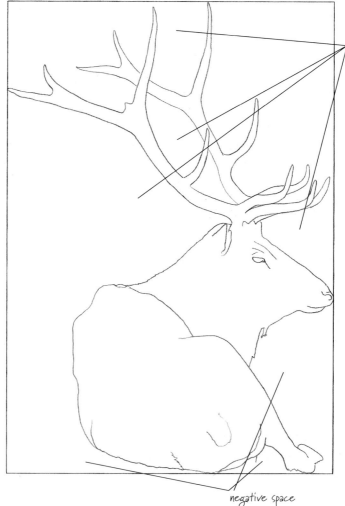

Negative space exists around and between the parts of your subject.

negative space

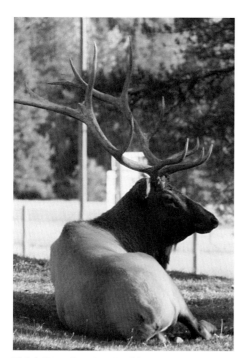

Think Negative, Not Positive
The negative space around this elk does much to define its form.

Invert Your Drawing

When I teach my drawing classes, I position the students in a "U" shape and I stand in the middle of the "U". This means when I assist a student in her drawing, I'm looking at it upside down. Students are initially convinced that I'm a supremely gifted artist because I can immediately spot the problem in their sketch, despite the view. What they don't realize is that it's often much easier to see something more accurately when it's inverted, or upside down.

You're thinking, sure, right, whatever you say. It's true, though: When something is upside down, it looks weird (profound thought). If it looks weird, your brain can't make assumptions, place preconceived patterns and otherwise shut out the reality of what you are viewing. In a sense, you are slowing down your brain and forcing yourself to focus on what is really in front of your eyes, not what you merely *think* is in front of your eyes.

If the inversion tool is so eye-opening, why not just use it from the beginning and make your line drawing upside down? The answer is because it is hard—very hard and frustrating. You can get pretty lost when trying to draw from an upside-down photo. Inverting something to draw it works better if you are attempting to copy a line drawing like the one on this page as opposed to a photo. However, the best time to use this tool is after you've made your drawing. Once something is drawn using a reference photo, inverting both the drawing and photo helps us see the corrections we might need to make.

Reference Photo

A Whole New View
Turning a line drawing upside down like this will help you see your subject as a bunch of shapes rather than the familiar image. Try recreating this line drawing upside down to see what I mean.

Compare by Tracing

We have a cat named Big Fat Kitty. She doesn't seem to mind the name, which she earned because she is, well, a big fat kitty. This is not a subjective judgment. Objectively, Big Fat Kitty, when compared to the other cats residing with us, is at least ten pounds heavier.

It's not unusual for us to compare one thing to another. We use many comparison systems in art as well. Let me share another comparison technique that will help you draw better.

Often your brain has trouble pulling one particular feature out of a complicated background. Have you ever despaired over not being able to draw the lips correctly on a portrait, or get the angle of a building's roof just right? If for a moment you can look at the lips apart from the rest of the face, or study the roof apart from the remaining structural elements, your task will be easier.

You've probably always been told that it was cheating to trace something.

Tracing the shape, however, allows you to see that shape in its simplest expression, separate from its busy surroundings. To try this technique, you'll need a piece of tracing paper, the original photo you're trying to draw and your somewhat-completed drawing.

❶ Trace Over the Photo

Place a piece of tracing paper directly over the photo and trace the troublesome shape.

❷ Trace Over the Drawing

Cover the shape you've just traced with your hand. No peeking! Place the same piece of tracing paper over the pesky problem area in your drawing. Trace it so that the two tracings will end up side by side.

❸ Compare the Tracings

Look at the two tracings. Subtle differences in shapes become very apparent when simplified into a line drawing and removed from the busy background.

Pssssssst!

Tracing paper is a fantastic multi-tasker. Not only can it help you work out problematic shapes, but if you place it beneath your hand as you draw, it will keep you from inadvertently smudging those shapes in your finished drawing.

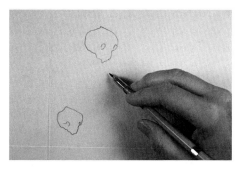

Flatten the Three Dimensional

On pages 50–51 you learned how to visually flatten an image to make it easier to draw. This technique is helpful whether you're sketching the overall scene or focusing on one particular part or shape.

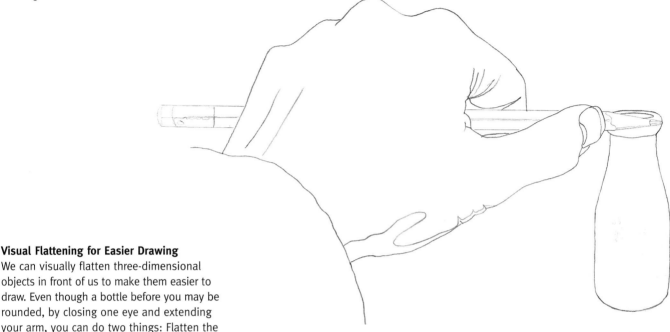

Visual Flattening for Easier Drawing
We can visually flatten three-dimensional objects in front of us to make them easier to draw. Even though a bottle before you may be rounded, by closing one eye and extending your arm, you can do two things: Flatten the curve of the top and bottom, and measure it.

Cheat Sheet

- *Seek the simplest expression of a shape in the form of straight or curved lines.*

- *Label or name the subject you are drawing in terms of its shape, not what you know it to be.*

- *Break up your subject into parts and practice drawing those parts before you tackle the entire thing.*

- *Ask yourself questions about what it is that you are actually seeing so that you truly understand what you're drawing.*

- *Measure a smaller shape in your drawing and compare it to other larger shapes to help keep your shapes in proportion.*

- *You can use any circular shape in your subject,* similar to how you would use a line, to help you correctly place the other shapes.

- *To better see the positive shapes of your subject, pay attention to the negative space around and between them.*

- *Turn a line drawing upside down to help you see shapes and spot problems more easily.*

- *When you can't get a particular shape right, compare a tracing of that shape from the reference photo to a tracing of your drawn attempt.*

- *Close one eye to flatten a three-dimensional object into two dimensions for measuring purposes and to check for angles and curves.*

Define With Values, Not Lines

Earlier in this chapter you learned how the mind places everything into patterns of perception, memorizes those patterns, then uses what's recorded in the mind rather than the reality of what's in front of us. Perceptions are more powerful than facts. And truth be told, most of the lines you draw are a perception, not a fact.

Say you are looking at a room painted white. How do you know there are walls and a ceiling? After all, they're all white. You might respond by pointing out that they have angles you can see.

Look again. Why do you know there are angles? Are there lines drawn on the walls and ceiling to tell you there are angles? What do you actually see?

To answer this question, first we need to understand what a line is. The most common definition of a line is "the shortest distance between two points." But that's not an artist's definition. A line, when used in a drawing, is a mark made on the paper to represent an edge of something—where one thing ends and something else begins. If I'm drawing my hand on a piece of paper, the lines I originally make represent the edges of my hand and are used to separate my hand from the rest of the paper. The reality of my hand is that it is not outlined: There isn't a black mark that goes around the outside of my hand.

What our eyes see in reality are not distinct, sharp lines, but changes in value. The term *value* means the relative lightness or darkness of an area. It's the different shades of gray that range from the white of your paper to the darkest dark your pencil can make.

Reference Photo

Line Drawing
We initially draw the edges of the subject, placing them in the correct site and with the correct shapes.

So, it is the changes in value, however subtle, that allow you to see where the walls end and the ceiling begins in the white room. One of your goals in shading is to make sure that you end up with value changes rather than lines defining your subject. There are very few real lines in this world, but there are countless value changes. Realistic drawings show value changes, not outlines.

Pssssst!

The closer in value two things are to each other, the less you can separate them with a line. In classic art training, you would practice your shading on a bunch of stuff painted white. This exercise forces you to practice subtle shading to define edges. It also simplifies things because you're not dealing with color.

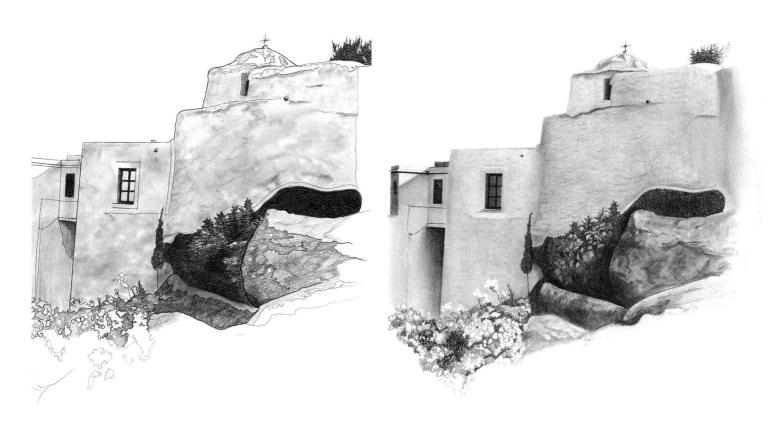

Bad Shading

Now it comes time to shade. Those same lines, useful at first to indicate the edges of things, are not truly lines at all. But the emerging artist leaves them in place, and the drawing looks amateurish as a result.

Good Shading

Although both drawings are correctly drawn, this one is clearly drawn better. What's the difference? The lines left in the first drawing, where there are no lines in reality, change the work from professional to struggling artist. A much more realistic drawing is created when you use value changes rather than lines to define your subject. Don't leave lines!

How to Get Rid of Lines

OK, so now you know that most of the lines in your drawing have to go in order for it to look realistic. How do you go about doing this? There are several ways to get rid of lines that were originally used to mark the edges in your drawing.

Absorb Lines
The background may be darkened so the line will be absorbed.

Erase Lines
The line may be erased so only the value change remains.

gradual value changes

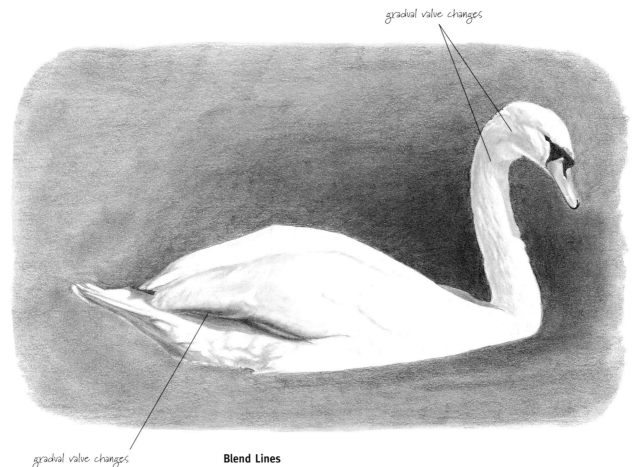

gradual value changes

Blend Lines
The line may be blended into the image where there's a gradual value change.

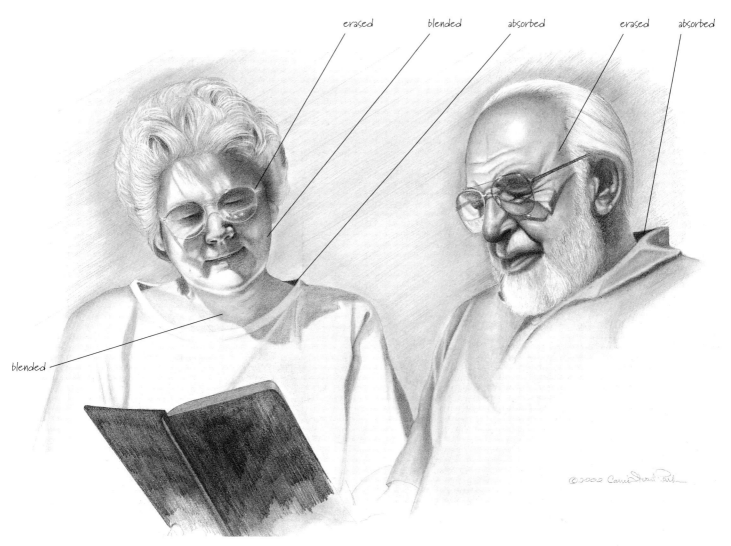

erased blended absorbed erased absorbed

blended

©2002 Carrie Stuart Parks

Combining Line Removal Techniques
Most drawings will require you to use a variety of techniques to
eliminate lines: absorbing some, erasing others and blending some
into the shadows.

PASTOR AND EDNA DAY
Graphite on bristol board
14" x 17" (36cm x 43cm)

Pssssst!

*In your drawings, examine areas that
were originally drawn as lines. When
deciding which lines will stay and which will go,
look at each line and ask yourself if it really appears
as a line in the reference photo or live reference, or
if it is a value change.*

Isolate and Squint to See Values

The answer to the age-old question "How do you eat an elephant?" is this: One bite at a time. How do you shade a complicated subject? One little part at a time. Isolate the individual parts of your drawing and see them as shapes with different values.

In spite of the parental admonition that squinting may cause your face to remain in that pose, squinting in art is a rather useful tool. When you squint, edges blur and you are left with lights and darks. Artists know this and often squint at the subjects they are drawing to more clearly see value changes.

Although I'm encouraging you to isolate specific areas and concentrate on the value changes, you'll need to be sure you look at the entire drawing and adjust accordingly. Make it a habit to shade a single area, walk away, then return and check that the value is correct to the overall image.

Break Down the Complex
It turns out that there wasn't just one lesson in that jar back on page 42. That image has a very complicated series of shadows and lights, so the drawing was broken up into smaller sections. The different parts, such as the section shown here, were isolated and viewed as shapes: square light shapes, rectangular midtones and rounded darks. The shades (values) are nothing more than shapes. Don't try to analyze why something is round or square, dark or light. Just duplicate what you see.

Psssssst!

Although not technically the same as the classic "squint," another tool for seeing value changes is a piece of red acetate. Colors have a way of interfering with our ability to distinguish values. Hold the acetate in front of your face or place it over the reference photo and it renders your subject into only values, removing the distraction of color.

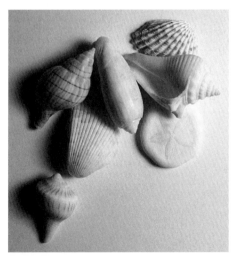

Squint to See Values Easier
Squinting at these shells encourages our eyes to focus on seeing values, not details.

Compare Values and Avoid the Guessing Game

It is always easier to make relative judgements rather than absolute judgments when it comes to art. Something is "too big" or "too small," "too light" or "too dark," in reference to something else.

A value scale is an invaluable aid for comparing values as you shade. You can buy a value scale or easily make one yourself with a piece of bristol board and a pencil. A value scale contains ten blocks of values ranging from black to white, with tones of gray in between. A hole is usually punched in each block. Place the scale over the different areas of the reference photo you are using to determine the correct amount of shading needed to duplicate what you are drawing.

Don't Guess at What You Can't See

One very important question to ask yourself when drawing is: Why do I see that? Force yourself to answer. You actually see something because there is a value change. Something is either lighter or darker than something else. When you ask this question, you are forcing yourself to analyze rather than guess at the values.

This question becomes especially important when you can't see everything in the reference photo, such as when details are lost in the dark areas. Many artists think they need to fill in the missing details. Guesswork like this can lead to drawing disaster.

If you don't see it, don't guess. Don't try to figure out what's happening in that mysterious dark area, because you'll be running it through your perceptions of reality instead of seeing it for what it is.

Value Scale
This is a handy tool for working out the value problems in a drawing.

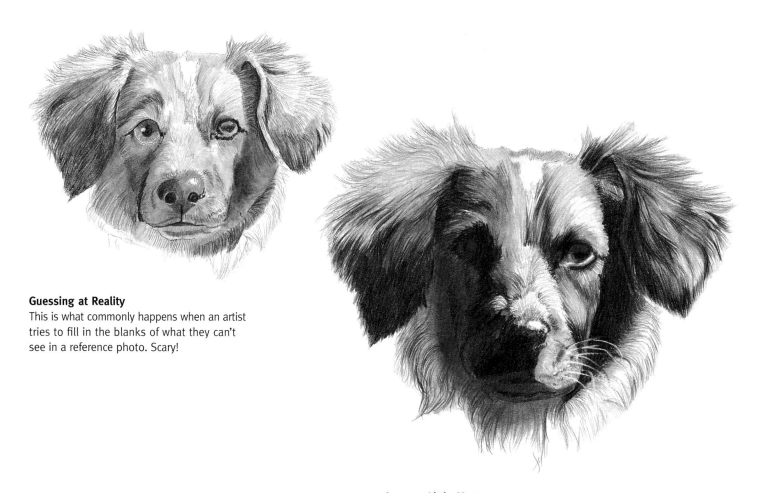

Guessing at Reality
This is what commonly happens when an artist tries to fill in the blanks of what they can't see in a reference photo. Scary!

Leave a Little Mystery
So what if we can't see every single detail of the dog's face? The drawing is better for it.

Seek to Understand the Effects of Light

Regardless of your choice of shading technique, you need to learn how to spot the different characteristics of light and shadow on your subject and recognize the potential challenges of recreating them on your paper. The effects of the light source are different depending on whether your subject is round or angular.

Working in the Round

I received a call a number of years ago from a friend in Long Island about an upcoming portrait drawing class. In a thick New York accent, he informed me that he was going to start the class by having everyone "drarl a bull."

This was a new one for me, so I asked why he would want to teach a class to "drarl a bull." He replied, "Because the face is based on a bull." Now, I was raised on a ranch, and I know a bit about bulls and cows in general. I had never observed the similarity between a human face and a bull. I thought that maybe the breed of bull made a difference—I mean, an Angus looks different from a Scottish Highlander bull—so I politely asked about the breed. There was an astonished silence; then in a quiet voice, he said, "A bull, a round bull. What was I supposed to call it, a sphere?"

So, let's talk about bulls—I mean balls. Round stuff. Most drawing classes require you to shade a ball and often other round things like cylinders and cones. Why this obsession with round? Because there's a pattern of darks and lights that occurs on something round and because it is affected by a light source. If you can shade using this pattern, you will create the appearance of something round and capture the three-dimensional feel of the subject.

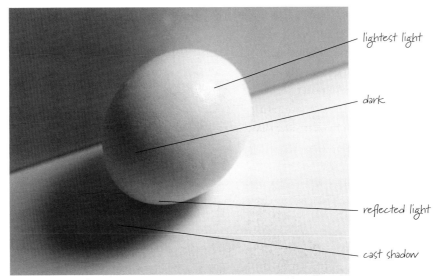

lightest light

dark

reflected light

cast shadow

Round objects have a predictable pattern of lightest light, dark, reflected light and cast shadow that helps to define their shape.

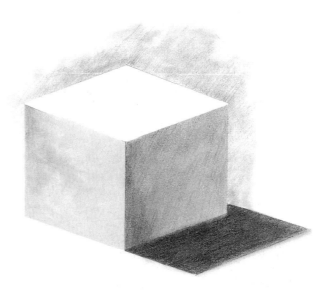

Angular subjects like this cube will show more abrupt value changes than what you see on rounded objects.

Psssssst!

Objects lit by natural light will have a predictable shadow because light rays travel in parallel lines, whereas artificial light may come from more than one source and cause more than one shadow.

The pattern of lightest light, dark, reflected light and cast shadow may be placed on any subject and it will create the appearance of roundness. Now, I realize I just said, "If you don't see it, don't draw it." This is the exception that proves the rule … or something like that.

Angular Subjects

Unlike round objects that shade gradually from the highlighted area through midtone grays into the dark shadows, angular subjects have abrupt edges and relatively little value changes within the flat surface. There may be reflected light on an angular surface—for example, a flowerpot sitting on a porch may cast a glow onto the wall behind it—so we want to be on the lookout for interesting plays of lights and darks. The technique of squinting will serve you well when observing more angular surfaces.

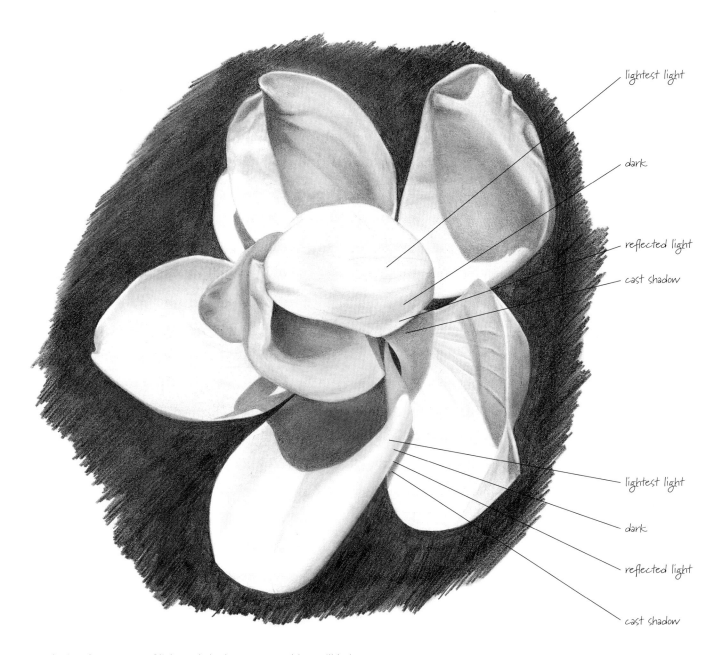

lightest light

dark

reflected light

cast shadow

lightest light

dark

reflected light

cast shadow

Developing the patterns of light and shadow on any subject will help realistically define its form.

Drawing Practice

COOPER LAKE, WASHINGTON
10" x 8" (25cm x 20cm)

If you want to produce realistic drawings such as the ones you see in this book, you will need to practice. And practice. And practice some more. The demonstrations in this chapter will help you do that. Please, however, don't think that loosely sketched drawings, drawings with exaggerated features or studies in lights and darks are in any way wrong, unacceptable or anything less than wonderful in their own right. You'll need to do many drawings in many styles and under various circumstances to improve as an artist. You're on a journey with lots of side trips.

Drawing a Detailed Sword Handle

This is an 1864 light cavalry saber with several unique drawing challenges. The man-made shapes need to be rendered with some type of mechanical assistance if the finished drawing is to be realistic. That's not to say it can't be drawn freehand and kept more sketchy, but if you choose to make it as real as possible, French curves and rulers are recommended. The different metallic surfaces, some shiny and some matte finished, are also a challenge and require different pencil strokes.

Reference Photo

① Make a Line Drawing

The sword was drawn freehand and the guidelines erased. Copy this drawing. Remember to not push too hard if you're using a harder lead, as those lines will score or gouge your paper. Some of the areas that will later be shaded are outlined or marked.

② Mechanically Clean Up the Drawing

We learned earlier in the book about the use of mechanical aids. This is a drawing of a mechanical, man-made object, so the use of French curves renders a more precise drawing. Go back over the initial handle and make it more mechanically perfect. Use an HB pencil to darken the links.

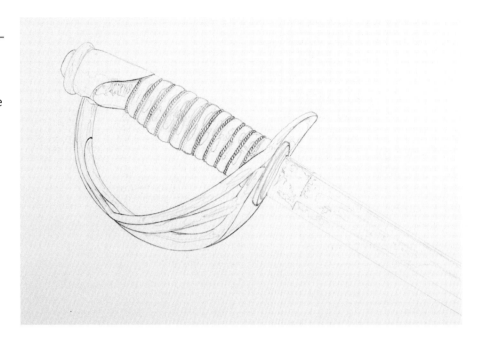

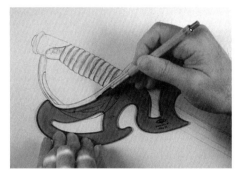

Detail
The French curve allows for greater control and smoother lines when you're drawing the curved handle.

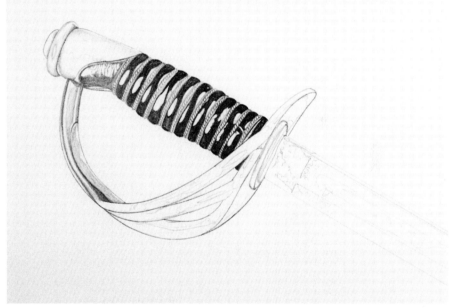

③ Establish the Range of Values

In this first shading, establish the darkest areas, some midtones and the lights. This provides the full range of tones that will be present in the finished drawing. The darkness in the handle should be shaded away from the highlights and to the outlined edge. Darken the details of the chain-like shapes.

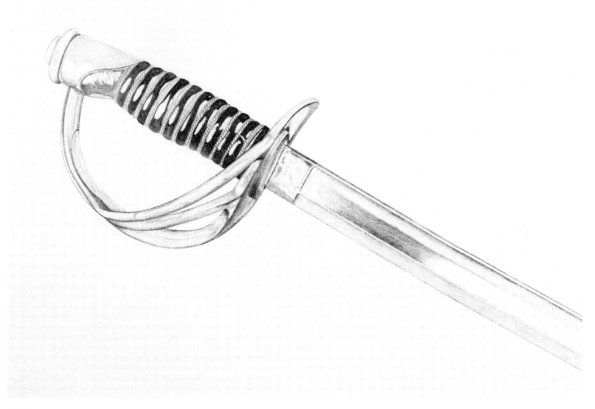

④ Adjust Values and Eliminate Outlines

Using the pencil only—no smudging at this point—adjust the tones of gray (the values) over the entire sword. The goal at this point is to eliminate the lines originally used to sketch the outline of the sword by absorbing them into the various values.

Detail
Notice that the pencil strokes are smooth, even in tone and very close together.

⑤ Blend

Using a paper stump, blend the strokes together and smudge the highlights.

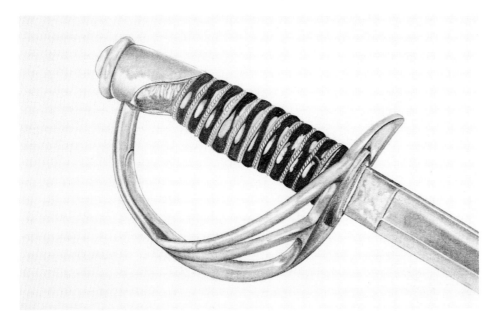

Detail
Now the handle begins to look truly realistic.

⑥ Erase Highlights

Using an electric eraser, restore the highlights to white. Use a kneaded rubber eraser to add texture by pushing it straight down, then lifting straight up.

SWORD
Graphite on bristol board
14" x 17" (36cm x 43cm)

Building the Values of a Water Lily

Our dear friends Dave and Andrea Kramer have their own personal lake complete with a picturesque corner of water lilies. I've painted them many times in watercolor, but never drawn them in pencil. There were several challenges in this subject, including the numerous values of gray and rendering the petals so they appear to be underwater. I started the drawing without first creating a black and white version. That was a bad idea. I originally shaded based on color changes, not value changes.

Reference Photo

① Make a Line Drawing

Make a line drawing based on the photo. If you use guidelines or a complete grid, erase them completely before moving on to the shading.

② Place a Midtone

Find a middle value in the photo and shade that area of your drawing. Check it by using a value scale.

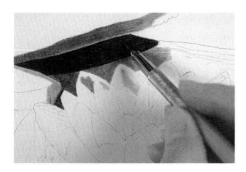

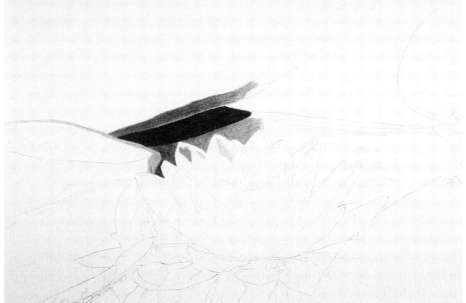

③ Establish a Range

Now find a good dark area and a good light area and establish the range of values that will appear in your drawing. The variations in values may be rather subtle in some places as you develop the rest of the drawing, so check to see that everything isn't ending up looking the same. Keep returning to areas and adding the darks so your eye always has a range of darks in front of it.

④ Think Shapes, Not Stuff

Earlier in the book we talked about how the mind can form a filter and prevent us from drawing well. At this stage in the drawing when you're developing the shading, it's important not to fall into thinking, "Ah, that's a petal! And that's a leaf!" Instead, think, "That's a square of mid-gray under that white thing, with a black line on the one edge." I even put my finger on the spot so I don't lose my place. If it is drawn correctly, the shading will resolve itself.

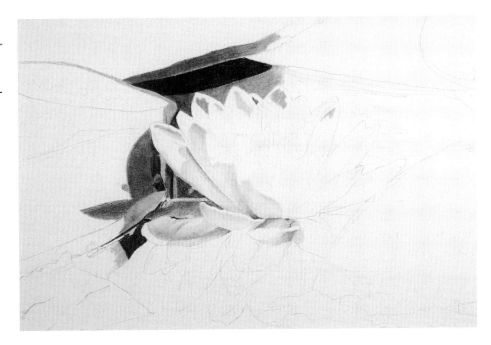

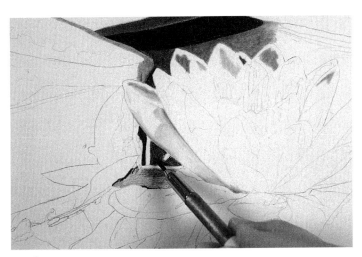

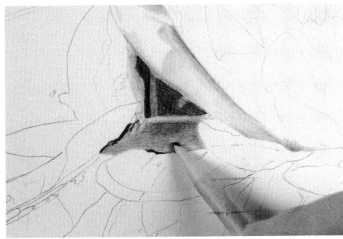

Details

I originally left a white area between two shaded areas. When I blended the two midtone values on either side, I just ran the blending tool over the white and it formed the proper value with just the graphite on the blending tool.

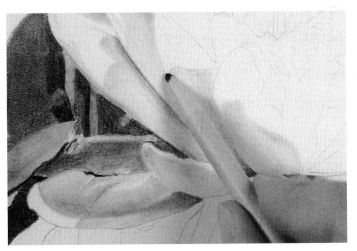

Detail

Every time you add graphite, you make something darker and a bit rougher. If you blend after adding the pencil, you smooth and lighten. You may go back and forth between shading with your pencil and blending with your paper stump many times.

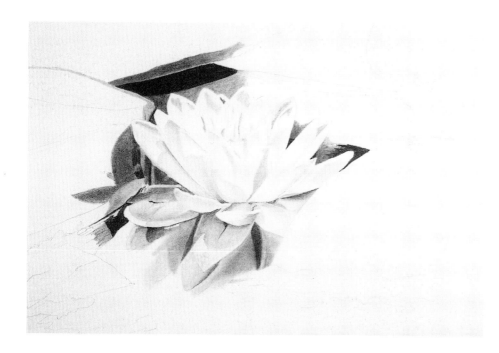

⑤ Work Over the Whole

As you continue to shade and adjust and the flower starts to emerge, look more at the overall picture and less at the little puzzle pieces.

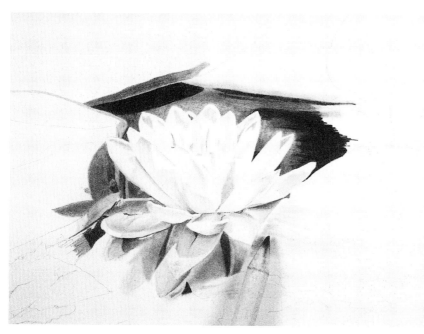

⑥ Place Big Darks Carefully

I usually don't put in a really big dark until I'm well into the drawing, because I might smudge it on the rest of the work. Proceed with caution!

❼ Keep Going

Keep building values all over the drawing.
Do the leaf shading by using the random
built-up graphite on the paper stump and
drawing it across the leaf in the direction
the shading is indicated.

Take some breaks and check your work
after the break. It may look fine when you
leave, but you may notice it needs adjust-
ment when you return.

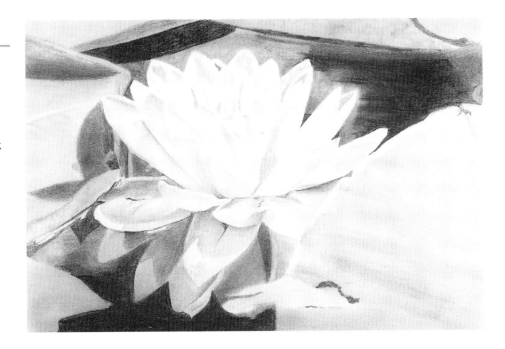

❽ Darken, Adjust and Clarify

See? The drawing needed to be darkened
some more and the shading smoothed
again. The leaf on the left of the flower is
further defined with values. Use a sharp-
ened electric eraser to clean up the slivers
of white highlight on the flower.

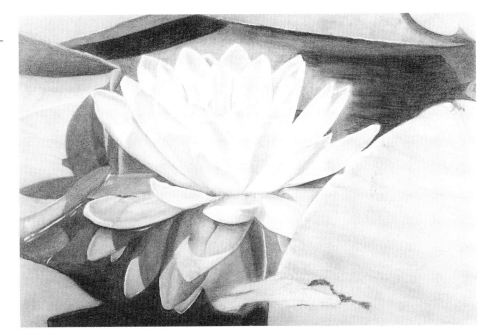

Detail

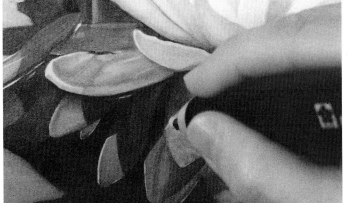

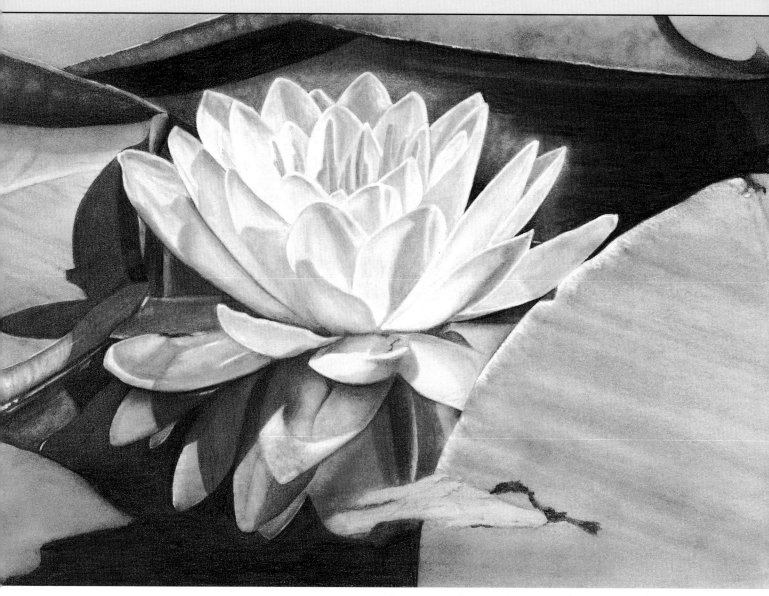

DAVE AND ANDREA'S POND (WATER LILY)
Graphite on bristol board 14" x 17" (36cm x 43cm)

Pssssssst!

This isn't a book on design, but design is part of art. Design and composition are often used interchangeably. It refers to the way the objects on the work of art are handled: Line, color, space, texture, value and a host of other factors join together to add to the design of a work of art. In a book as basic as this, our goal is to make the drawing look interesting and deliberate, not like an accident.

Here are a few suggestions to help you:

- *Try to keep your drawing from having a single object in the center (the bull's-eye look).*

- *Think about connecting your drawing to the edges of the paper, but don't look like you ran out of paper.*
- *Divide the objects or elements of your subject into groupings that provide variety.*
- *Pay attention to what you see first when you look at the drawing. Do your eyes bounce back and forth between two equal (and therefore competing) objects, or do they flow from one object to the next?*
- *When in doubt, cut the paper to better frame the drawing.*

Capturing the Values in a Skull

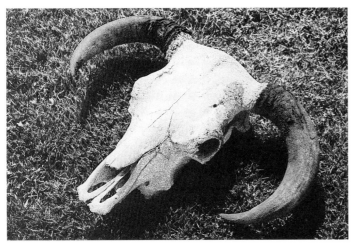

Reference Photo

We've talked about becoming a shutterbug and taking pictures of everything around you for possible artwork. This skull was part of the decorations in the rustic lodge at Busterback Ranch in the Stanley Basin in Idaho. This photograph was taken more than fifteen years ago. Subtle as well as dramatic shading will be required to render it in pencil.

① Make a Line Drawing and Begin Light Shading

Make a line drawing from the photo and compare it to the line drawing shown. Don't forget to erase any guidelines you use. This particular subject has many complex areas of lights, midtones and darks. Rather than sketch the edges or outlines of where the different values come together, we look at these areas as shapes and lightly shade them in. Otherwise we'd have to mark them or somehow note to ourselves, "Ah, this little area shaped like Florida is a midtone."

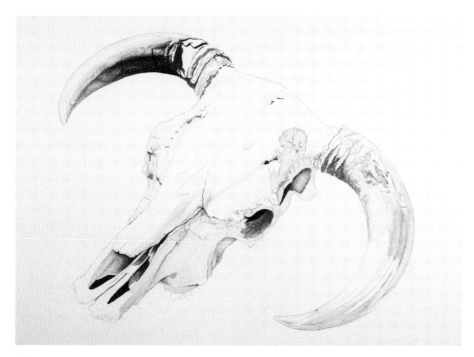

② Establish Some Darks

Find a dark area and really darken it with your pencil so the full range of darkest darks to lightest lights is now in front of you. With a 2B to 6B pencil, go over the entire sketch and reassess the values, adjusting them so the range of lights to darks more closely matches the photo.

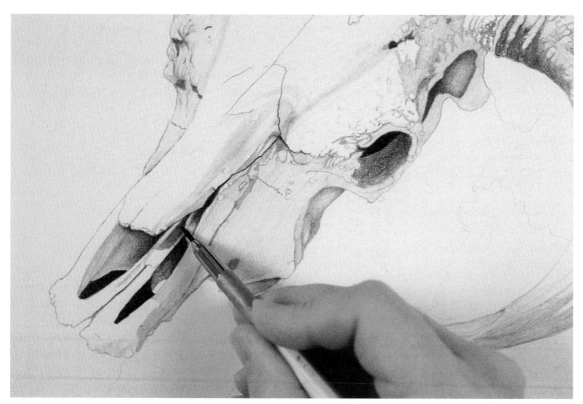

Detail

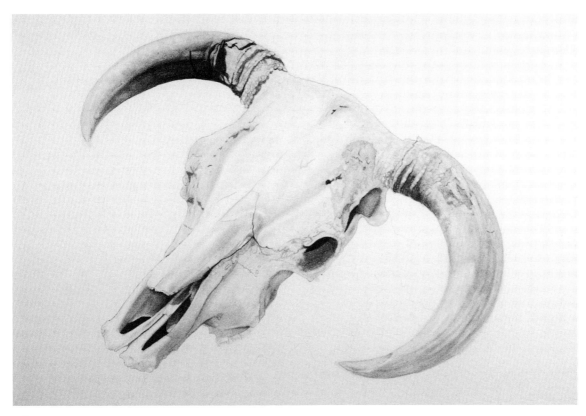

❸ Blend

Using the side of your paper stump, blend the pencil strokes together for a smooth appearance. This will lighten the dark areas of the drawing somewhat as you are lifting the graphite, but don't worry about it; we'll go back and re-adjust later. Work your stump evenly over the areas that will be considered white in the finished drawing, adding a light tone to these areas.

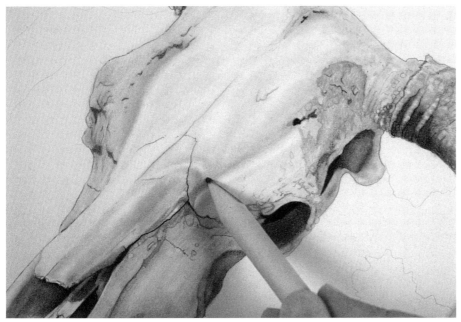

Detail

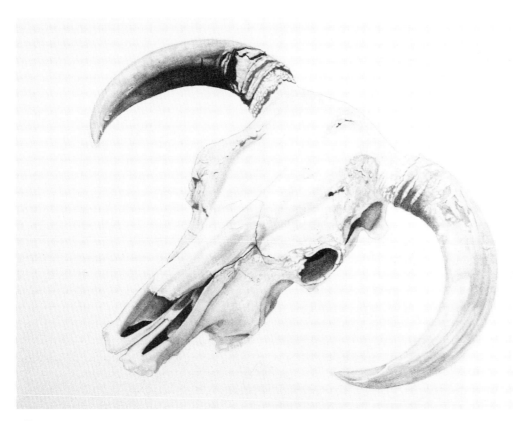

4 Erase Out Your Whites

Go back to the areas that were originally white and blended to a light value in step three. With a sharpened electric eraser, or a white plastic eraser with a sharp edge, erase out the white areas.

Detail
An electric eraser is incredibly useful for erasing out the most intricate whites, which will result in true-to-life texture.

Detail
The whites were established around the eye sockets, among other areas.

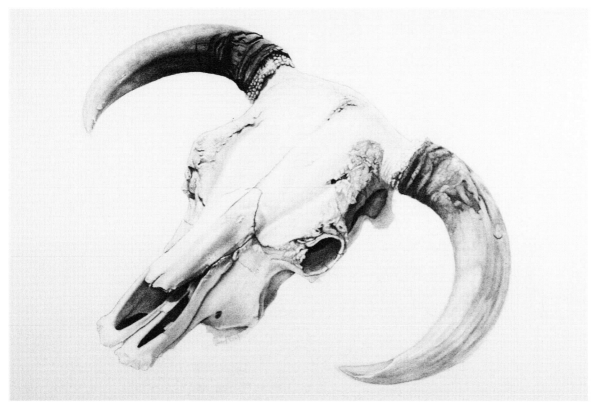

⑤ Re-Darken

Using a 6B pencil, go back to the areas that were originally your darkest darks and re-darken them, emphasizing the lighter areas. This is where you can fuss your little heart out over the itty-bitty details.

Detail

Detail

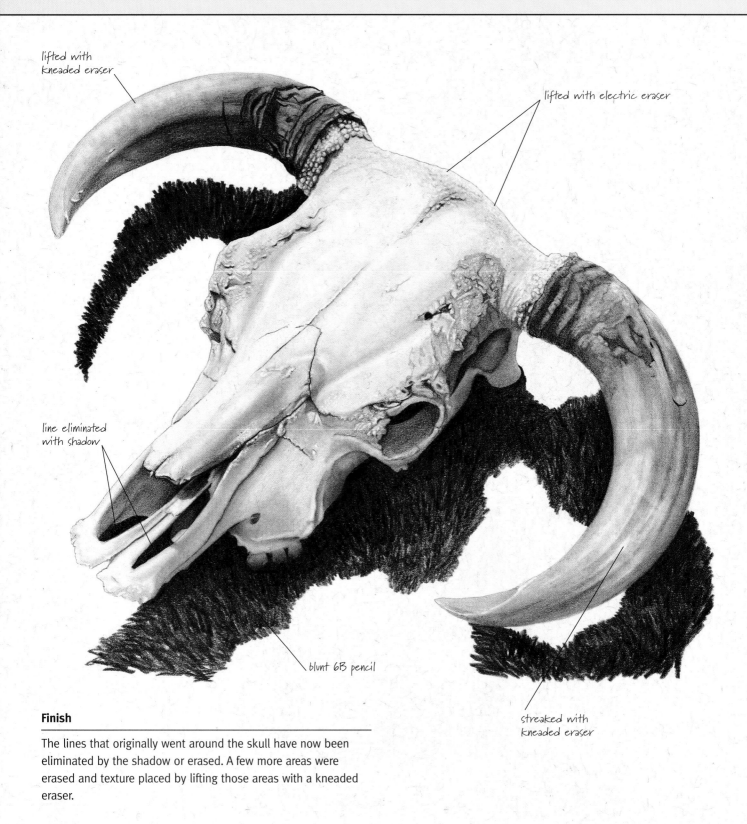

lifted with
kneaded eraser

lifted with electric eraser

line eliminated
with shadow

blunt 6B pencil

streaked with
kneaded eraser

Finish

The lines that originally went around the skull have now been
eliminated by the shadow or erased. A few more areas were
erased and texture placed by lifting those areas with a kneaded
eraser.

SKULL—STANLEY BASIN, IDAHO
Graphite on bristol board
14" x 17" (36cm x 43cm)

Punch Up the Contrast

I have come across many competent art students who are able to render beautifully drawn art, but their drawings aren't particularly interesting. It's because they lack contrast. Usually the drawings are very light in appearance with no true darks. An interesting drawing ranges through the full value scale, from white to black, with tones in between.

Let's take the following washed-out drawing from so-so to spectacular by heightening the contrast and adjusting its values.

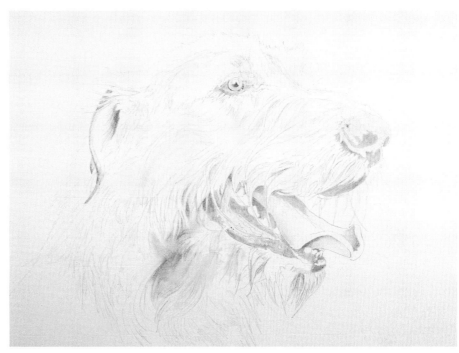

A Drawing With No Draw
This is a nice but boring drawing. The values were created with a very timid hand. The shapes are dead-on and everything's well proportioned, but will the viewer even notice?

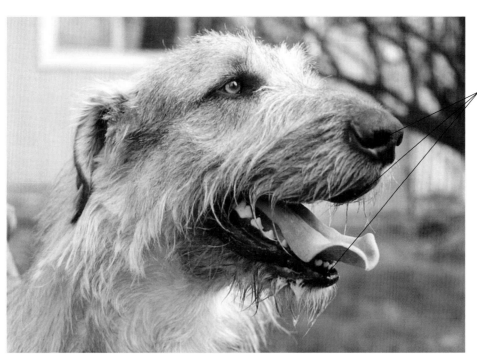

darkest darks

1 Revisit Your Reference

The drawing needs more contrast, but where do we begin? Go back to the photo and find a place on the subject that's dark—really dark. The dog's nostrils and lips look like the best bet.

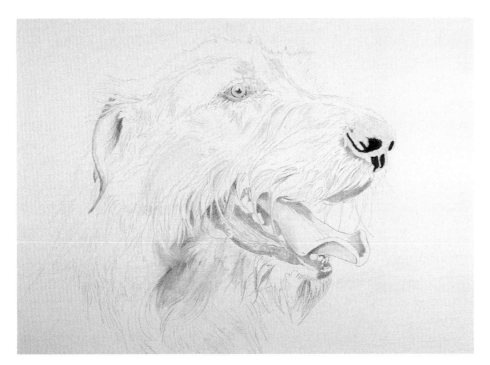

2 Get Dark

Now take a 6B pencil and begin darkening those spots on your drawing. Push hard. Harder. There, now you can take a deep breath. That was the hardest part.

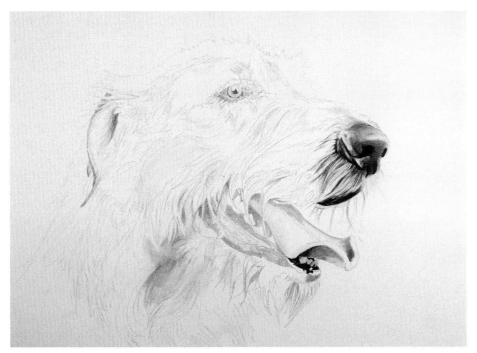

3 Adjust the Other Values

In order to fix this drawing, you now have to adjust the remaining values so the darkest value you just created no longer awkwardly jumps out of your drawing. Start small with the hair at the tip of the nose and the tongue.

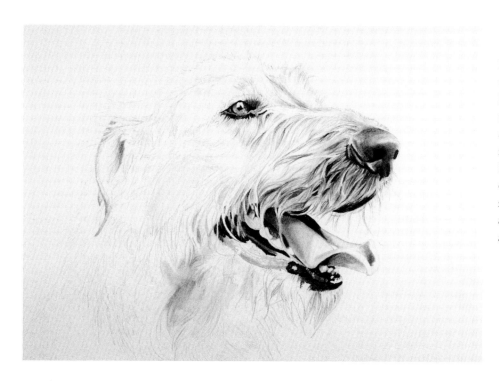

④ **Keep Going**

Progress to the dog's eye and the corner of his mouth, adjusting values as you go. Notice the variety of techniques used: close pencil strokes for darker areas on the fur and spaced-out strokes for the lighter areas; smudging for midtones; and erasing (or lifting graphite) for highlights on the nose, eye and tongue. Using an eraser to lift very small groupings of hair strands not only adds depth to the values of the drawing but also creates the realistic texture of fur.

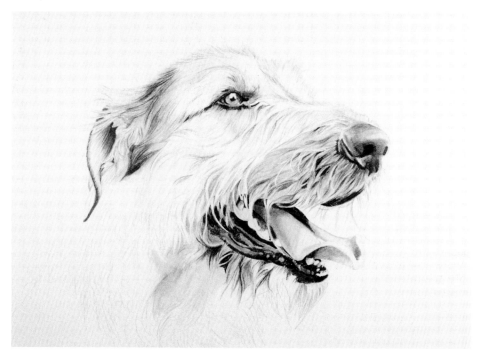

⑤ **And Going ...**

Work your way back to the dog's ear. Just remember not to darken everything—the dark values will only be effective if they appear next to lighter ones.

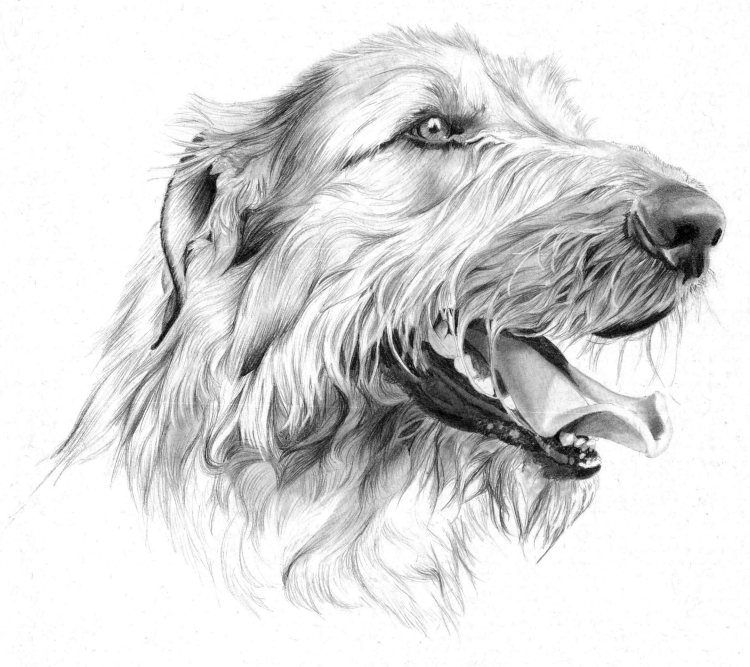

⑥ ... There! Much Better

The reworked drawing has much more depth, realism and interest than the original. Well-executed values and enough contrast can make all the difference between a ho-hum drawing and an eye-catching work of art.

IRISH WOLFHOUND
Graphite on bristol board
14" x 17" (36cm x 43cm)

Rendering Hair on a Mountain Goat

This fellow was lying in the dappled shade along the path at the top of Logan Pass at Glacier National Park in Montana. We will use a number of different pencilling, blending and erasing techniques to not only accurately draw the goat, but also to render the light effects on its body.

Reference Photo

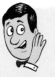

Psssssst!

Before you can begin to shade your drawing, erase all the guidelines, marks, aids and notes that you used to get the image right. I know, it sounds like a reminder of the obvi-ous, but it's easy to forget and almost impossible to remove them once the shading process has begun.

 Make a Line Drawing

Make a line drawing from the photo, or copy this one. This drawing was rendered extremely light and may be hard to see. You'll want to keep your drawing as light as possible at first. Erase any guidelines that you use.

❷ Add Some Midtones

There's no rule that says a particular area of your subject needs to be drawn first. Just select a midtone and jump right in. There is a secret, though, to drawing fur: "Comb" the fur with your pencil. That is, your pencil strokes should go in the same direction as the fur or hair.

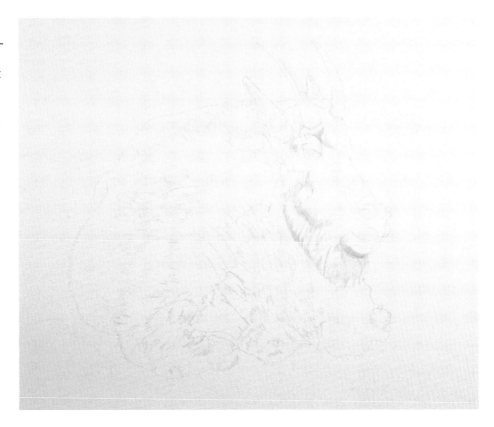

❸ Add Darks

Pencil in those darks so the range of values is in front of you. A 6B pencil is a good choice for this. Don't be shy—remember when we looked at drawings that weren't interesting because the value range wasn't present?

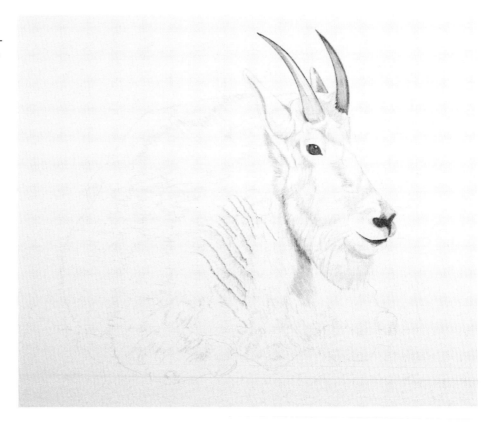

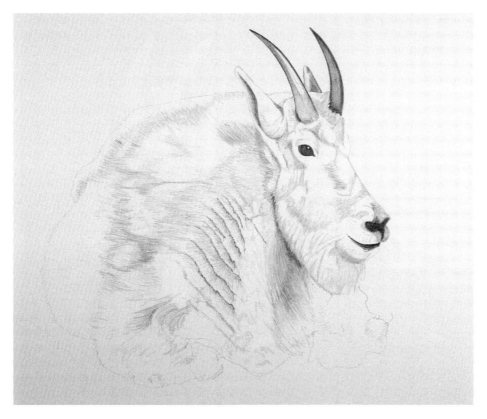

4 Adjust Values and Continue to Darken

Now that the darks are in place, we can adjust and reshade to correct the values.

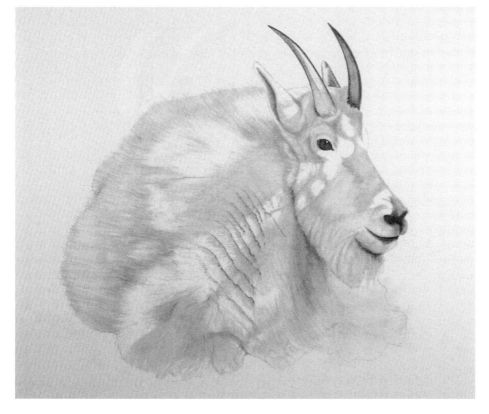

5 Blend

With a paper stump, blend your strokes together to create the shadows. This will lighten the drawing and you'll lose some of the fur-like look. Don't worry, though; we'll come back and fix it.

6 Comb the Fur Again

Take an HB or 2B (very sharp) pencil and recomb the fur to provide the correct texture and reestablish the direction of the hair. Darken the areas that got lighter when you smudged.

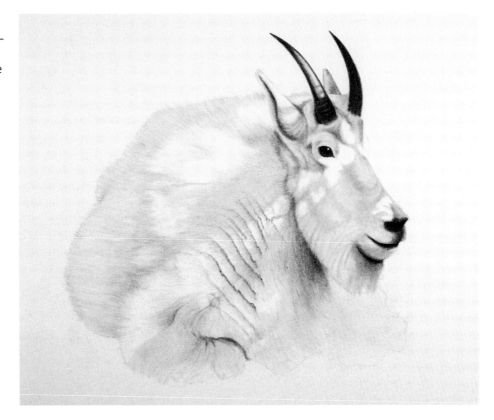

7 Erase

Erase the dappled sunlight back out. If you are using an electric eraser, place it on a somewhat rough surface, turn it on and create a point in your eraser. Use it like a pencil and comb white hairs in the fur. You'll lose the point as you go on, so you'll need to repoint the tip as you erase. If you're using a white plastic eraser, simply take a craft knife and whittle a sharp edge to do this.

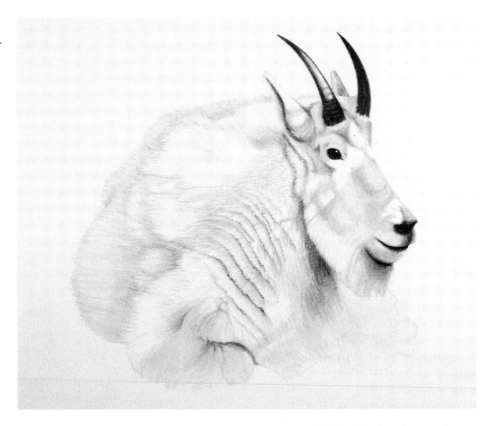

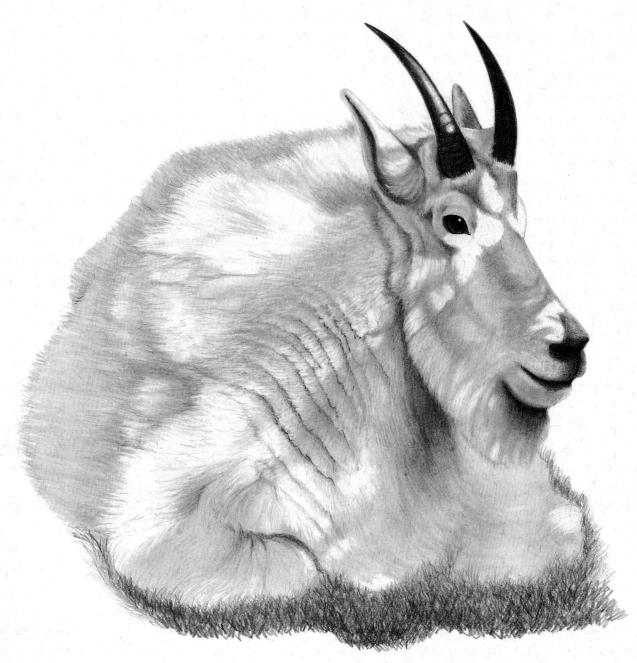

⑧ Adjust

The eraser is not hair-fine, so go back to those erased "fat" hairs and use your pencil to thin the hairs and break up the whites. Soften the highlights and adjust the values yet again. Ground the goat using a soft graphite pencil in short strokes to add grass.

GLACIER MOUNTAIN GOAT
Graphite on bristol board
14" x 17" (36cm x 43cm)

Fine-Tuning the Shading on a Greek Torso

This drawing is from a photo we took of one of the Greek sculptures at the Parthenon. I did the initial shading, then turned it over to Rick to fine-tune it. He worked on just one side, the right, so the difference would be abundantly clear. This demonstration shows just how realistic you can make your drawings if you take the time to refine the details.

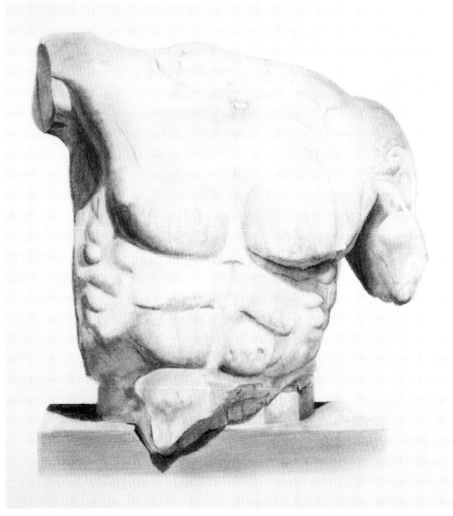

❶ In the Beginning ...

This was the original drawing I gave to Rick. I thought it looked pretty good. Watch Rick work his magic with the pencil, stump and eraser to make it even better.

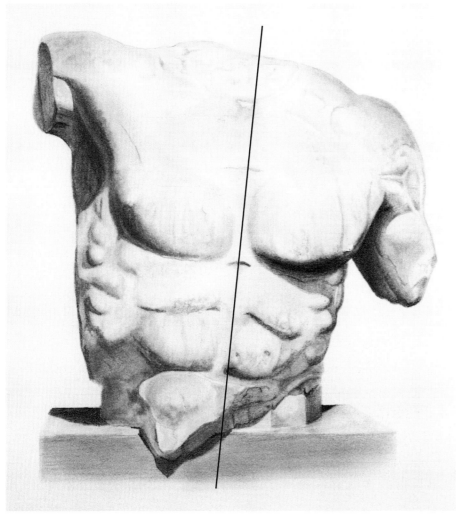

❷ Darken With Pencil

The first thing Rick did was to go over the right half of the drawing with a pencil, darkening my shadows but keeping the textures in place.

Pssssst!

It doesn't matter what technique you choose to use for shading. The technique, whether it's hatching, crosshatching, smudging or a combination, is a matter of personal taste, skill and the statement you want to make with your drawing.

❸ Blend

He now blends his strokes together, smoothing out some areas where the stone is smooth and using short, random strokes to create the rougher parts of the stone.

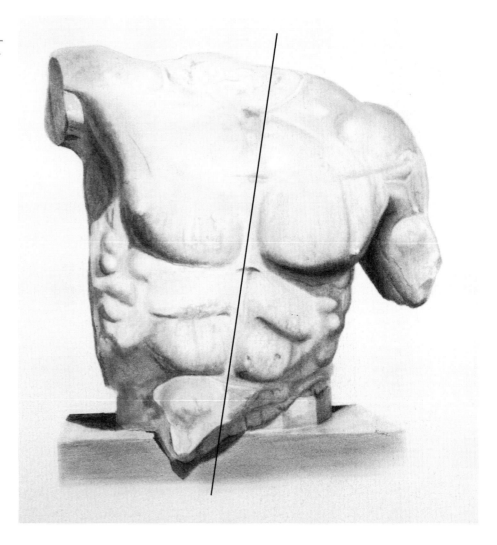

Detail

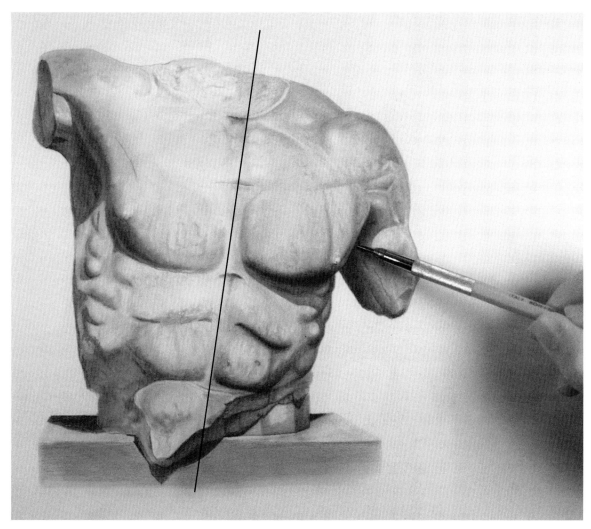

➍ Back to the Pencil

The blending step will take some of the more linear texture out of the drawing, so the pencil is again used to reestablish the cracks and smaller roughened areas.

⑤ Lift Texture

Using a kneaded rubber eraser, some of the uniform dark areas are lifted. This creates the naturally uneven look of stone.

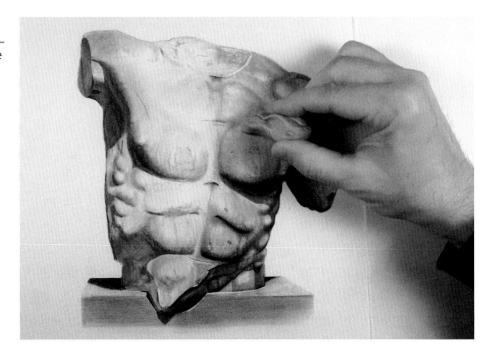

⑥ Erase

Fine white areas are erased with the electric eraser, which has been sharpened to a point. If you lift too large an area, you can come back in with a pencil. Remember, you also learned how to create a template if you need to make a very fine line.

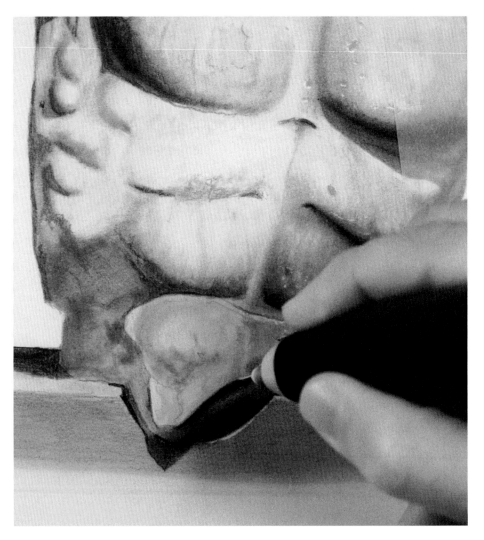

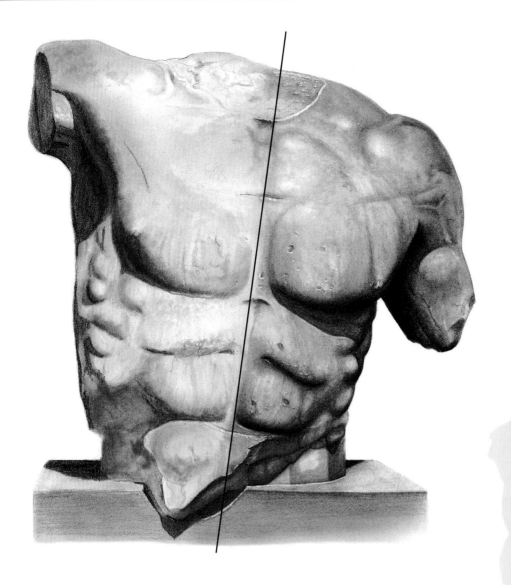

7 Finished Drawing (Well, Almost Finished)

Wow! What a difference the fine-tuning makes when you compare the improved right side to the original left. There's no limit to how realistic you can make your drawings if you have the right tools, practice, and, of course, a little time.

Psssssst!

Never let your brain convince you that you're not learning anything. Instead, outsmart your control panel by tracking your progress. You can do this simply by choosing a single image to draw at various points in the learning process. Be sure to pick something you like since you'll be drawing it over and over again! Once you've settled on an image, sit down and begin your first drawing. Don't tear it up whatever you do, even if it's awful. Just hide it somewhere and save it for later. When you come back to it two dozen drawings and several months later, you'll notice the marked improvement and quiet your fears.

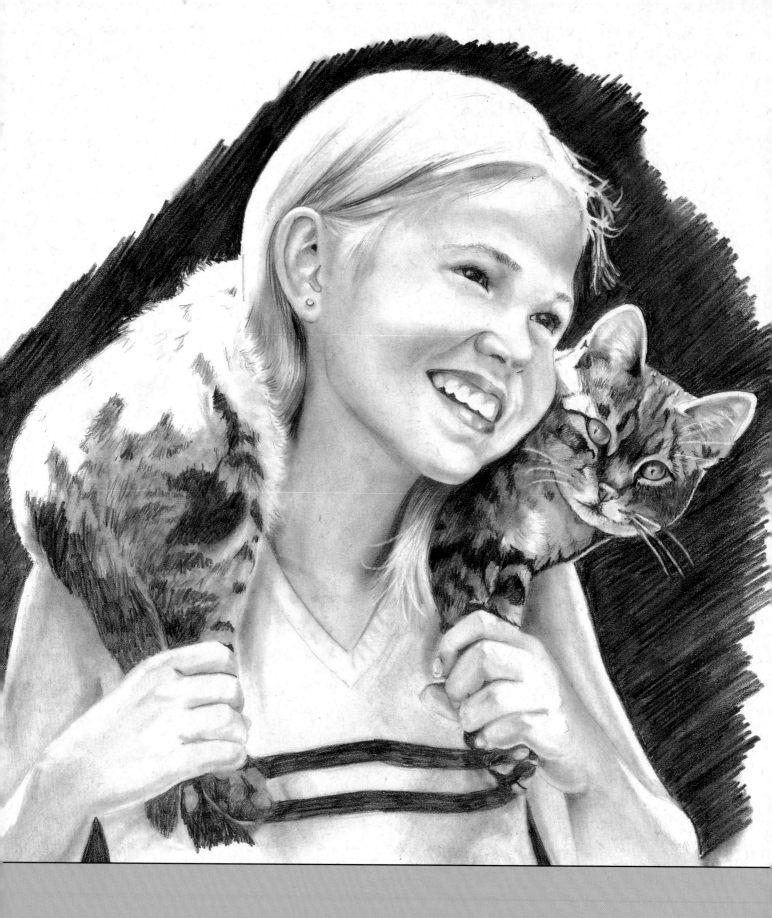

Techniques for
Drawing Realistic Faces

CORRINE
20" × 16" (51cm × 41cm)

When artists first start to draw, they usually begin by sketching the overall images—the location and placement of where things will go. If they intend to make a realistic picture, they'll need to make sure everything fits and is the correct size. Once everything is scaled, they'll start refining the details. I will teach you to approach drawing the face in the same way. We will start with the locations, or sites, of the facial features. Then I will instruct you how to render the correct proportions of the average adult face.

Learning proportions and scaling a picture is not a skill people are born with. I'll teach you how to figure out the proportions using tools to help you. You'll learn three primary tools in this chapter: measuring, flattening and optical indexing. In the past, you've probably heard about vanishing points, eye levels, two-point perspective, horizon line and parallel perspective. Scrub all that. You can draw anything in perspective using only measuring, optical indexing and flattening.

Natural Artists

People I call "natural artists" are those who, for some reason, have been able to draw accurately without knowing exactly why or how they are able to do this. Generally speaking, this ability seems to be spotty. They can draw some things well and other subjects not so well. Such comments as, "I can draw animals and landscapes great, but I can't draw people," are very common.

These artists have learned some drawing techniques naturally, but have yet to learn how to change all their perceptions about the world around them.

Natural artists who have undergone some form of art training are usually able to draw most everything well. However, whether you are a trained artist or a natural artist, your mind still places all incoming information into a pattern of perception. After a short time, you stop seeing what you are rendering and draw a pattern. It's a more sophisticated pattern, a well-drawn pattern, but a pattern nevertheless.

Without having the phenomenon of pattern memorization explained, you might have used some technique to "review" the completed drawing. You might have to take a break from your drawing, turn your drawing to a mirror or place it up on an easel. Now you can see why this is necessary. It helps break the patterns and to "see" your work of art with fresh eyes. This is called checking for accuracy, and it's a drawing tool that natural artists use.

What Are You Looking At?

The best way to begin your artistic journey is to learn how to look at things. Drawing is seeing.

I have taught many art workshops. I remember in particular this sweet woman and her first oil painting. It was a half-completed bowl of daisies on a table. The daisies were all facing toward the viewer, and every one was identical. There wasn't a single small or big daisy reaching for the sky. I asked the eager artist if I could see the reference photo she used for this painting. I needed to point out the variety of images, shapes and colors. She said there wasn't a reference photo, the image came from her mind.

Your mind pretty much has a pattern for everything. Never try to imagine something in your early art career—look at it. Then you will be able to draw it accurately. Always look at it.

OK, So I'm Looking at It

I have told you so far that drawing is seeing, that your brain uses patterns to record the information and that you rely on those patterns to draw. Furthermore, you know that you need to break those patterns of perception by having something in front of you to draw. OK, so you're looking at it. Now, a miracle happens and you can draw, right?

Ah, not quite. Knowing what the problem is doesn't solve the problem. You've just completed step one: Why you can't draw. Now I will go into step two: What are you looking at?

There is simply too much information for your tired, pattern-hungry brain to go through without some kind of manual or guideline. You need to learn how to sift through all the information to make sense of it and be able to use it. Like a "some assembly required"

kit, the parts are all there, but it takes a manual to know what you are looking at and where it goes. There are four basic components to assembling a kit—and to drawing:

- Site
- Shape
- Shade
- Accuracy

You need to know what the parts look like (shape), where they go (site), what the finished product looks like (how to make it look real—shade) and how to fix the wobbly parts (accuracy).

Site

It's easy to say that artists need to learn how to see things the way they really are, not the way they think or perceive them to be. Most books say that. Not only do most people not see the reality of the world around them, they also don't place the objects in the correct location. Sure, they know that the eyes are above the nose and mouth and that somewhere beyond that is hair. But there's more to it than that.

Measuring and determining the correct location and size of different items is called proportion. When something is in proportion, it's correct in scale to the other items in the picture. It's easy to look at a picture and know when something is out of proportion, but how do you draw something in proportion? Learning how to correctly proportion images in a picture through the use of artistic tools will be covered throughout this chapter.

Natural Artist?

You weren't born with the innate ability to know how long a meter is or how many cups are in a gallon. You learned which of the various measuring tools to use for each application. Drawing also has measuring tools. Look at the two examples shown here, both drawn by the same student. Notice the relative size and location of the facial features in the pre-instructional drawing. Even if the features were correctly drawn, they are still in the wrong place. Note the difference in the later drawing.

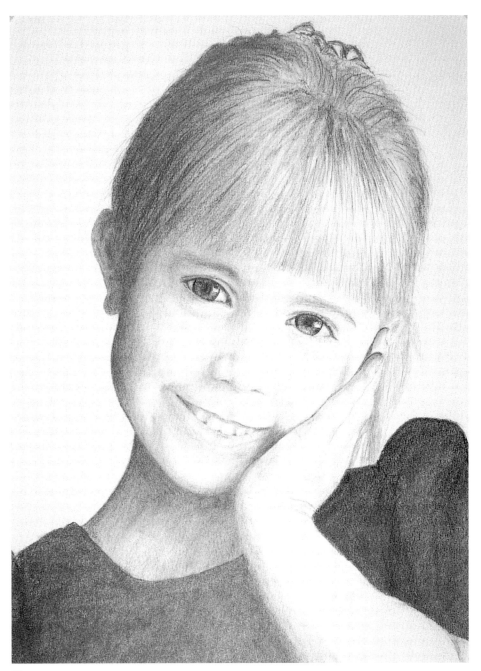

HEATHER
14" × 11" (36cm × 28cm)

Shape

Basic shapes are not easy to identify when drawing. You need to know what to look for. Shape Identification 101 started in kindergarten, and ceased shortly thereafter. Most people are not formally trained to see shapes for drawing purposes. You have to learn this skill. Once you've determined the correct size and location of an object, you can then concentrate on the shapes of the object you wish to draw.

An artist automatically filters out all but the barest shapes to begin with. This is not talent, it's training. We are training our minds to see the subtle shapes in the visual world around us.

Shade

The next step in the drawing process is shading. Shading makes something look real (as shown in the example to the right). Most people have never learned, however, to evaluate and see shading. Yes, you can see that black jeans are darker than blue jeans. But shading requires more special knowledge and tools. Learning to shade also involves learning more about your mind and the power of your perceptions.

Accuracy

Finally, you need to be able to learn how to overcome your brain's desire to put the world back into patterns. How can you keep checking to see if you are doing well? In the back of most do-it-yourself kits is a problem-solving section. You need a similar chapter in your drawing routine. Ask, "What is wrong with the shape of this face?" This is checking the accuracy of the image.

Simplification

The visible world around you is rich in information—actually, there is too much information for any emerging artist to understand. It first needs to be simplified for you to see just exactly what it is that you are looking at. This is why it's easy for people (especially children) to draw cartoon characters so well. The shapes are simplified, outlined in black and easy to see. Most people can draw these shapes with little or no instruction, other than what they've learned about drawing letters.

This is the photograph that the drawing on the following page is based upon.

Seeing Without Outlines

Many children show great interest and talent in drawing cartoons. Often when they are introduced to regular drawing, they will lose interest or give up. The problem is not their lack of talent or even interest; it's in how they are taught to see the same simple shapes in the photograph (or world). Drawing the world around you involves using the same basic shapes. They're just not outlined in black ink anymore.

Look at the girl's hair and face. Without the appropriate shading her features would have looked unrealistic and incomplete. Learning how to shade properly can save your drawing from the recycle bin.

PHOTO BY KELLY DULANTY
12" × 9" (30cm × 23cm)

Measuring for Realism

Any object in front of you is measurable. Most people have been taught to measure an object by comparing it to something they know. Traditionally, you may compare something to a specific measurement, such as a ruler. There is an expression "bigger than a bread box"—though most young people today have never seen a bread box. This is a comparison. Everything in front of you can be compared. An object is either the same size as, larger than or smaller than something else.

Bigger Than a Bread Box

Using a map as an example, you check the distance from one point to the next by comparing it to the map scale. You don't use the scale to measure another map or the length of a baseball field—only the contents of this particular map.

You can measure a variety of objects using other forms of measurement, such as a gallon or a meterstick. Artists also measure objects. The difference is that they measure an object by comparing it to itself.

All About Baselines

A baseline is a comparison system. For example, when compared in a range of Chihuahuas to Great Danes, a "big" dog is a German shepherd. A German shepherd, however, is not all that big when compared to an elephant. Size is relative to what is being compared. When you use this system in art, you compare the baseline in the image in front of you to something else in the same image. For example, you may wish to compare an object's length to its width. Because you'll be drawing this object, you also have a straight line that you can use as a baseline in your drawing.

Establishing Baselines in Photographs

The easiest way to measure objects with a baseline is to use photographs. Photos don't move, are already in two dimensions and are easy to refer to. To do this simple exercise, you will need a pencil, an eraser, a sketch pad, a scrap of paper and a large, easy-to-see photograph.

How to Establish a Baseline on a Three-Dimensional Subject

1 Select the Baseline on the Subject

Select a portion of the face or body to use as your baseline. The baseline should be a fairly small horizontal or vertical line. Remember that a baseline is something you will compare everything else to in your drawing.

Proportions

Proportions are like maps—they provide an overall view of where things are and how they fit into the whole picture. Most people have a pretty good idea where the facial features are located. The eyes are above the nose and the nose is above the mouth and so forth. The first drawing concept is on how to locate various items we wish to draw with more exactness.

Some books written about faces are not always correct on the placement of the facial features. They may generalize or use some kind of Greek idealized face with a long, thin nose. Once again, it's important to look at something to draw as you continue this process. It's hard to measure, line up and view images that you've created in your mind.

Proportions are a comparison, a relationship between objects dealing with size, volume or degree. You may be able to draw the greatest eyes in the world, but if they are in the wrong place, the drawing will be off. Proportion is the relationship of different elements in a work of art.

② Measure the Baseline

Extend your arm straight out in front of you, holding the pencil as illustrated here. Close one eye and use the tip of the pencil to mark the start of the head. Use your thumb to mark the end of the head. This measurement is your baseline.

Psssssst!

Three important secrets to using a pencil as a measuring device:

1. Hold your pencil as if it were a piece of paper in front of you. In other words, don't angle the pencil away from you. You're trying to draw a three-dimensional object on a two-dimensional piece of paper. You cannot draw into the paper, so hold your pencil flat.

2. Extend your arm fully. If you keep moving your arm to varying lengths, your measuring will be off.

3. Always close the same eye.

③ Compare the Baseline Measurement to the Figure

Using the measurement of the tip of the pencil to your thumb, compare the figure to establish if something is the same size, larger than or smaller than that measurement. For example, compared to the height of the head, the height of this person's body is six "heads."

Using this system, you can compare the height of the head to all other parts of the body. Whatever measurement you choose to make the head on your paper, you will compare the rest of the body to that starting point.

A Quick Review

Let's summarize what you've learned so far. To establish the correct proportions of a three-dimensional world and put it onto your two-dimensional piece of paper, you do the following:

1. Select a baseline from some object in front of you that should be straight, short and horizontal or vertical to you.

2. Use a pencil, pen or other straight object held in front of you at arm's length to record the length of the baseline.

3. Make a mark on your paper to represent that same length.

4. Use the baseline measurement for comparison to other objects in the picture in front of you. Everything should be the same length, longer or shorter than that baseline.

5. Use the drawing baseline to make the same proportions on your paper.

Measuring the Face
You can locate the eyes by using the same concept of measuring the head and comparing it to the body. This is an easy exercise for all ages.

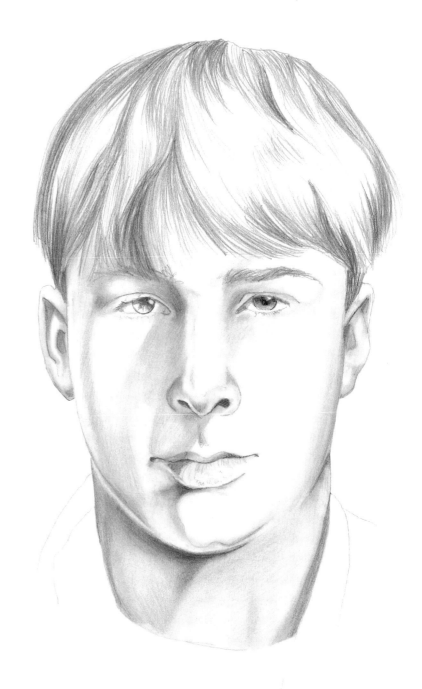

Here's the finished drawing that will be the base for the exercise in measurement.

Measure the Face to Locate Features

You can locate the eyes and other parts of the face by using the same concept of measuring the head and comparing it to the body. This is an easy exercise for all ages.

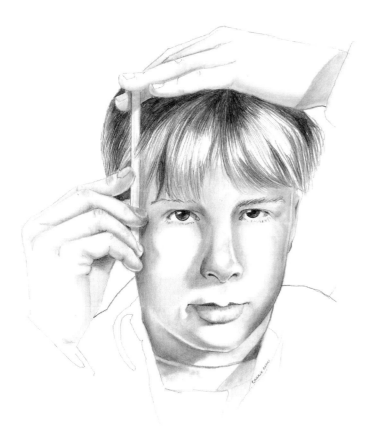

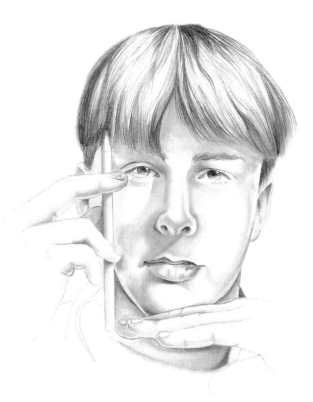

❶ Measure the Location of the Eyes

Compare the distance from the top of the head to the eyes. This will be the first and simplest baseline.

Lay one hand flat on top of your head, and take a pencil in your other hand. Hold the pencil tip with your flat hand. The hand holding the pencil should point toward your eyes. Use the pencil to help you measure the distance from the top of your head to your eyes and locate the eyes.

❷ Compare to the Distance Between the Eyes and Chin

Compare the previous distance to the distance from your eyes to your chin. On most people, the distance between the top of the head and the eyes is about the same as the distance between the eyes and the chin.

Enlarge Your Drawing the Easy Way

This site-measuring technique is very useful. Not only can you measure something in front of you and draw it the same size, you also can use the same tool to enlarge or reduce a picture. To draw something the same size, mark the established baseline and one other measurement on your paper.

① Scrappy Solution

To enlarge a drawing, take a scrap of paper and mark the original measurement on one side and the enlarged measurement on the other. In other words, make the baseline larger.

② Eyeball It

By establishing the eye as the original baseline, you can now compare that measurement to every other feature on the face. Use the original baseline side of the paper every time you measure a feature on the original photo.

My Sketch

Original Photo

More Measuring Aids

There are more tools—some of them are pretty expensive—to help you measure. Besides being able to enlarge or reduce the size of a picture, you can also use these tools to help you measure curved shapes. Probably the most useful tool, although expensive, is the proportional divider. This device offers an adjustable way to measure and compare two images. It has a sliding screw that allows you to adjust the width to any two images—your drawing and the image you wish to draw.

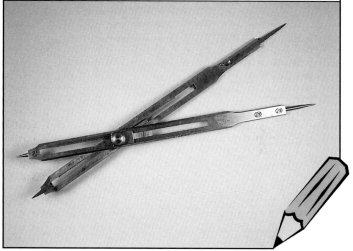

3 Reuse or Reverse

You will use the enlarged side of the paper to draw that same feature again and again. You can proportionally enlarge a drawing to any size using this method. Reverse it to make something smaller.

Measuring Curved Shapes

Measuring a curved shape with a straight edge can cause you problems. It is difficult to correctly see and accurately draw curved shapes. How can you measure a curve with your straight-edged measuring tool? The good news is that you use the same tool, you just measure the start and finish of the curve.

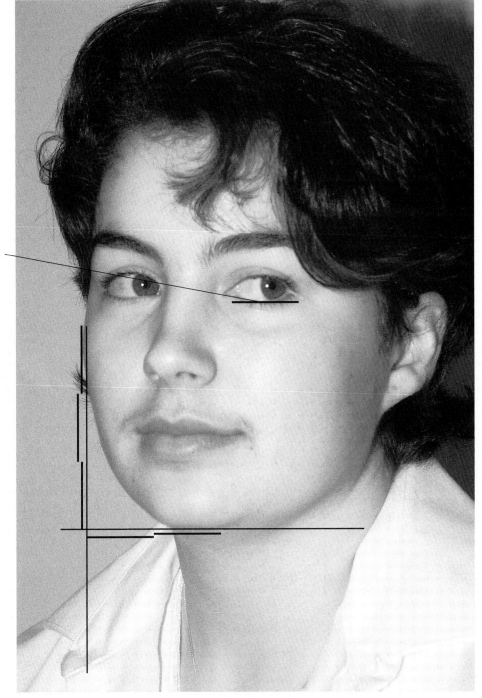

width of eye

Straighten the Curve
You can measure the curve of the cheek in the photograph by using the eye baseline. Draw two lines, one at the start of the curve of the cheek and one at the chin. The horizontal and vertical lines are measurable distances and give you the start and end of the curve. Take the measurement of the eye and compare it to the cheek. Her cheek curves down two and a half eyes and over one-half eyes. Measure how far up and over the curve goes. You have also created a negative space that will be explored in more detail on page 135.

Flattening and Optical Indexing

Flattening Tool

When you first used your pencil as a measuring device, you extended your arm and closed one eye. Why did I ask you to close one eye? Try it with both eyes open. It doesn't work. It takes both eyes to have depth perception, which you don't want, because you're drawing on a two-dimensional piece of paper. Closing one eye flattens the world around you. Aha! You've just established a drawing technique! To draw a three-dimensional image on a two-dimensional piece of paper, you must close one eye.

Optical Indexing Tool

The next tool to help you find out where the facial features are located is called "optical indexing." That is a fancy way of saying things line up. What features on your face line up? Is it possible to use the location of one facial feature to find out where the others are located? Take a look at the two drawings on this page and notice how the features line up.

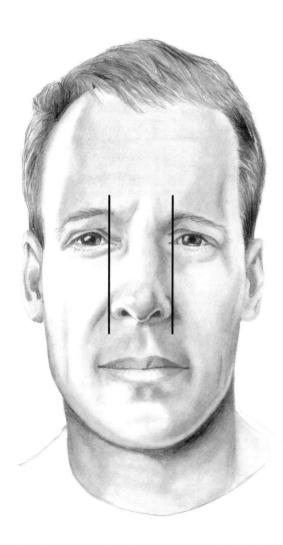

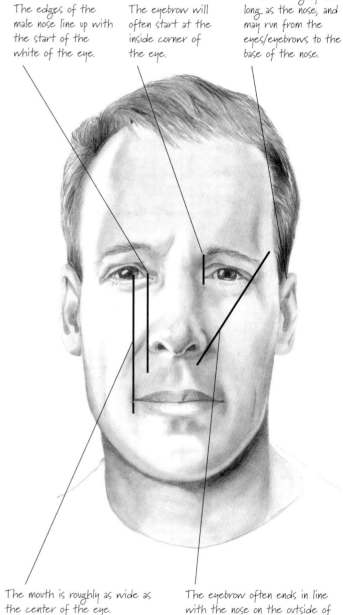

The edges of the male nose line up with the start of the white of the eye.

The eyebrow will often start at the inside corner of the eye.

Ears are roughly as long as the nose, and may run from the eyes/eyebrows to the base of the nose.

If I make an imaginary line straight down from the eye in this drawing, it will bring me to the outside of the nose. I now know how far down the nose comes to (because I measured it compared to the eye) and how wide the nose is.

The mouth is roughly as wide as the center of the eye.

The eyebrow often ends in line with the nose on the outside of the eye.

Simplify and Relate

Earlier I mentioned that children find drawing cartoon and comic strip characters easy. This is because the drawings are outlined with black ink. The simple shapes—curves and lines—are easy to see. A photograph, or real life, doesn't have the same black outlines to show the artist what to look for. To see the subtlety of the shapes takes training.

In linear drawing, there are only two basic shapes: a straight line or a curved line. The lines go up, down, right, left, but they are either straight or curved. When artists look at the face, they don't try to find eyes or lips, they seek the simplest linear shapes. Seeking the simple shapes removes your memorized, incorrect perception of what constitutes an eye and allows you to focus on the actual reality of an eye. Artists seek the simplest expression of shape as a foundation for building the face. They look for the simple curve, line, circle or shape, rather than an eye, nose or lips.

The dictionary defines "relate" as bringing into logical or natural association, to have reference. The face has a unique shape that helps artists relate other information. The iris, the colored part of the eye, is a perfect circle. The pupil, the black center of the iris, is also a perfect circle and is in the center of the iris. The average adult iris does not vary much from face to face. You can use this information to help you see and draw better.

Psssssst!

You might be wondering how big to make the pupil of the eye. The answer is: It depends. The pupil expands and contracts to light. Studies have shown that it also expands and contracts as a reaction to seeing something likable or unlikable. Most artists unconsciously record this piece of information. Therefore, an eye with a small pupil is less likable than an eye with a larger pupil. If you want people to like your drawing (or in other words, get paid for your portrait), make the pupil large. If you are drawing a bad-guy composite of a cold-blooded killer, make those pupils pinpoint—you'll naturally dislike the guy.

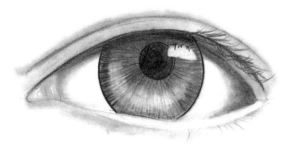

Bad Drawing, Bad, Bad! Now Sit...
Using the relate tool, place the pupil in the center of the iris before drawing the lid and other eye parts. You'll resolve the problem of off-centered pupils and the resulting comments like, "I don't know, Marge, there's something wrong with this picture."

Draw a Correctly Proportioned Iris

Look at this correctly drawn eye. Then, Follow the steps to learn how to draw a correctly proportioned iris.

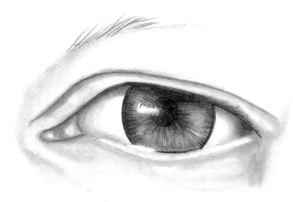

A correctly proportioned eye.

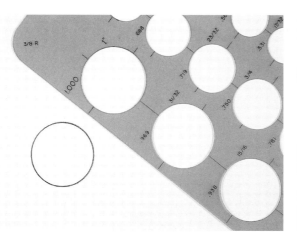

❶ Relating Shapes

There is an association between the various parts of the eye that you can base on the circle of the iris. Using a circle template, draw a circle.

❷ *X* Marks the Spot

Using the top and bottom sides of the circle in the template, connect the lines to the center of that circle.

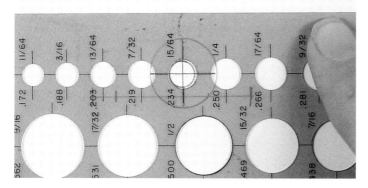

❸ Circles Within Circles

Center the pupil of the eye in the middle of the iris. Check that you are using the correct circle size on the template; it should fit nicely around the center of the lines.

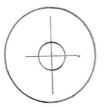

Locating Features

Earlier in the chapter, you learned that you can measure anything in front of you. This method helps locate the facia features, which can then be measured. Once a single shape is in place, you can use that shape to locate and determine other locations and shapes. Remember that there is one shape that occurs in every average face: It's the perfect circle of the iris.

Go Figure...

Measure it for yourself. Knowing that you can correctly measure an eye on a photograph means you should never draw an incorrect eye. It's truly as plain as the nose on your face.

You can use the width of the eye to measure the height of the eyebrow, the length of the nose and any other measurement you might need to check.

Just as you established a baseline within the site tools section, you can select and use a baseline in the shape tools.

Invert

Another way to learn to see shapes is to invert, or turn, the line drawing upside down. Sometimes the mind can't make "heads or tails" (pardon the pun) of the picture you want to draw, so instead of looking for a specific feature, try completing your drawing using shapes. By working upside down, as shown in the example on this page, you focus on seeing shapes rather than the familiar image. Turning a photo upside down and checking your work is also a way to check for accuracy, which is covered on page 114.

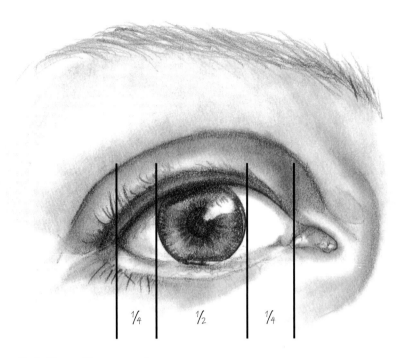

Eyeballing a Measurement
You can use the width of the iris to determine how wide the eye will be. The iris of the average adult eye is one-half the width of the white of the eye. Note that I said white—not the entire eye. You still have a bit of your eye left over.

Invert Line Drawings
The invert tool is an aid to help artists "see" better, however, it works best if used on line drawings. Turning a photo upside down and trying to draw it is quite difficult. Instead, use a line drawing to help you copy the image on your paper. The inversion tool is excellent training for anyone.

Make Your Drawing Look Real

It's often a struggle to make a drawing and a picture look alike. This is especially true when you are drawing a family member. It may be that the mouth is causing the difficulties, so you draw it again. And again. And again. The paper starts to thin in that area from all your erasings. You may become frustrated because you can't see what the problem is in that shape.

Drawing is difficult at times, especially when the shapes you see are subtle. There is a simple solution to helping your poor, beleaguered brain see the elusive shape: the compare tool.

❶ Cheat

Place a sheet of tracing paper over the photograph and trace the outline of the shape causing the difficulties.

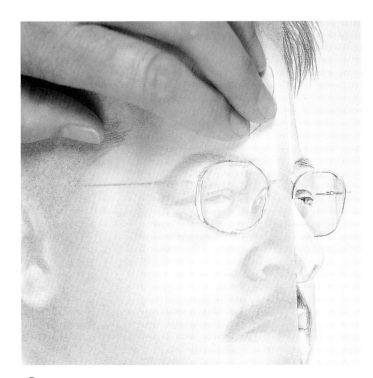

❷ Trace Again

Move the tracing paper over to your drawing. Place your hand over the tracing you have just done, so you can't be influenced by it. Trace the same shape on your drawing that is causing you problems.

❸ And the Answer Is...

Move your hand over, and look at the two shapes side by side. You have removed the "background noise" of the information-rich photograph and created the shape in its simplest form. The subtle difference between the shapes is apparent when you compare it in this manner.

Flattening the Face

You previously learned how to take a three-dimensional image in front of you and transform it into a two-dimensional image on your paper by closing one eye. This is true for finding the site or location of an object as well as the shape of an object. A facial feature, like the nose, can be difficult if you don't flatten it by closing one eye.

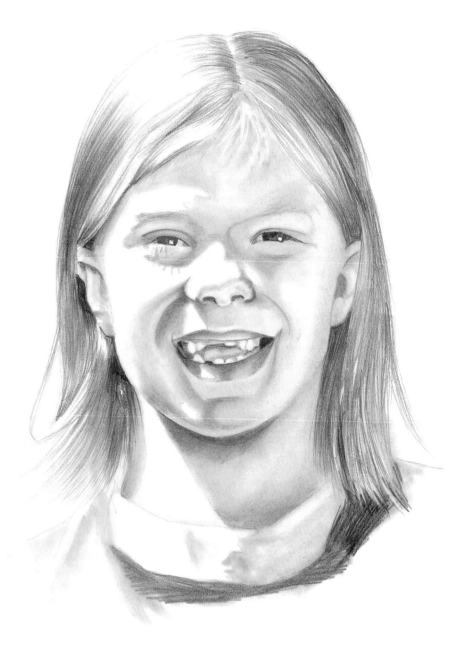

By closing one eye, I was better able to translate this three-dimensional image to my two-dimensional paper. Without this technique, Aynslee's image would most likely have looked strange and out of proportion, almost like looking into one of those carnival mirrors.

AYNSLEE
12" × 9" (30cm × 23cm)

Values/Lines

Now we will delve into the deep, inner psychology of art, asking the age-old question, "What is a line?" When you draw, you usually start with lines to tell you where you are on the paper and where the edges of various items occur. Beyond geometry and other math applications, you have probably never thought any more about lines. Your brain, however, loves lines and will lie to you about them.

It's true. In chapter two, you learned that the mind places everything into patterns of perception, memorizes that pattern and uses that pattern instead of the reality of what is actually present in the photo. Your mind figures it knows all about things like facial features and therefore will provide information about that feature, regardless of reality. Perceptions are more powerful than facts.

Drawing lines represent one of two things: a thin, dark value on the face (such as the crease in the eyelid) or a value change. A line in the latter instance shows where a dark and a light value come together. Here's a secret: There are few true lines on the face. Most of the shading on the face comes from value changes, not lines. When you draw lines to indicate value changes, you tend to leave the lines in place. I think of this as Carrie's Dictum: The closer in value two shapes are to each other, the less you can draw a line to separate them.

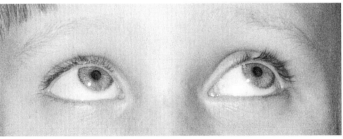

Eyeball to Eyeball
A close examination of the eyes, for example, will show us that the bottom lid is a shelf. This shelf picks up light and is light in color. You see it often because it is actually lighter than the so-called white of the eye. There are no lines on the bottom lid; it's a series of value changes.

I Got You, Babe
Because your mind tells you that there is a line on the bottom lid, you draw it in. This is fine if you're drawing Cher, circa 1965, "I Got You, Babe..." but it is incorrect for most other eyes.

Look at this illustration. Your mind accepts the lines you originally use as correctly defining the shapes of the face. Your mind (perceptions) really likes those same lines and will leave them in place at the end of the drawing.

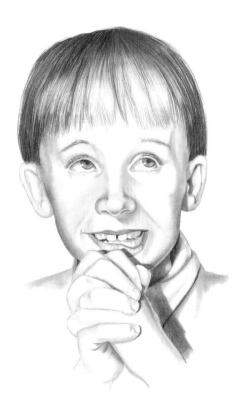

Handling Lines Like an Adult
You have two choices when shading: Either kill the line (that is, shade up to the line and make the line disappear because it's now the same shade at that point), or don't draw the line in the first place.

When Less Is More

Grids, proportional dividers and slips of paper are all useful tools for drawing the correct proportions of the face. Sometimes, however, just a simple line will do. We talked earlier in the chapter about the power of a line. It gives the eye a concrete reference point. Sometimes you just need that little boost to see a subtle problem in your drawing.

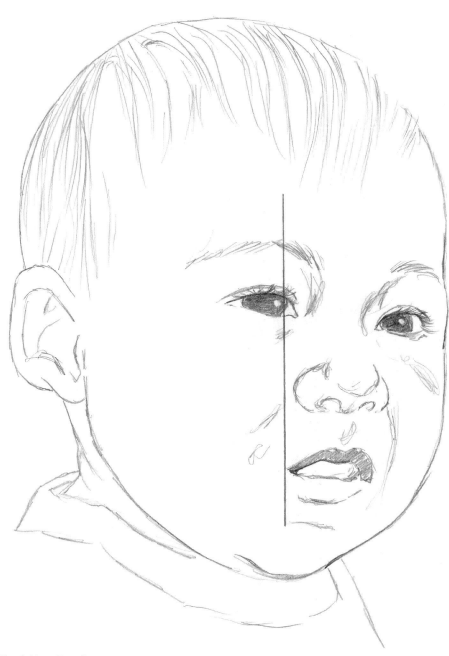

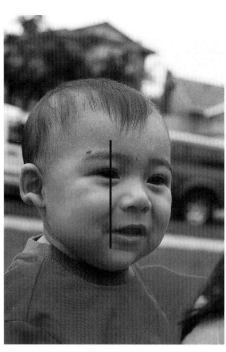

Draw a Line
A subtle error will jump out at you if you simply apply a horizontal or vertical line. Here a line is drawn on the photo of Daniel Deffee that goes from the edge of the mouth to the outside edge of the iris. These two points line up.

Check Your Drawing
When I apply the same line to my drawing, I can see that the width of the mouth is a bit off. This error is made clear by checking with a line. Now that I have the correct location, using the line, I can make the mouth the correct width. This technique is often referred to (by artsy types) as optical indexing.

Psssssst!

A straight line is an artist's best friend. It provides a concrete reference point that assists our eyes in recognizing even the most subtle angles of our subject.

Proportions Change

Because proportions are essentially comparisons, they can change. The proportions of the face change with age. The baby's face is wider, with most of the head above the eyes. The nose is short, and the eyes are wide set and large in the face. The lips are full, but small in the face. Similarly, a face turns and the angle from which you view it changes, so do its proportions according to your view.

Proportions Change With Age
In the drawing above, compare the proportion of the baby's face to that of the twelve-year-old girl. Can you see the difference in proportion?

Proportions Change With Viewing Angles
Look again at the proportions of the face as it turns. Notice that one eye gets smaller, the tip of the nose moves from the center of the face, the mouth is asymmetrical, and the width of the face changes.

The Three-Quarter Turned Face

Many photos of children are captured as a three-quarter turned face. It makes for interesting angles, a lot of great lighting and exciting shading.

The biggest problem is that there are few hard-and-fast rules that will help you master the techniques for drawing such a face. There are simply too many variables. I'm going to come right out and say it: You're going to have to pay close attention to your subject. The eyes won't be the same size, the lips will be unequal, the nostrils won't match, ears, hair, forehead . . . sigh. Now factor in all the angles required to master drawing the range from a baby to a teenager, and you might need an entire library of rules.

Now, before you throw this book across the floor because you've realized that that's exactly the angle you're trying to draw, I'll offer a suggestion or two.

Nicholas Gonzales

Serena Heppes

Three-Quarter Turned Faces
Four faces, four ages, four sets of drawing challenges. To achieve correct proportions, you must pay very close attention to all these different angles.

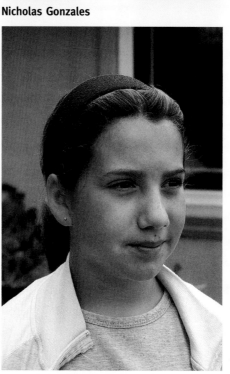

Taylor Gonzales

Casey Castro

Keep It Curved

Almost every art book has an illustration that demonstrates how the face is a round shape. The authors note that by observing this shape, the budding artist will correctly render the facial proportions. Unfortunately, the single most difficult shape to draw is a curve. The slightest deviation can alter the image. Eyes, noses, lips, ears—in fact, most of the face has curved and rounded shapes, and to create a likeness, these difficult curved shapes must be rendered perfectly.

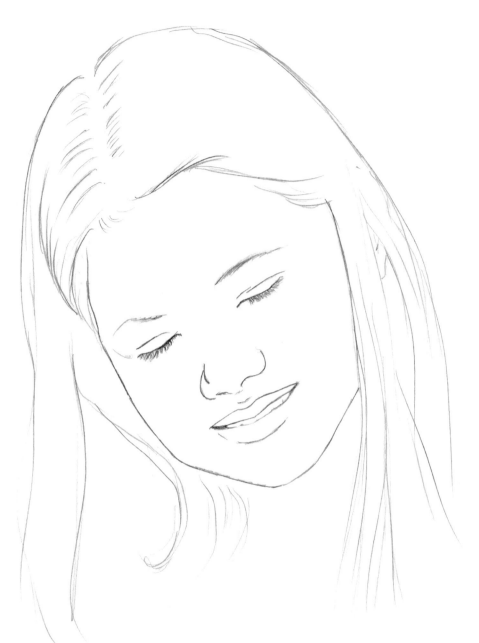

Remember the Curves
There are several simple techniques that will help us accurately render a curve, in addition to the measuring techniques already covered in the chapter.

Box and Measure

A useful technique for finding the curve of the cheek in a three-quarter profile is to box it in and measure it. Draw a vertical line down from the cheek and connect it to a horizontal line drawn from the chin. You can measure the width of the eye and compare it to your box. In this case, the width of the eye is repeated about four and one-half times down to the bottom of the chin and about four eyes over. On the photo you're using, you'd measure x number of eyes down and x number of eyes over.

Box and Measure
The curve of the cheek is easier to see when compared to the straight lines.

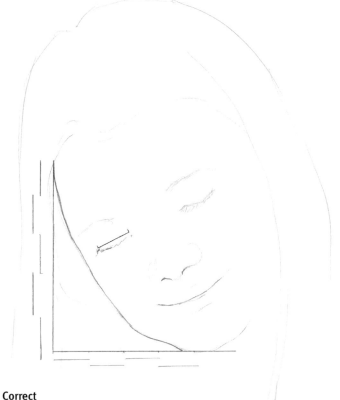

Correct
Here we see how the correct measurement makes the face the right length and angle.

Incorrect
If you draw the wrong angle, the measurements will also be incorrect, and your drawing will be off.

Create Negative Space

Another way to see a curve is to create "negative space," which is the area around a "positive space." If you're drawing your hand, your fingers and palm form the positive, and the spaces between the fingers and around your hand form the negative. If the negative space is incorrect, the hand will be incorrect. By placing straight lines and boxing in the shape you want to draw, it is often easier to see the curve in the space outside the cheek.

Create Negative Space

If I box in the side of the face, I create a shape that consists of the negative space. My goal will be to make sure my drawing matches this shape.

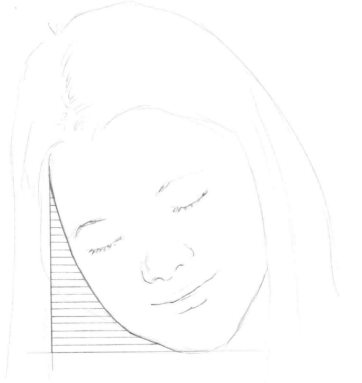

Correct

Here I've correctly duplicated the negative space; therefore, my drawing of the cheek is correctly angled and shaped.

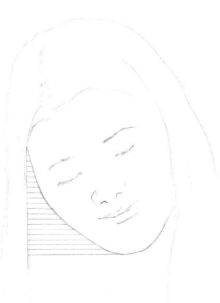

Incorrect

Compare the shape here to the correct shape. It's easier to see that the drawing is off because I'm drawing just shapes, not the darling face of the precious child.

Facial Foreshortening

The same challenges found in drawing the three-quarter turned face are present in drawing a child looking up or down.

The main issue we encounter is foreshortening, which is the illusion of depth created by the apparent distortion of the object—in this case, the face. As the face looks up or down, our eyes see the illusion of parts of the face becoming longer or shorter.

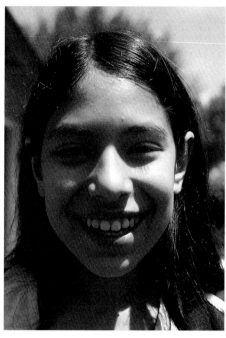

The Level Face
In this level view of the face, notice the location of the eyes and the distance to the top of the head and the chin.

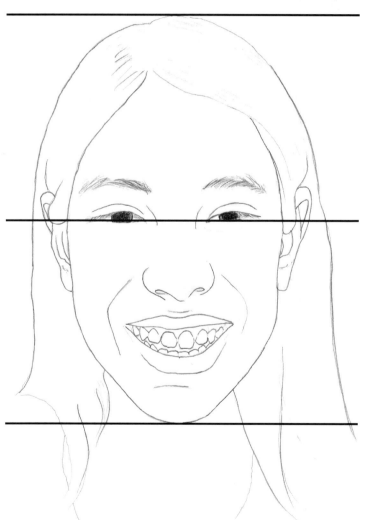

Psssssst

If you're uncertain whether the child is looking slightly upward or downward, check the location of the ears. The lower the ears are on the face, the more the face is looking up. The higher the ears, the more the face is looking down.

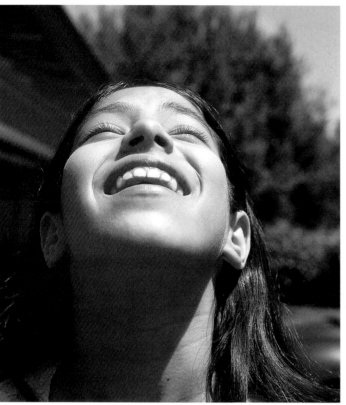

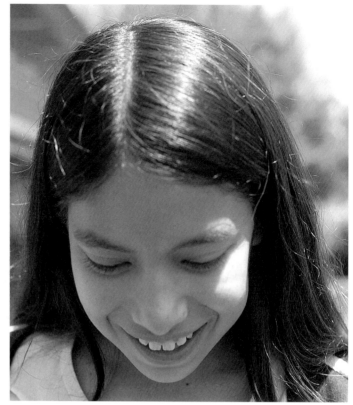

Looking Up
As the child looks up, the lower face is longer
and the upper face is shorter.

Looking Down
As the child looks down, the lower face is shorter
and the upper face is longer.

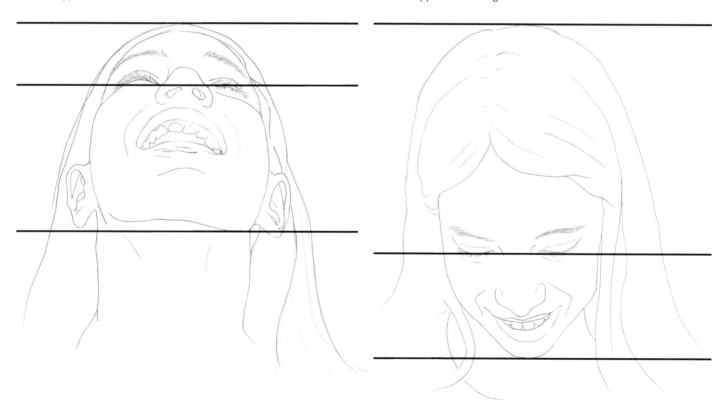

Practice Shading the Face

Let's take a step-by-step approach to shading. Your pencil strokes should be smooth, close together and shift from dark to light.

1 Start Light

Begin with a 2H lead pencil and make numerous smooth marks close together.

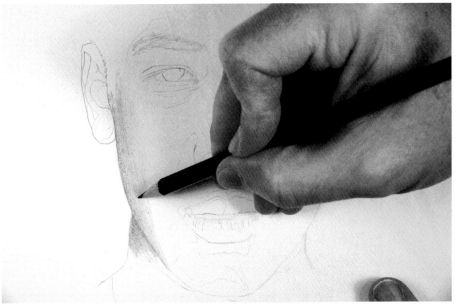

2 Add Medium (Midtone) Shades

Repeat the same marks using an HB lead pencil, but this time don't make the marks completely over the previous lines. End the HB shading, creating a gradual tone moving from midtone to light. Stop your strokes about halfway across the lighter strokes.

3 Darken the Tones

Repeat the same process using 2B or darker lead, this time ending the dark area so as to create the darkest tones. By the third pencil stroke, you'll again end about halfway over the previous midtone strokes.

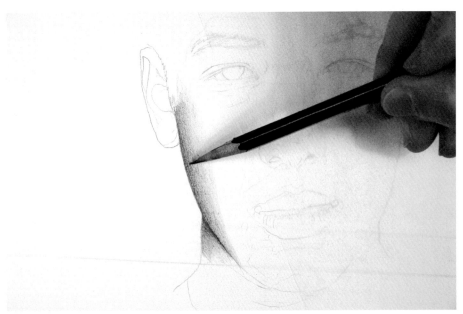

Shade a Sphere

Now it's your turn. Take something round, like a small bowl, and use it to trace a circle. Use the shading pattern found in the photo and shade it as a sphere.

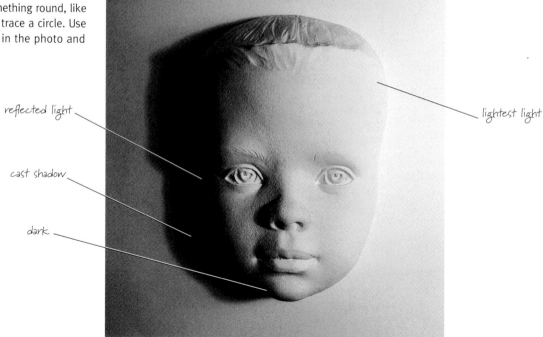

reflected light

cast shadow

dark

lightest light

Going Round and Round
Can you find the pattern of light-dark-light-dark in this photo?

Pencil Tones

Now it's your turn to apply the graphite and shade the face. You can draw, copy or trace this line drawing onto a piece of paper for practice. Start by looking for the darkest darks in the photo, then identify the lightest lights. Your lightest light is the white of the paper. The darkest dark is the heavy 6B lead. All of the other tones are between these two in the value scale. Keep your whites clean and work inward from your darks.

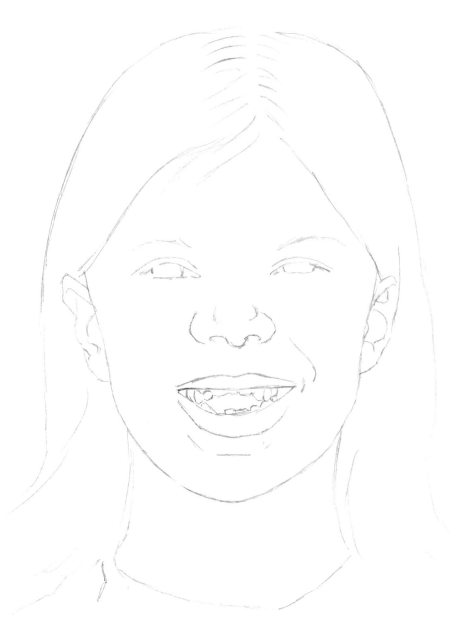

Reference Photo
Watch for the light-dark-light-dark pattern on the face. Squint to see it better. If you need to, cut a hole from a piece of paper to examine each area.

Your Turn
This is a line drawing of the reference photo. Practice shading to get the feeling of roundness. We'll cover individual features and how to scale them later in chapter five.

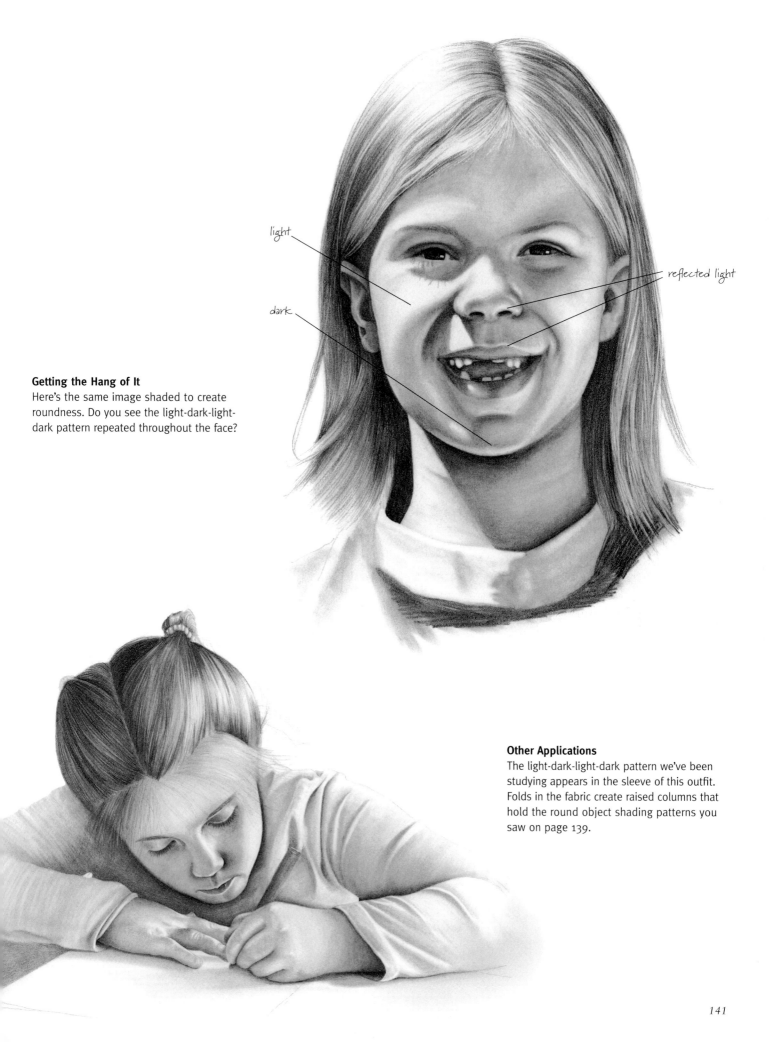

light

dark

reflected light

Getting the Hang of It
Here's the same image shaded to create roundness. Do you see the light-dark-light-dark pattern repeated throughout the face?

Other Applications
The light-dark-light-dark pattern we've been studying appears in the sleeve of this outfit. Folds in the fabric create raised columns that hold the round object shading patterns you saw on page 139.

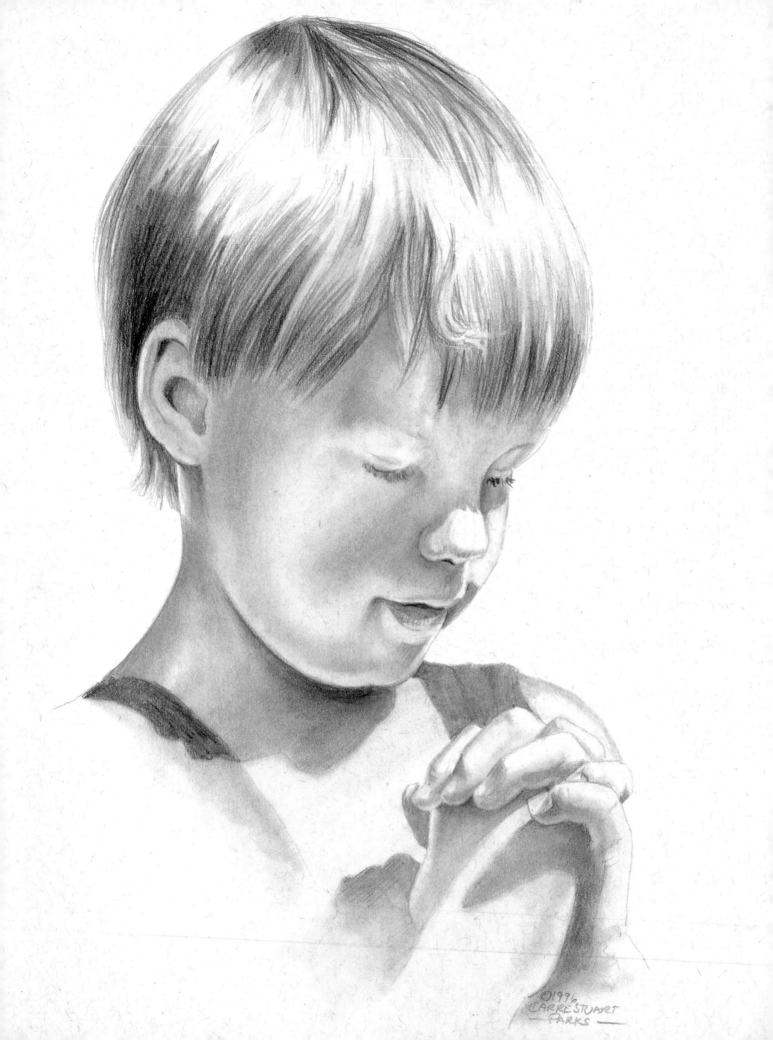

©1996
CARRE STUART
PARKS

Drawing
Realistic Facial Features

Now that you've mastered facial proportions and drawing techniques, you'll work on drawing the features of the face. It can be a big challenge to accurately represent the shapes of the individual features. We'll work on overcoming drawing what we think we see compared to drawing what is actually present.

In this chapter, you'll learn some rules of thumb for drawing facial features such as eyes, nose, ears, hair, lips and smiles. Take the lessons you learned here to draw the subtle shapes of a friend or relative.

BENTLEY STUART
14" × 11" (36cm × 28cm)

Drawing Eyes

So much has been written about the eye. Henry Theodore Tuckerman wrote, "The eye speaks with an eloquence and truthfulness surpassing speech. It is the window out of which the winged thoughts often fly unwittingly. It is the tiny magic mirror on whose crystal surface the moods of feeling fitfully play, like the sunlight and shadow on a quiet stream." Given that the eye is indeed the window of the soul, artists need to get the window right.

Eyes as Shapes

Eyes are shapes, so you will use the shape and shading techniques to help draw them better. This section is the practical, step-by-step application of the various techniques presented in the preceding three chapters. You will isolate the feature of the eyes, simplify the shape and rename the parts of the eye as shapes.

What Color Are Your Eyes?

In addition to placing the pupil in the right spot and at the right size, the pupil must be black. I don't mean a soft, whispery grayish black. I mean black. Can't-push-on-the-pencil-any-harder black. It has to be one of the blackest blacks on your paper because contrast is important. Initially we'll be concerned with the contrast between the pupil and the iris, because it's that contrast that tells the viewer the eye color. So, when we see a black-and-white photo, we subconsciously compare the black of the pupil to the value (lightness or darkness) of the iris. Dark-brown eyes make it difficult, or even impossible, to see a separate pupil.

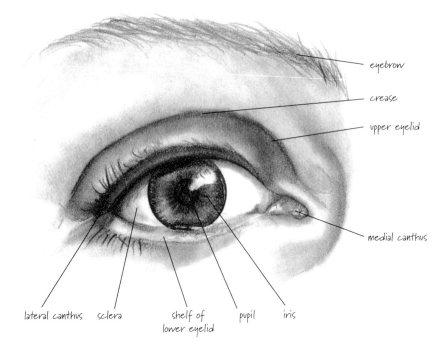

eyebrow
crease
upper eyelid
medial canthus
lateral canthus sclera shelf of lower eyelid pupil iris

The Parts of the Eye

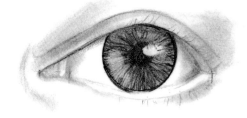

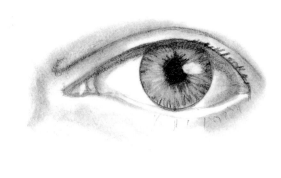

Eye Color
You can determine eye color by how light or dark the iris is in comparison to the pupil.

Locate and Measure the Eye

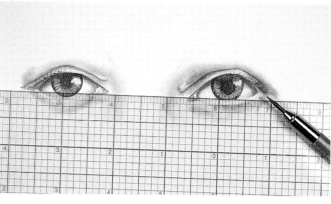

① Start With a Line

You will need a ruler, a circle template, a pencil and an eraser to do this exercise. Draw a line 7½-inches (19cm) long. Break it up into 1½-inch (4cm) sections. This will become an imaginary line running across the eyes. Keep in mind that there are "five eyes" across the average face: an eye between the side of the face and the eye, the eye itself, an eye between the eyes, a second eye and the space between the eye and the side of the face.

② Look for the Incline

When you draw a horizontal line through the eyes, from the outside to the inside corners, it's immediately apparent if the eyes are level, one higher or lower, or tilted at the corner.

③ Subtract the Doohickey

You probably thought the inside corner of the eye was called the medial canthus. I call it the doohickey. On most people, it is a small, triangular, pinkish area in the inside corner of the eye. Now that you know it is the doohickey, you need to ignore or subtract out that measurement.

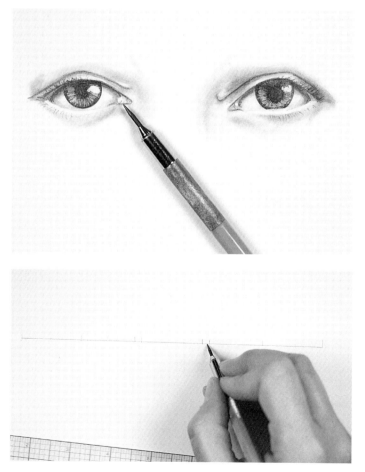

The Doohickey (or Medial Canthus)

My students give me a hard time because I call the inside corner of the eye the doohickey. I know, I know . . . it's a medial canthus, but if I start rambling on about a medial canthus, will you care? Nope. But a doohickey, now there's something we can really get our minds around. It's located on the inside of the eye nearest the nose. It's usually pinkish in color and triangular in shape. It's one of the areas that changes with age. Babies have tiny doohickeys. As we get older, the shape changes, with the bottom growing flatter and longer in shape.

Centering the Iris

Now that you have established the initial measurements, you must find the center of the white of the eye—not the center of the entire eye (remember you are ignoring the doohickey). This is where you center the iris. You might need to refer back to page 125 to refresh your memory on how to draw a correctly proportioned eye.

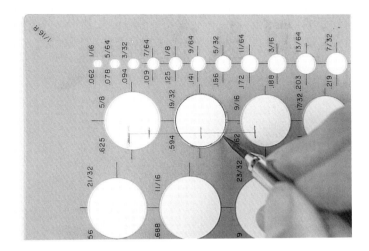

1 **Looking for Circles**

The iris, on the average adult face, is one-half the width of the white of the eye. You could fit two irises into the white of the eye, as shown in the photograph above. The point where the two circles touch is the center. Mark this point.

2 **Place the Circles**

The circle of the iris is not centered on the line you've drawn from top to bottom; about one-fourth of the circle extends below the line with most of the iris above the line. Find a circle in the template that is one-half the width of the eye. Draw that entire circle, using the center mark you just made.

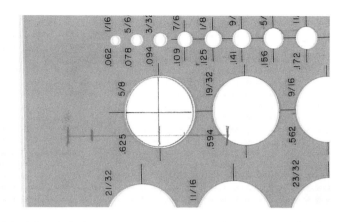

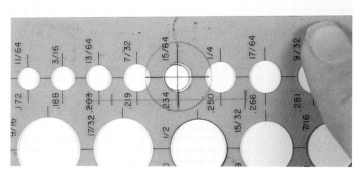

③ Center the Pupil

You will be repeating the process you learned on page 125, but let's review it one more time. Using the marks at the top, bottom and sides of the circle template, connect the lines to find the center of the circle. Center the pupil of the eye in the middle of the iris.

Eye Shapes and Variations

Remember: Everyone's iris is round when viewed from the front. Some variations can occur that make an eye distinctive such as the lids or the shape of the whites of the eyes.

Relate

This is a good place to stop and revisit the topic of "relate." Remember, this means that once you have a shape, you can relate other shapes to that shape. The circle of the iris is a good example. Another feature you can relate shapes to is the upper eyelid. Notice where on the circle of the iris the eyelid touches. On wide-open eyes, the entire circle shows. On average eyes, the lids are above the pupil. "Sleepy eyes" show very little circle (see page 149). Don't vary the circle to fit into the eye; vary the lids according to the iris.

medial canthus

Whites of the Eyes

The amount of white in the eye makes a huge difference. The eye of a child is almost all iris, with comparatively little white. Can you pick out the child's eye versus the adult eye? The iris remains about the same size, but as we grow older, our eyes grow larger, creating more white. In addition, the inside corner, called the medial canthus, grows longer and larger with age.

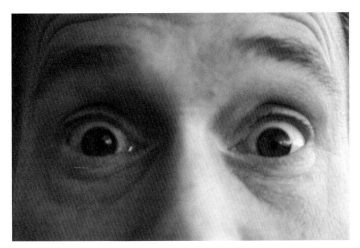

Wide-Open Eyes

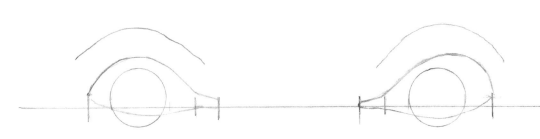

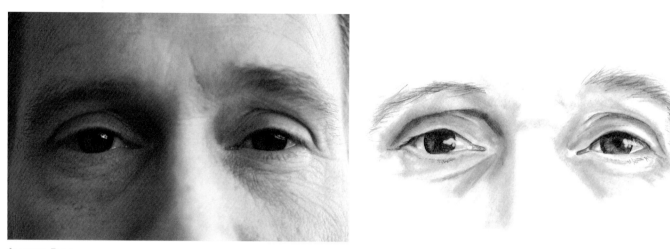

Average Eyes

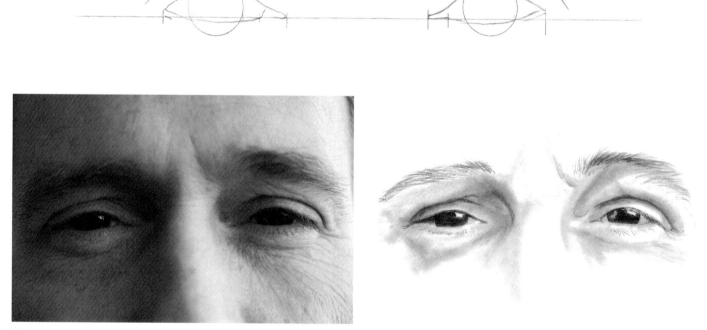

Sleepy Eyes

Eyelid Creases

Above the eye, the upper eyelid forms a crease. In the average eye, this looks like a line following the upper eyelid. When the crease is very high above the eye, it's called "heavy lids." When it's very close to the eye or doesn't show at all, it's called "over-hanging lids." Pay close attention to the location, direction and appearance of the upper lid crease.

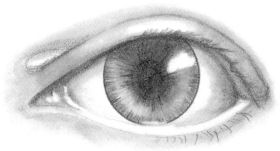

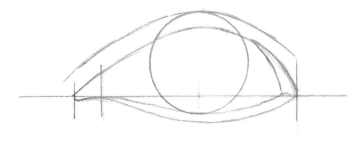

Average Eyes

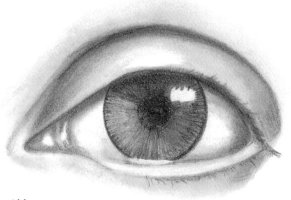

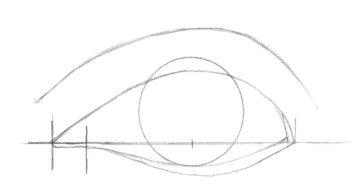

Heavy Lids

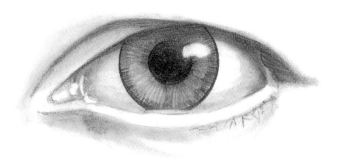

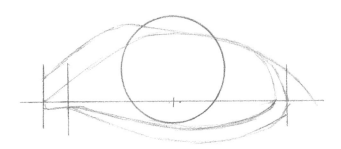

Overhanging Lids

Lower Lids

Both the upper and lower lids have a thickness to them, as shown in the drawing to the right. The upper lid's thickness is indicated by its cast shadow and by the appearance of an edge in one corner. The lower lid is a shelf that will often pick up light. If fact, in the outside corner of the eye, the shelf of the lower lid is often lighter than the white of the eye. Make sure that you haven't made the shelf a single line, and that your lines aren't showing when you are done shading.

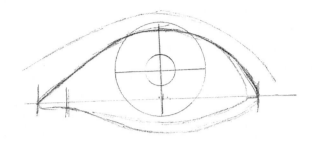

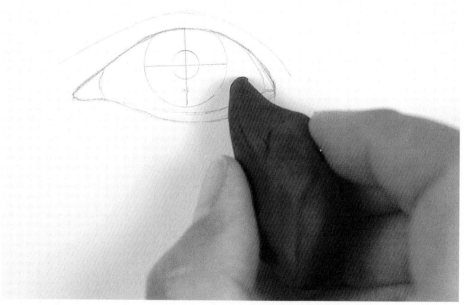

Keep It Neat
Before shading the eyes, erase the interior guide lines you have made. Leave the crosshairs in the iris, as you can use them in shading.

Eyes contain one or more highlights in them. To keep your whites white, leave these areas white rather than try and erase out the highlights.

Finish the Eye With Flair

Back to the step-by-step demonstration. You will need to incorporate all of the lessons from the last few pages, so don't be afraid to go back to the information at any point.

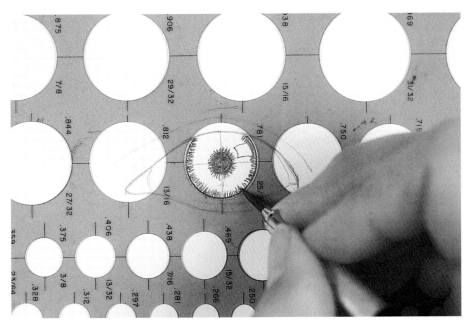

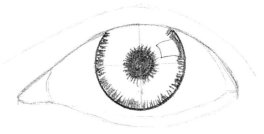

① Shade the Iris

To keep the circle of the iris neat, leave the circle template in place initially as you shade. After filling in the black pupil, fan outward with a dark pencil to keep it from looking so stark. Go around the outside of the iris (with the circle template in place), and fan inward for the same reason.

Pay close attention to the contrast between the black pupil and the color of the eye. Because you're drawing in black and white, it's the contrast between the black pupil and the shading on the iris that you see. With some very dark eyes, you won't see a separate pupil and an iris—it's all dark. Some eyes have a darker rim on the edge of the iris.

Pssssst!

Shade outward from the black pupil to the edge of the circle template. This will enhance the appearance of the eye.

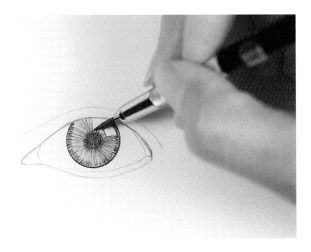
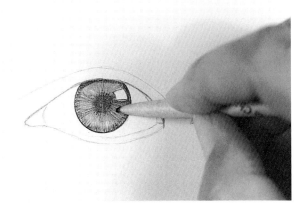

② Fill in the Iris

The iris is made up of linear shapes fanning out from the center. Using an HB pencil (on lighter colored eyes), fill in between the pupil and the outer rim. Keep the highlight white. Then, use a paper stump to blend the shading together, again saving the highlight. On dark-colored eyes, use a darker lead to fill in the space between the pupil and iris edge.

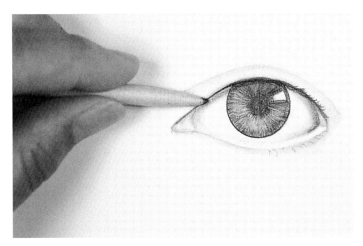

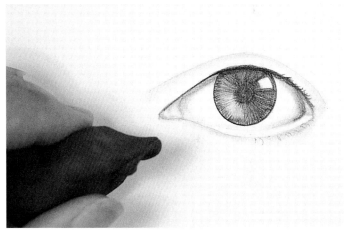

③ Shade the Eye

Using the paper stump, place the shadow cast by the upper lid, and a shadow in the corners where the "ball" of the eye goes back into the head. Erase and absorb the lines of the lower lid into the shading.

④ Add the Finishing Touches

Finally, use your kneaded eraser to lighten the iris on the side opposite of the highlight. This creates the appearance of light passing through the transparent cornea.

Drawing the Eye in Profile

Here's an easy way to keep the eyes in profile correct.

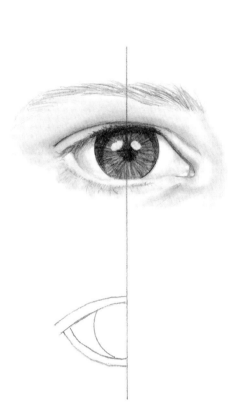

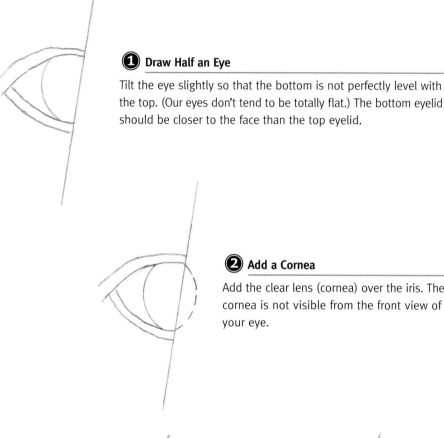

1 Draw Half an Eye

Tilt the eye slightly so that the bottom is not perfectly level with the top. (Our eyes don't tend to be totally flat.) The bottom eyelid should be closer to the face than the top eyelid.

2 Add a Cornea

Add the clear lens (cornea) over the iris. The cornea is not visible from the front view of your eye.

Half an Eye

Another way to look at the profile eye is to understand that we're looking at half an eye.

In profile, we see the outside edge of the eye to the center of the iris.

3 Build the Eye Socket

The eye sits inside the socket. Remember to wrap the lower eyelid around the eye. Eyelids appear straighter in profile.

4 Add Eyelashes

The lower eyelashes grow outward from the outer part of the lower lid. The upper lashes grow down and forward. Now that you've added the eyelashes, notice how little you can see of the white of the eye.

Shaping the White of the Eye

As the head tilts in different directions, the shape of the white of the eye gets larger or smaller. One helpful secret is to trace the shape of the white of the eye, then trace the shape of your drawing of the white of the eye, then compare the two shapes side by side. The subtle differences in the shape become more apparent. This is because the tracing paper removes all the unnecessary details that clutter up the brain, helping you to focus on one shape.

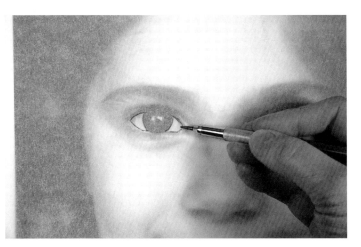

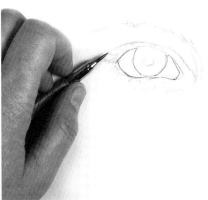

❶ Trace the Photo

Trace the white of the eye using tracing paper.

❷ Trace the Drawing

Trace the same shape from your drawing.

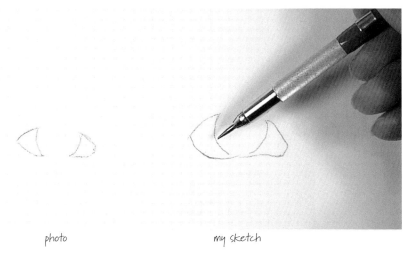

photo my sketch

❸ Compare

It's easy to see that I haven't drawn the eyes correctly when I see the two shapes separately. I'll need to correct my drawing to make it better.

Practice Drawing Eyes

Ready to give it a go? Here's a lovely pair of eyes, let's draw them. Follow along as I complete one of the eyes with you. Then, follow the steps again to complete the second eye on your own.

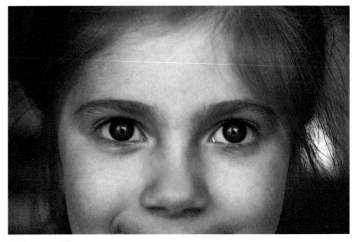

Reference Photo

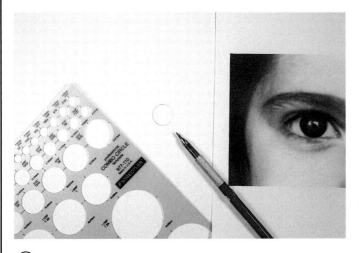

① Draw a Circle

It is logical to start with the iris because it's easy to explain. Using your circle template, draw a circle. Make it large enough to work with.

② Measure the Iris

Using a small slip of paper, measure the width of the iris on the photo. (See "Measuring for Realism" on pages 116–117.)

③ Measure Placement for the Second Iris

Using the measurement from the first iris, measure to the second iris. You should find it is three and one-half irises over.

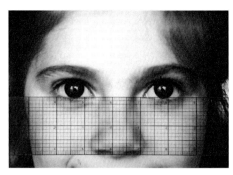

④ Repeat on Your Drawing

Make the same measurement on your paper. Be sure to measure the size of the iris you drew and use that measurement, not the measurement you took from the photo.

⑤ Find the Center

Using your circle template, find the center of both circles. Then select the correct pupil size. Remember that big is better than small!

⑥ Straight or Angled?

Eyes may be level or may tilt up or down in the outside corner. It's difficult to see the subtle tilt of the eye without help. Think back to chapter four (page 130) and place a ruler on the photo to create concrete reference points (lines).

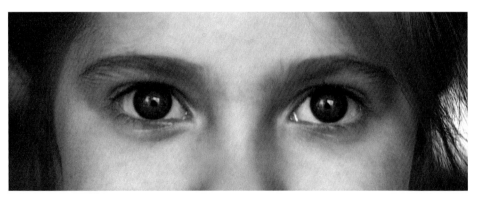

Reference Photo Close-Up: Lower Eyelids
This is an area where a very common mistake is made. Notice that the lower lid forms a shelf. The shelf is widest toward the outside corner and disappears toward the inside corner.

⑦ Draw Upper Eyelids

Draw the upper lid. Pay close attention to the shape and where the lid goes over the iris.

⑧ Draw the Lower Eyelids

It will take two lines to create the shelf of the lower lid; one line to indicate where the lid touches the eye and one line to show the outer part of the lid where the eyelashes are found.

Erase all the guide marks and lines except for those within the iris.

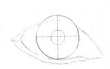
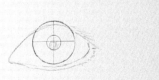

Reference Photo Close-Up: Eyelid Crease
The location of the crease of the lid, formed by the eye when open, varies from child to child. An average eye has a crease that follows the upper lid. In some children, the crease is very high and forms heavy lids. In other cases, there isn't a crease at all. Eyes that don't have creases are known as overhanging lids. The eyes we're working with have average eyelid creases.

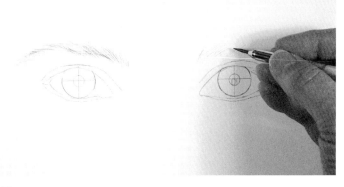

⑨ Draw the Eyelid Creases and Eyebrows

Note the location of the lid creases and place them on your drawing. Eyebrows are made up of short, fine lines that grow away from the center of the face and taper at the ends. Lift your pencil at the end of the stroke to create a line that tapers.

⑩ Start Shading

Establish the darkest-dark, the pupil, using a 6B pencil. Place the circle template over the iris and darken the circle. Create short, dark lines going inward toward the pupil. If you are drawing dark-brown eyes, you won't have to worry about this part—the entire iris is dark.

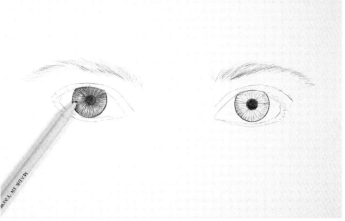

⑪ Develop the Iris

The iris has a linear quality that fans out from the pupil. Shade in the iris by drawing thin lines outward from the center of the eye. Use your paper stump to blend the lines.

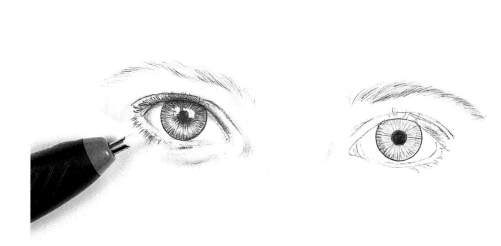

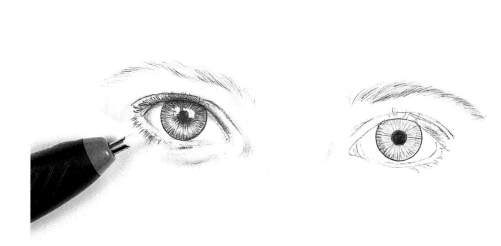

12 Add Shading; Leave Whites White

Find the areas of the eye that are white. This will be the part of the paper you leave white. That means that unless it is white, everything else (and I do mean everything) must have some shading on it. Use your pencil and paper stump to darken the rest of the drawing. Think of it as a test of lights and darks, not of shading the eye.

Using your electric eraser, lift out any highlights you may have shaded over or not yet included. Lift out the shading on a diagonal from the highlight (on the lower left side of the iris) to create the cornea. Using your kneaded eraser to lift out (tapping gently once or twice) the area diagonally across from your highlight will create the appearance of a lens.

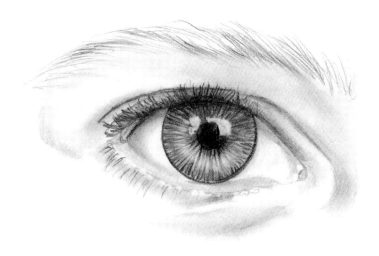

Eyebrows and Eyelashes

Eyebrows are made of short hairs. Interestingly enough, a pencil stroke is shaped like a hair; fat where it starts and tapering off into a thinner end. "Comb" eyebrow hair with your pencil—place the pencil lines in the direction the eyebrow hair grows.

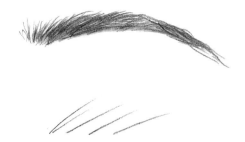

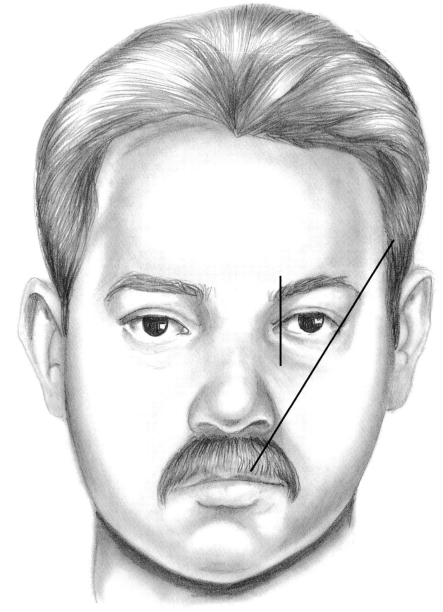

Eyebrow Location
Eyebrows vary quite a bit. Most start at the edge of the eye and end in a line that runs from the nose past the eyes.

Eyelashes
You generally won't be able to see eyelashes when you look straight on at most eyes. The exceptions to this are mascara-coated lashes and very heavy, long lashes. The lashes come forward and curl upward, appearing as a ragged edge. One way to imply long lashes is to place their shadow into the highlight of the eye.

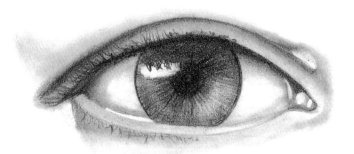

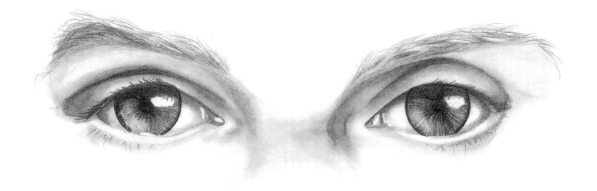

Eyebrow Shape

Eyebrows may curve, be straight, close to the eyes, have a bend in them or arch high or low.

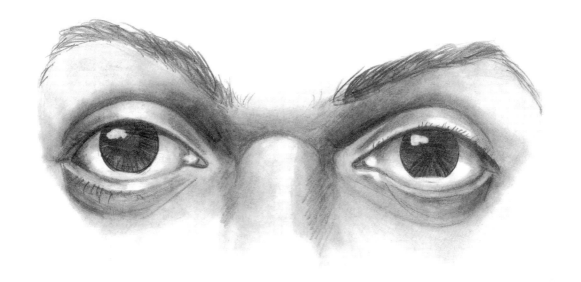

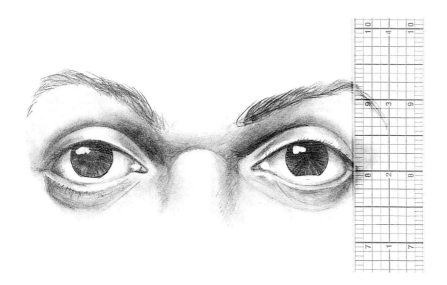

Use Your Tools!

Once again, use the tools for "seeing" that you have learned about in the past few chapters. Eyebrows have a site that you can determine by measuring. As shown here, place a ruler next to the eyebrows to see their incline. Then use the eyes to relate the location of the curve of the brows.

Drawing Glasses

Drawing glasses doesn't have to be a nightmare. Following are some ideas that will help you—and they're cheaper than buying your child contacts because you can't draw glasses.

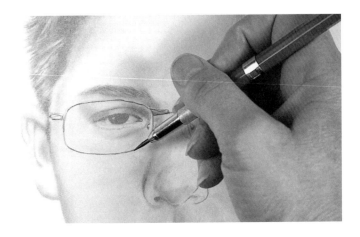

1 Sneaky Idea: Trace

If you are drawing a child who is looking directly at you, it can be difficult to make both sides even. Get one side the way you want it, then trace it on tracing paper.

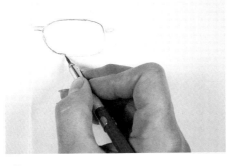

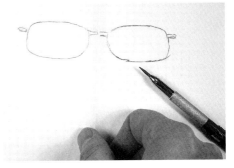

2 Fold

Fold the tracing paper in half at the side of the glasses that form the nosepiece.

3 Trace Again

You can see through the tracing paper and hence see the side you've drawn. Trace it.

4 Open

Open your tracing paper. You have drawn matching sides.

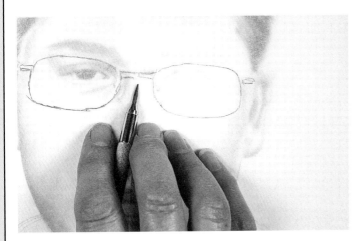

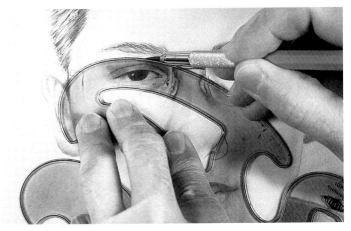

5 Trace Again

If you place the tracing paper facedown on your drawing, you can trace over the glasses you've sketched and the graphite will transfer to your drawing.

6 Add Final Touches With a French Curve

Glasses are mechanical items; that is, they have a man-made, symmetrical appearance. To achieve this look, you'll need to use French curves. Which French curve you choose depends on the shape of the glasses. Most French curves come in a package of three of the most common curved shapes. The different curves may be placed over the glasses in the photo to determine the closest match. I sketch the glasses first, then use the French curve to clean up my edges and curves.

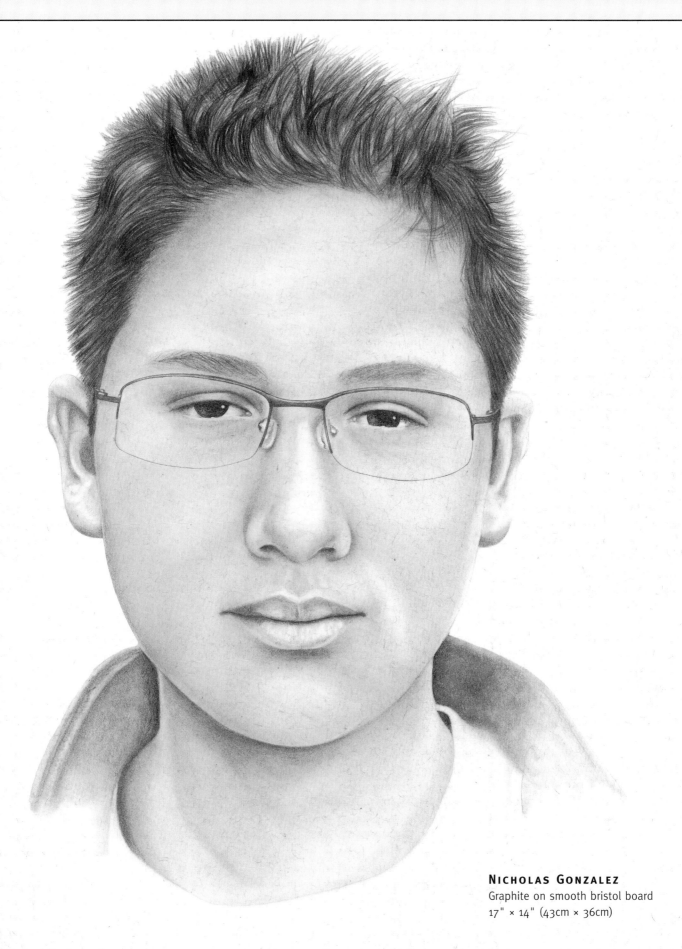

NICHOLAS GONZALEZ
Graphite on smooth bristol board
17" × 14" (43cm × 36cm)

Know Your Nose

Once again note that noses are shapes. As seen in the illustration, the nose shape is created from two rounded shapes: the ball and the column. The nose is not created from lines.

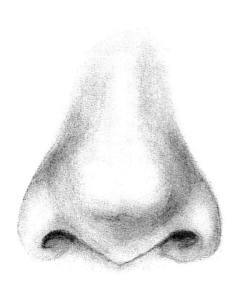

The Button Nose
The younger the child, the shorter the nose and the less shading that is required to create the shape. The important parts of the nose are the shapes of the nostrils, the tip and the wings (see page 92).

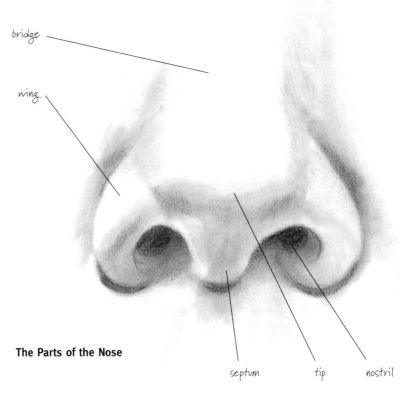

The Parts of the Nose

bridge

wing

septum tip nostril

Practice Casts
As you're learning how to proportion and shade the facial features, you may want to invest in some practice drawing casts. Notice how lighting changes the appearance of the nose.

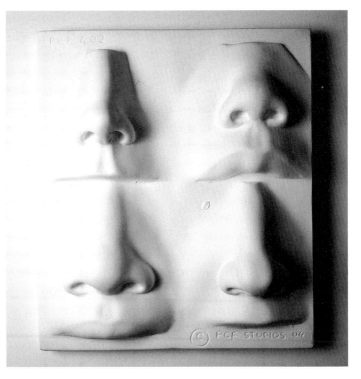

Nose Site

Note: I am referring to the average nose in the following description.

The site of the nose is contained within a rectangle that begins in the forehead. It is as wide as the inside corner of the eyes on the female face (shown on the bottom left) and the start of the white of the eye on the male face (shown on the bottom right). Most people make the nose too long and too narrow. This is because the nose causes the artist to overrule what he or she really sees and perceives to be true. The nose starts in the forehead, but artists really don't pay attention to it until it is level with the eye. They therefore draw the nose the correct length from the eye down to the tip, not from the forehead, and the resulting nose is too long. Most books also show the male nose as too narrow—the width of the nose on the female face. Male noses are wider.

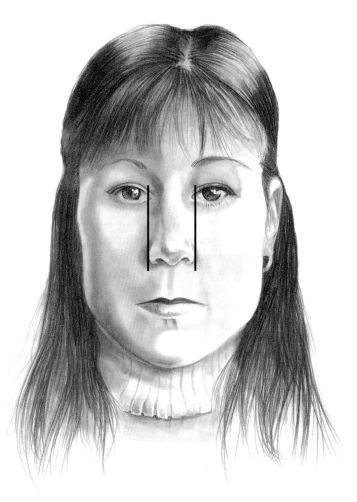

Female
Notice how the width of the nose begins at the corner of the eyes.

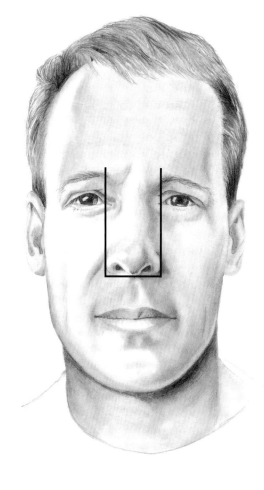

Male
The width of the nose is bigger; it starts at the white of the eye.

Wing Site

The wings of the nose are about one-third the height of the nose, if you measure from nose tip to the top of the eyebrow, as shown in this drawing.

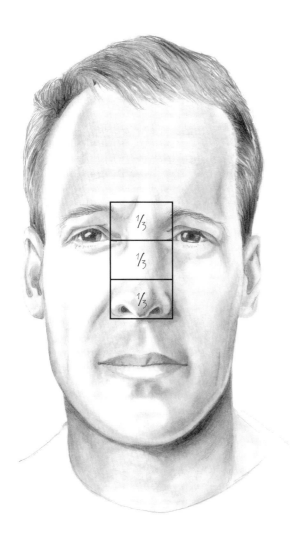

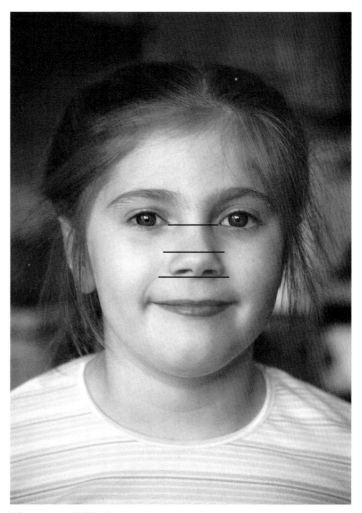

Wings on a Child's Face
The wings of the nose on a child's face are often half the distance between the bottom of the eye and the bottom of the nose.

Nostril Basics

To get the hang of the nose (if you pardon the expression), study the nostril area. OK, so art isn't as glamorous as you once thought. The size and shape of the nostril help define the shape of the tip of the nose. The more the nostril shows, the more the tip of the nose tends to tilt up; the less the nostril shows, the more the tip of the nose tends to turn down. On some people, you cannot see the nostrils at all.

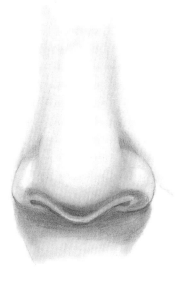

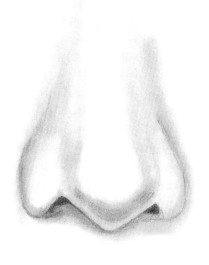

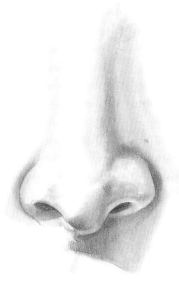

Nostril Shapes
The nostrils have differing shapes. Some nostrils are round, some are more triangular and some are quite oval.

Pssssst!

You've looked at the tip of the nose. Now study the start of the nose, the bridge. The nose begins in the forehead. I know that may seem obvious, but I have seen some drawings where the nose is connected to the eye. Some noses are on the same plane as the forehead. Some noses dip inward at a point below the eyebrows, while others are very flat across the bridge or protrude like the bow of a ship. Artists create all the shapes of the bridge of the nose by shading.

Nose Tricks

If you identify the shape of the nose highlight, find where the nose picks up the most light and "read" the nose as a series of lights and darks, you will have correctly shaded the nose... up to a point. There are a few tricks to make your nose look more realistic. Many of these tricks involve not drawing the photograph exactly as you see it but adding or subtracting details. The tricks are:

- Seek reflected light.
- Watch the level of nostril darkness.
- Avoid lines.
- Ask yourself questions.
- Link to other features.

Now, look at the man's face again and see if you can you use these tricks to help you make the nose look more realistic.

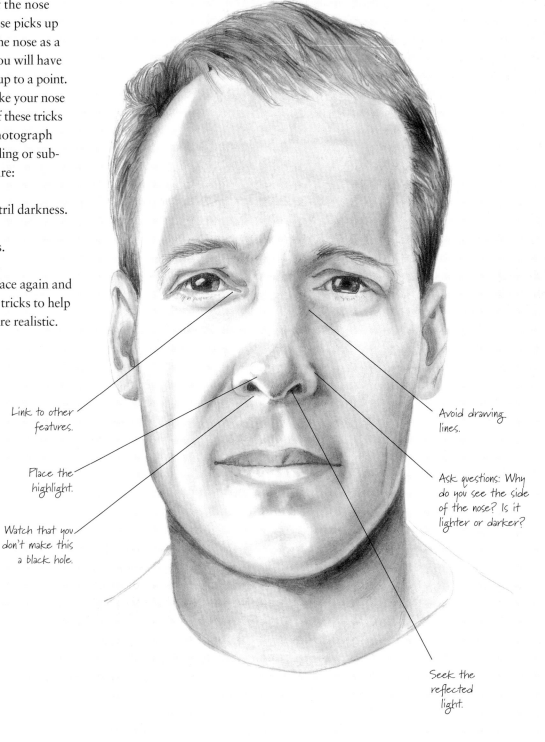

Link to other features.

Place the highlight.

Watch that you don't make this a black hole.

Avoid drawing lines.

Ask questions: Why do you see the side of the nose? Is it lighter or darker?

Seek the reflected light.

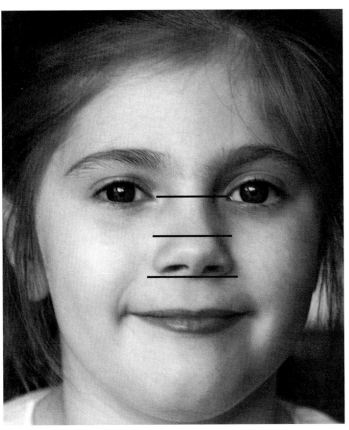

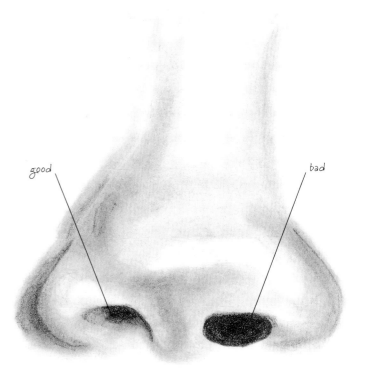

Find the Highlight

In chapter three we worked on the shading process. Now we'll start to apply those lessons. First, find the lightest part of the nose. Keep it as light as the paper (meaning everything else must be darker than the highlight).

Watch Your Darks

Although the nostril looks like a round, dark hole, don't darken it as a solid, black circle. Color the top of the nostril the darkest and gradually get lighter toward the bottom.

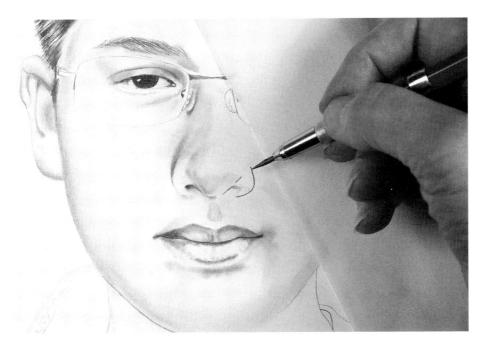

Remove Lines

Although you'll draw lines to show where the outside of the wings will be, you'll need to blend the lines so that they don't show.

Boxing In the Nose

Draw a box to contain the nose. Draw it the correct size and place it in the proper area on your drawing. Trust the size of the box. Many of my students figure the nose can't possibly be as large as the box they've drawn, so even though the box is correct, they still draw the nose too small. This is because the line drawing of a nose appears much broader than the finished drawing. After the shading is added, the nose becomes more narrow. Let's practice.

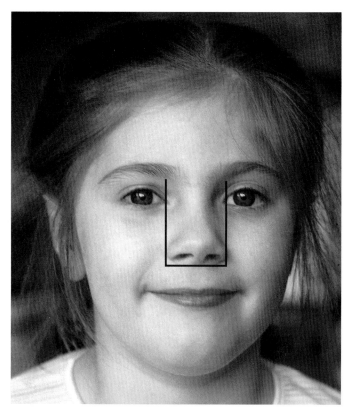

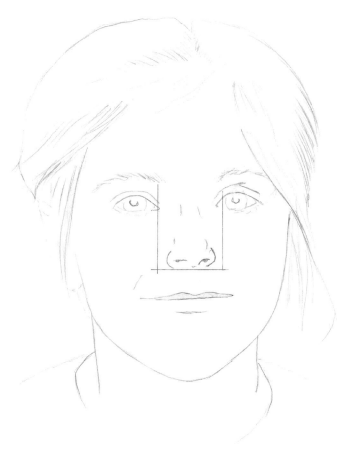

Reference Photo
Create a box around the nose to help draw it proportionally correct.

① Create a Roundish Shape

Use a lot of lines. My exampleis more oval, but it will become round.

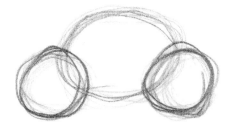

② Add Two More Roundish Shapes

Your drawing should look a bit like a Volkswagen with big tires.

③ Add Nostrils

Weave a pair of nostrils through the round shape. Think of the letter *M* with very rounded ends.

❹ Move up to the Forehead

Create the shape of the part of the nose that continues up to the forehead. I've used a series of scribbles that curve.

❺ Begin Smudging

Using your paper stump, smudge in the same circular shape that you originally sketched. Leave the center white to create the highlight.

❻ Smudge the Wings

Move down to the wings of the nostrils. Smudge in the same circular strokes used to create the wings.

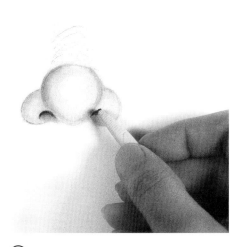

❼ Create the Nostrils

The nostrils here are round, although nostrils may be oval or somewhat triangular in shape. Younger children's nostrils tend to be rounder than adult noses, then develop as the child ages. Darken the top using a tortillion (above) or a soft-leaded pencil (2B–6B) and blend downward. Don't color the area totally black.

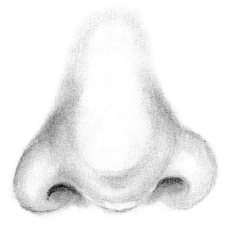

❽ Back to Smudging

Blend the sides of the nose by smudging and using the rounded strokes you created as you worked your way up to the forehead. Notice how the nose has a rounded look due to the shading direction?

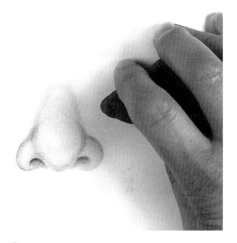

❾ Smooth the Nose

Use your eraser if the nose looks a little too round at the tip. Erase the rounded top of the nose to remove some of the bulbous appearance, and add more dark to the top of the wings.

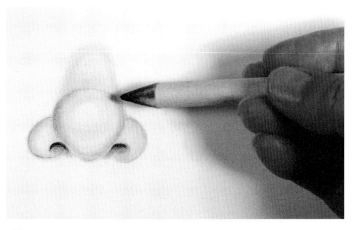

10 Make the Nose More Prominent

Add a bit of dark to the tip and move the shading in to make the nose appear more pointed and prominent. Do you see the hint of reflected light at the base of the nose?

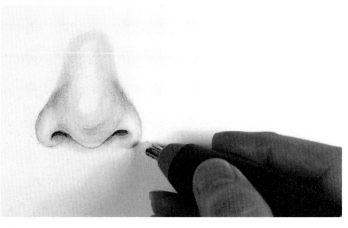

11 Flatten and Narrow the Base

Use your electric eraser to flatten and narrow the base of the nose by erasing the outside of the wings.

12 Refine the Nostrils

It is easy to refine the shape of the nostrils in these final stages. Change the rounded bottom of the nose by the nostril from a curve to more of a "V" shape to alter the appearance of the nose.

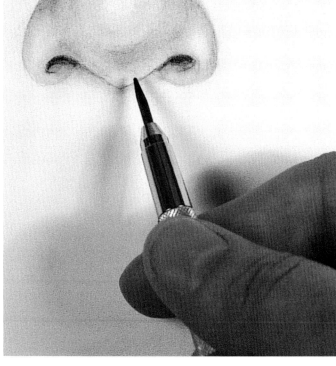

Ring Around the Nosy

The nose I've created is very round and bulbous at the tip and may not be exactly the shape you are seeking. You can alter the shape of the nose by moving lights and darks, or subtracting shadows.

The Nose in Profile

Children's noses in profile often turn up at the end. As they age, they turn a bit downward. The angle of the nose is important to get right. Capturing a child's likeness necessitates paying attention to the smallest details such as this.

The wings of the nostrils of an adult nose should appear above the columna (the column that divides the nostrils).

Nose Placement

The placement of the nose remains constant regardless of the angle from which it is viewed.

When we view the face from the front, the sides of the wings should line up with the inside corner of the eye.

Turning the face to profile doesn't move the nose. Notice that the back of the nose needs to be in front of the eye. One common problem I see in profile noses is that artists tend to place the back of the nose in line with the center of the eye. This makes the nose too large and is incorrect.

Children's Noses Turn Up in Profile
A single line drawn on the photo will help you see the correct angle.

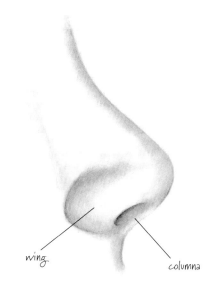

The Wings Should Appear Above the Columna
The wings are short, curved shapes that wrap around the nostril.

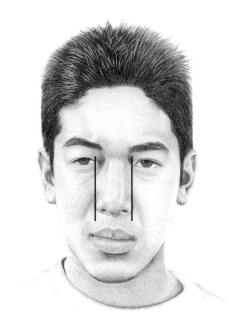

From the Front

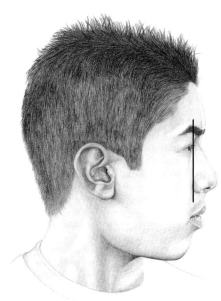

From the Side

Parts of the Mouth

The lips can be divided into three major areas of concentration: the upper lip, the line where the lips come together and the lower lip.

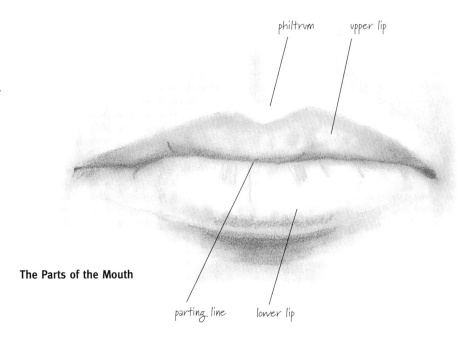

philtrum upper lip

parting line lower lip

The Parts of the Mouth

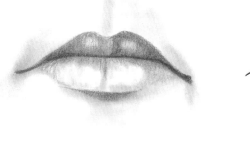

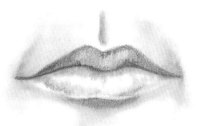

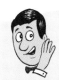

Pssssst!

The younger the child, the smaller (in width) the lips are on the face. As the adult teeth erupt, lips grow wider and often the small "bump" in the center is stretched out and flattened.

OK, So the Face Has One Line...

I usually start with the line of the mouth. Yes, the mouth is one of the few facial areas that actually contains a line. It is formed from the upper lip and lower lip touching each other. Pay particular attention to this line. Does it go up or down at the corners? Is it straight or wavy? Use a ruler to help you see the direction.

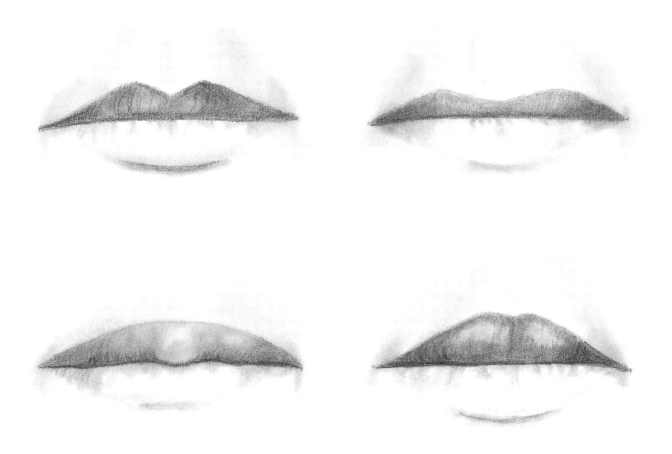

Upper Lips

The upper lip is like a mountain range with two mountains. Some people have rolling hills, some have the Rockies and some have the Himalayas. Pay close attention to the location and shape of the two points of the upper lip.

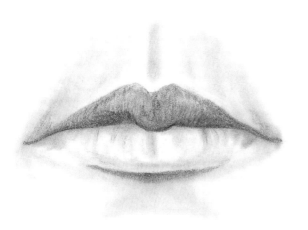

In the Groove

The top of the two mountains come to a point at two ridges that extend up to the nose and form a rounded groove called the *philtrum*. Some people have a pronounced philtrum, while on others it is slight.

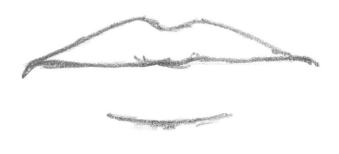

The Lower Lip

The lower lip may be equal in size to the upper lip or smaller or larger. Use caution in indicating the lower lip.

Shading the Mouth

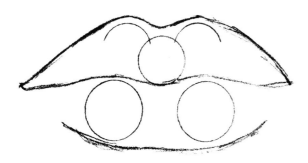

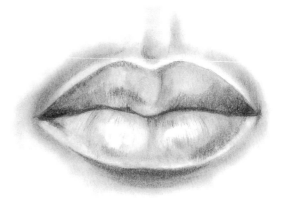

Don't Drop the Ball

We could, in a manner of speaking, say that the lips contain "five balls," that is, the lips form rounded shapes. These shapes may not appear in many mouths, but if you are sensitive to them, you will seek them when you shade the mouth.

Correct Shading

Though upper and lower lips are about the same shade, artists usually shade the upper lip darker than the lower lip. This will help differentiate the two lips and add to the illusion of depth in the work.

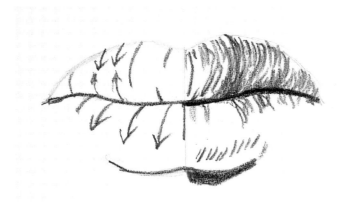

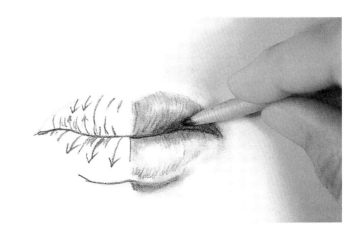

What to Look For

Within the lip there are small lines or grooves. Use caution here, as they are usually subtle. Shading in the direction of the lip structure will help you define the roundness of the lips.

Think of a Pumpkin

Consider a pumpkin when you shade the mouth. The ribs of the pumpkin help define its roundness. The "ribs" of the mouth help to define the roundness of the lip. This concept of shading something while thinking of the roundness of a pumpkin, is the same for shading mustaches, hair and other features.

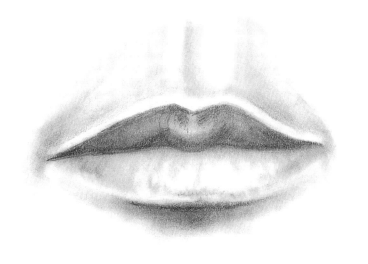

Lip Rims

Around the mouth you might see a lighter area caused by a lip rim. This is a narrow area where light is captured around the mouth.

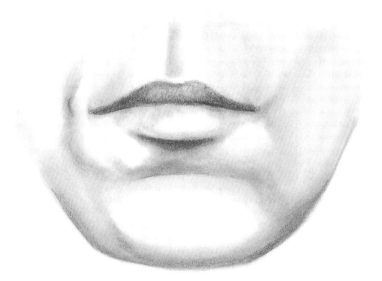

Other Mouth Shapes

The mouth forms a barrel, or rounded shape, over the teeth. There may be pouches and dips of lighter or darker areas caused by the shape of the underlying teeth, jaw and muscles.

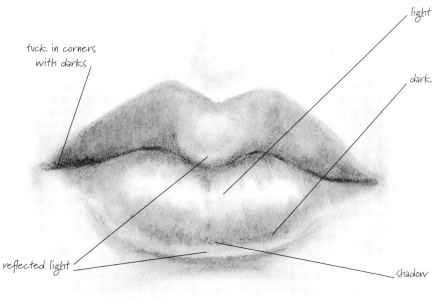

tuck in corners with darks

light

dark

reflected light

shadow

Full Lips

Children often have fuller, shinier lips than adults. To achieve this, think about what it takes to make something look round. The pattern is the same: light, dark, light, dark.

Dealing With Teeth

Drawing teeth seems to cause a great deal of grief to some budding artists. This is usually due to the "picket fence effect." They draw each tooth as a separate shape and place hard lines between the teeth.

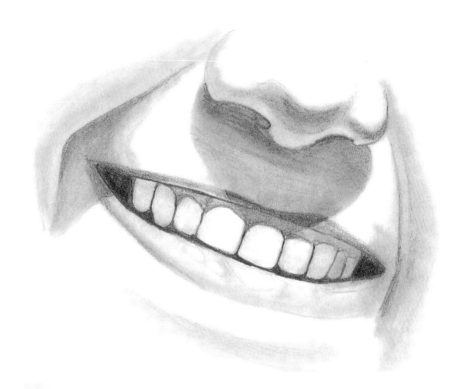

Don't Fence Them In
If you emphasize the separations between each tooth, your drawing of the mouth becomes distracting and unrealistic.

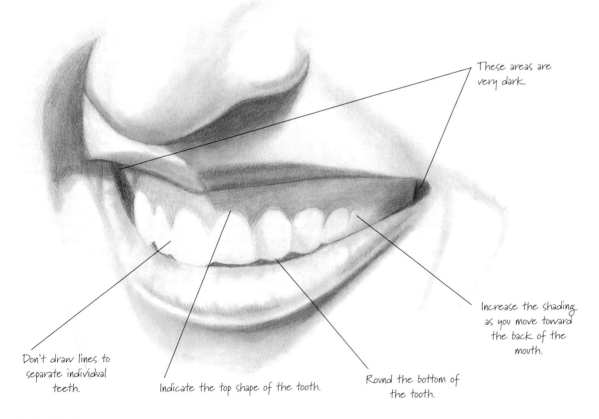

These areas are very dark.

Increase the shading as you move toward the back of the mouth.

Don't draw lines to separate individual teeth.

Indicate the top shape of the tooth.

Round the bottom of the tooth.

Gently, Gently
Think of shading teeth as gently indicating the location and shape of teeth, rather than pounding out the details of each tooth. Don't floss the teeth with your pencil. Gradually shade the teeth darker as they go back into the mouth. Then indicate the gum line, add shadows to round the teeth and call it quits.

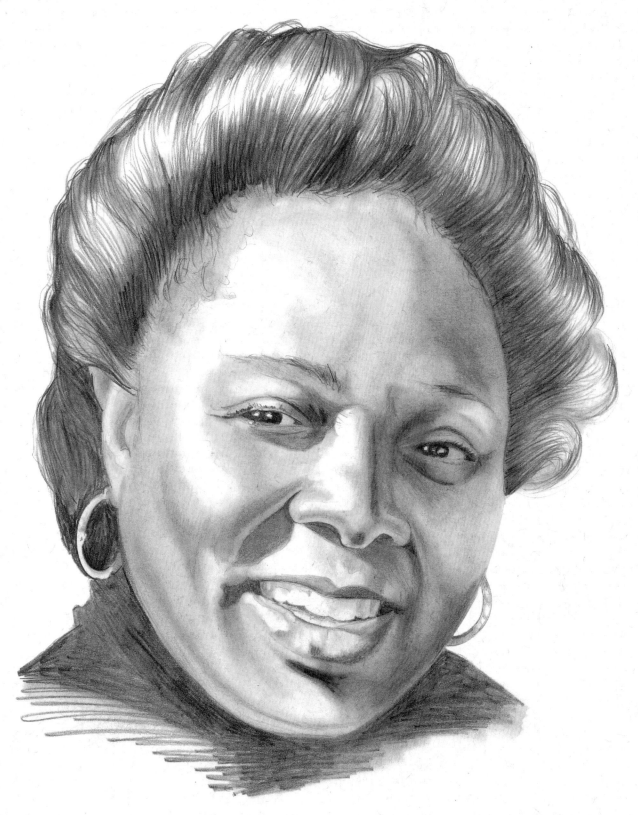

Smile Changes

When a person smiles, not only does the mouth change size and shape, the entire face becomes involved. Eyes pucker, cheeks bulge and the nose broadens and flattens. There is no hard-and-fast rule as to what changes take shape within a smiling face. The important part is to draw what you see using the tools provided.

DETECTIVE CAROLYN CRAWFORD
14" × 11" (36cm × 28cm)

The Lips in Profile

Three common problems in drawing
profile lips include length, shading and
angle. Let's take a look at these issues.

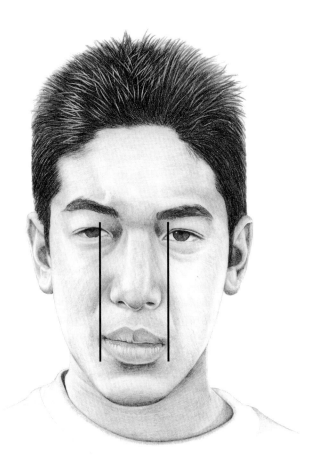

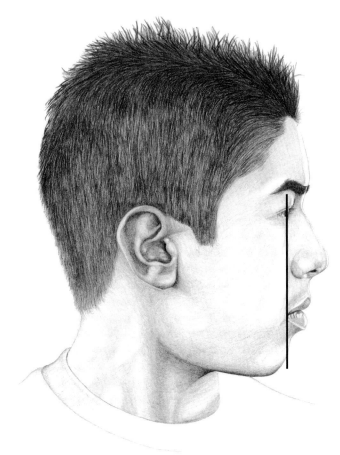

How Wide Is Your Mouth?
A child's mouth is smaller from side to side and grows wider as the
adult teeth fill in.

Where Does It End?
In profile, the mouth should end long before you reach the eyes
in young children. As the child grows older, the lip will be longer.

Round Lips
You'll want the lips to have a fullness, so be aware of the roundness of the lips.

Angled Lips
Generally, for both adults and children, the top lip sticks out a bit farther than the bottom lip. A quick application of a vertical ruler will help here.

Drawing a Smile

Smiles usually show off teeth (with the exception of babies, which usually display gums and perhaps drool). The toothy smiles of children are often half baby teeth, half adult teeth, missing or covered in braces. They almost always end up looking like a picket fence if not drawn carefully. Let's draw a mouth now.

① Use a Reference Photo for the Right Location and Shape

To ensure you draw the shape of the mouth correctly, draw a horizontal line on the photo just above the corner of the lip. Check to see if the corners of the mouth go up or down. Align the width of the mouth to the eyes. Double-check your drawing by measuring.

② Sketch the Mouth

Sketch the mouth based on your measurements, then count the number of teeth you can actually see. Don't throw in a mess of teeth to fill the space. Observe which teeth are longer and larger and fill them in accordingly.

③ Erase!

Most of the time, the lines you've sketched for the teeth will be too dark. You want to imply the division between teeth, not perform a root canal with your pencils. Erase a portion of your lines and lighten, then lightly shade them in again. (If you're drawing widely gaping teeth, ignore this step.)

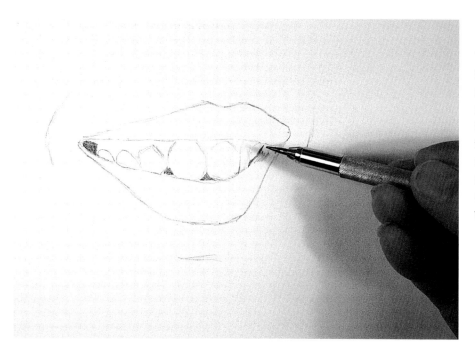

④ Add Shading

The values (relative lights and darks) around the teeth and lips tend to be very close, but they're not the same value or you wouldn't see where the gums end, where the lips begin or the roundness of the lips. If there is a shine on the lips, that will be the white of the paper. We need to place the darkest dark so we have a full range of values. Often the darkest area is in the corners of the mouth. By shading in this dark, you are starting to form the back rows of teeth.

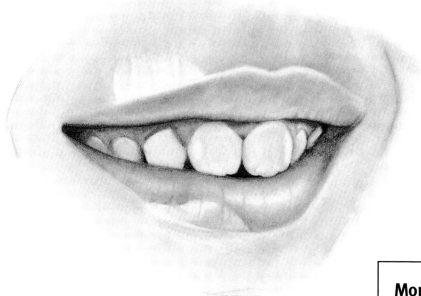

⑤ Adjust

Between the shiny white for the lips and the back corners, everything else is shaded. Ask yourself why you can see something—is it because the lip or gum is lighter or darker than something next to it?

More Smiles

BRACE YOURSELF

Maybe your teen doesn't appreciate his or her braces, but there's no reason to wait for them to come off to draw that face. Notice that braces are actually areas of light, shiny metal, which means you need to darken the teeth so that they will show.

PICKET FENCE

There is a stage in a child's life when the baby teeth fall out and the adult teeth emerge. At this time, the spaces between the teeth resemble a picket fence. You simply draw and darken them.

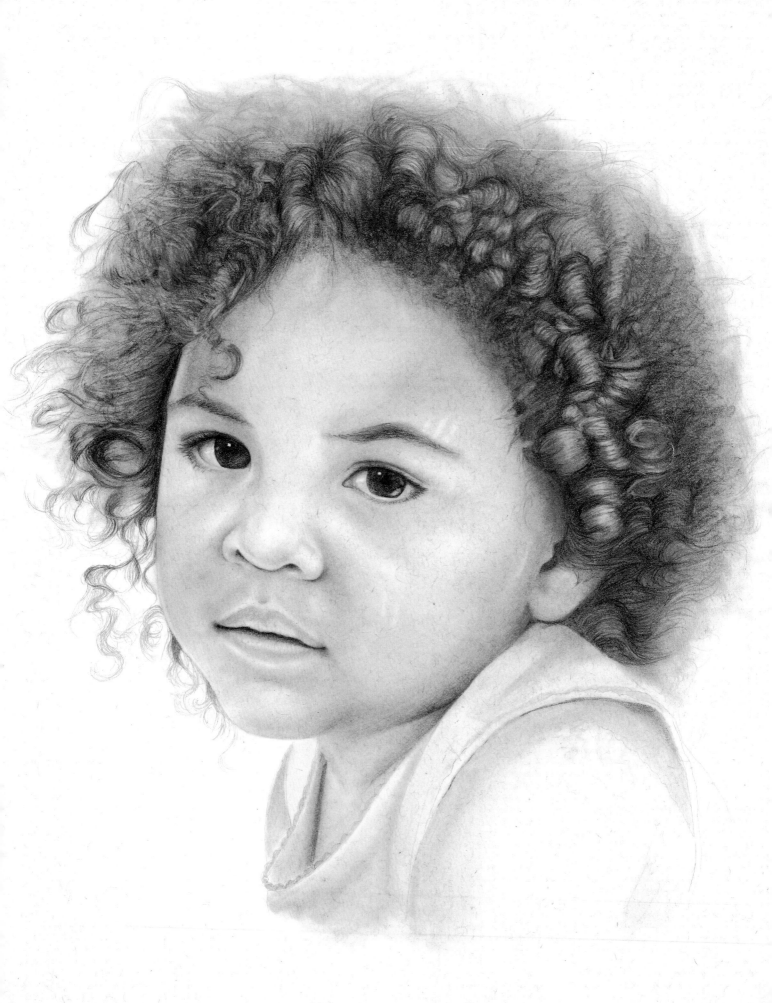

Drawing
Realistic Portraits

U p to this point, we've looked at different facial features, examining their shapes, how to shade them and how to proportion them on the face. We've also explored some rules of thumb for drawing in general. But that's just a start. Our drawings should be more than just the rendering of accurate facial features on a correctly proportioned face. We want to show the personality; the essence of the child or grandchild. We want others to glimpse in our art the lovable, clownish, whimsical or impish nature that makes that particular child special.

In this chapter, we'll put it all together to create drawings of children that are more than portraits. As Rick and I worked through the various "major" drawings in this book, we photographed the steps we took in drawing. You'll see many applications of the different points we've made throughout the book.

CHIARA MASK
16" × 13" (41cm × 33cm)

The Structure of the Head

I have developed a different attitude toward drawing heads ever since I completed a facial reconstruction class by Betty Pat Gatliff. This remarkable woman has spent years teaching (and creating) three-dimensional facial reconstructions. She sculpts with clay directly over the skulls of unidentified people, as shown in the drawing. Handling skulls, even if they're plastic ones you can purchase through art supply stores, is a wonderful way to understand the structure of the face.

Egghead

Generally speaking, people's heads are egg-shaped. The bones and muscles of the face combine to create many different appearances.

Location, Location, Location

Although faces differ with the underlying bone structure, I seek certain points on the face where "something happens." For example, I know that if the person has prominent cheekbones, the bottom of their cheek will be even with the base of the nose. This is not always the case, but it is an example of certain parts of the face that I check.

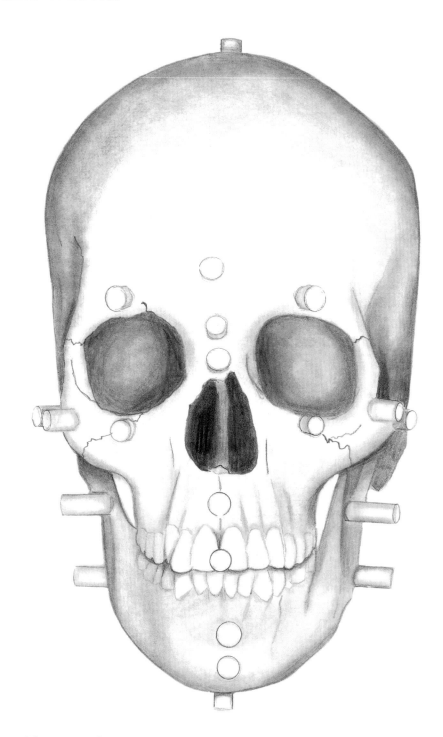

Facial Reconstruction
Forensic artists have a number of duties, including facial reconstruction or approximation. They start with the skull of an unknown person and attach tissue-depth markers made from an electric eraser (as seen here). This provides the outline of the face.

The bottom of the cheek occurs at the base of the nose.

If the face has hollow cheeks, they tend to occur in this area.

The jaw will generally angle in to the chin below the level of the mouth opening.

The top of the cheek is below eye level.

The chin tends to round at the outside corners of the mouth.

The Parts of the Head
Here are a few areas to seek out before you begin to draw any face; you can expect "something to happen" in each of these locations. Knowing these points and how they influence the appearance of the facial features will give you a great jumping-off point.

Cheeks

Cheeks may be prominent, average or sunken. The cheeks generally start below the eye and end near the bottom of the nose.

Prominent

Sunken

Chins

On average, the lower face tends to be divided into three parts between the base of the nose and the chin. The first part is between the nose and the opening of the mouth. The second section is between the mouth opening and the deepest point on the mandible (lower jaw). The third section is between the deepest point on the chin and the bottom of the chin. A chin may be long, short, rounded, square, pointed, double, protruding or receding, or it may have a cleft.

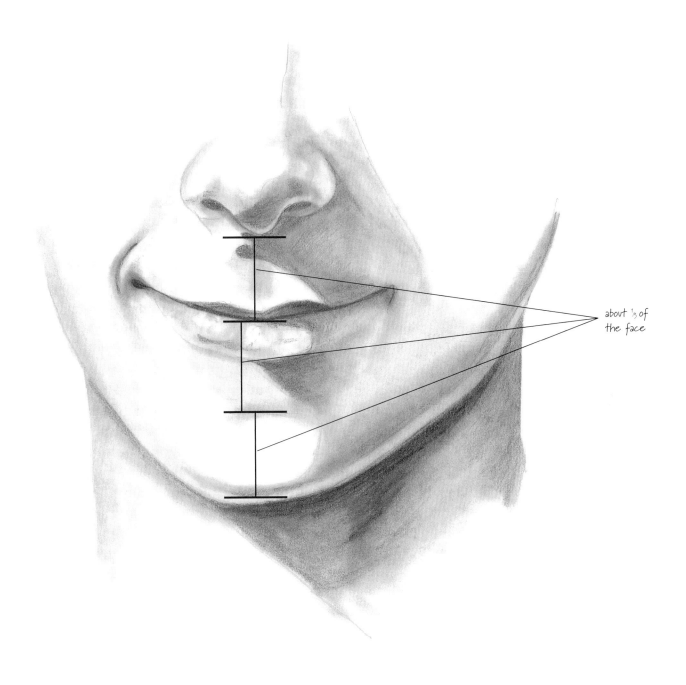

about ⅓ of the face

Necks

Like other parts of the face, necks vary in size and shape. If there is a common mistake that artists make, it is in making the neck too long and thin. The neck begins at the shoulder area and attaches at the chin, but it doesn't end there. It continues up to the ear area, although we usually don't see the entire length when we look at a person straight on. Therefore, check that the length of the neck is in proportion to the angle you are viewing it at. (The neck will appear shorter if you look at it straight on, and longer if you view it from the back.) Clothing fits relatively high up on the neck.

Don't Stretch Your Drawing too Thin!
There is one fact that you must remember when drawing necks: You must start them at the shoulder area and continue up to the ear area. Don't forget to check that the length of the neck is in proportion to the angle you are viewing it at.

The Female Face

Female faces tend to be more narrow in the chin and jaw area and have a more narrow nose. The eyes are the same width apart as on male faces. Yet, because a female face is more narrow, the eyes may look larger in relation to the rest of the features. Also, the eyebrows tend to be higher and thinner on female faces.

Child vs. Adult Features

Children have different proportions that change as they grow older (this is especially apparent in the face). The lower face grows and lengthens with age.

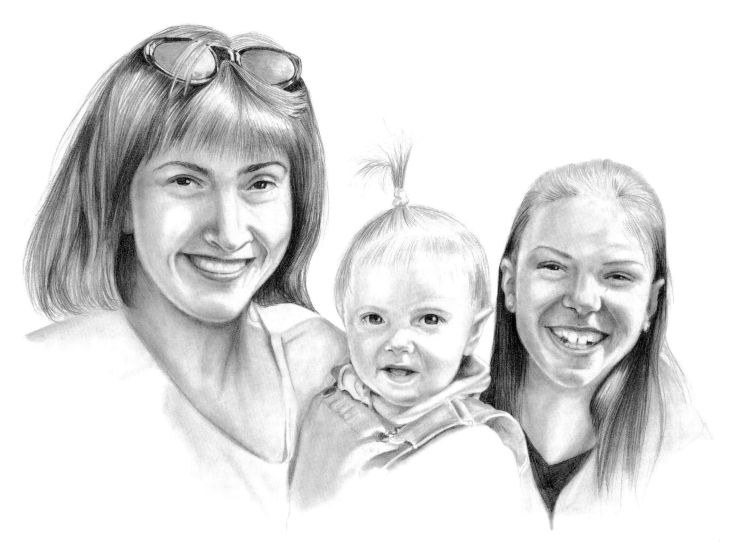

This drawing clearly shows how faces can change in appearance as the person ages. Notice how the lower face lengthens, the lips become fuller and hair tends to be less fine. Look at the illustration on the next page for more details that are specific to the faces of children.

DIANA, SHILOH AND AYNSLEE STUART
11" × 14" (28cm × 36cm)

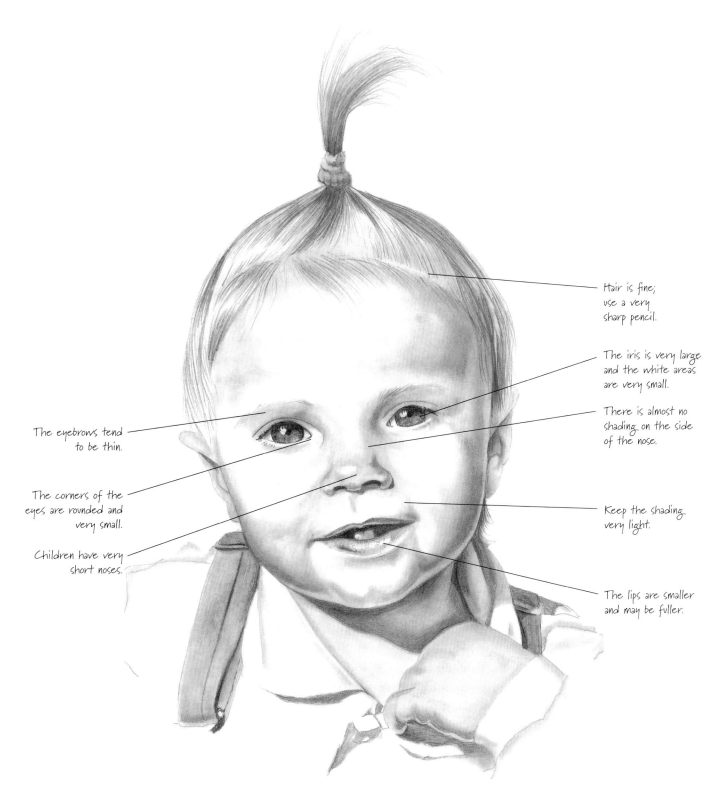

Hair is fine;
use a very
sharp pencil.

The iris is very large
and the white areas
are very small.

There is almost no
shading on the side
of the nose.

The eyebrows tend
to be thin.

Keep the shading
very light.

The corners of the
eyes are rounded and
very small.

Children have very
short noses.

The lips are smaller
and may be fuller.

Drawing a Child's Face
Many people have trouble making children look young. You need to be
aware of certain secrets when drawing the face of a child. For example,
the child's face should have very little mid-face shading—especially
around the eyes and nose—the iris is very large and the hair is fine.

Drawing Ears

Ears differ from face to face. The ear is about as long as the nose and runs approximately from the eyebrow to the tip of the nose. But these are only rough proportions—use the proportion of the ear you are viewing.

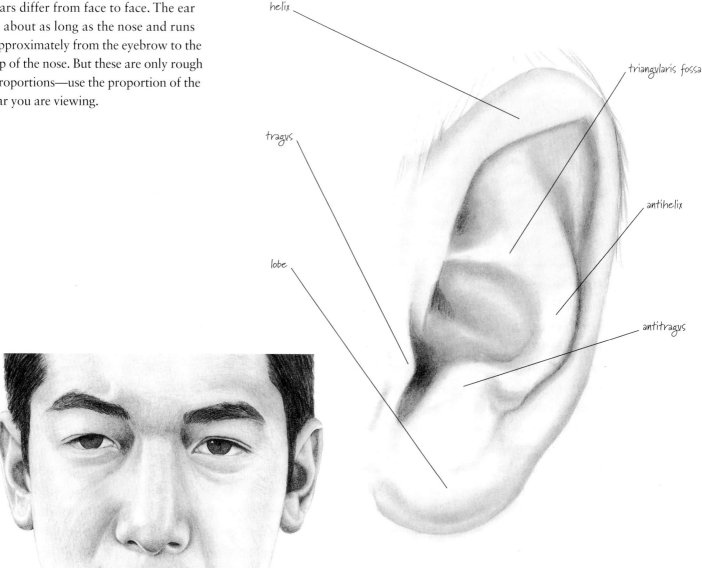

helix

triangularis fossa

tragus

antihelix

lobe

antitragus

Parts of the Ear

Ear Shapes
Although ears vary from child to child, the basic shapes of the ears remain essentially the same as an adult's. Let's practice drawing an ear.

Making Faces

Portraying a facial expression takes a drawing from mundane to delightful. You can do this by carefully observing and drawing minor details. Subtle details such as the lift of an eyebrow, the tug at the corner of the mouth, or the slight widening of the eyes are items that our weary brain needs to record. Of course, some children's expressions cannot exactly be classified as subtle.

Ear Placement

The back of the head tends to be rounded. We want to be sure the head shape is correct when we place the ears so they relate in location to the front and back of the head. Ears are not placed in a vacuum.

A common mistake artists make is to place the ear the correct distance from the front of the face, then cut off the back of the head, resulting in "flat-head syndrome."

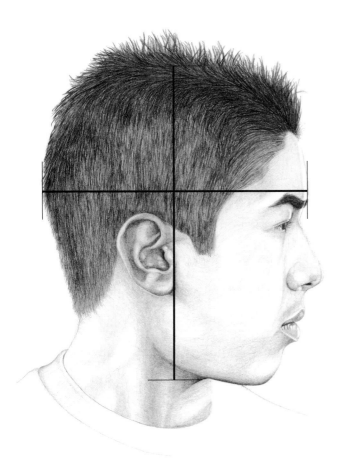

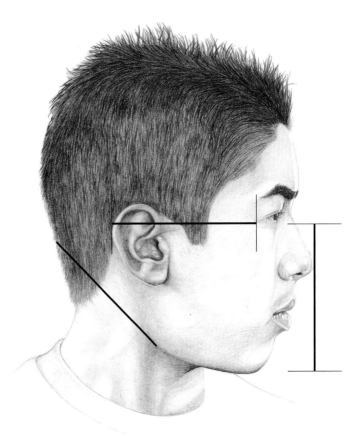

Measure to Avoid Flat-Head Syndrome
Draw a line from the top of the head to the chin, then a second line from the middle of the forehead to the back of the head. This measurement will help you avoid flat-head syndrome by giving you the correct size and curve of the back of the head.

Place the Ears
When children draw faces, they commonly line up the top of the ear near the eyebrow and the bottom of the ear at the bottom of the nose. In actuality, the distance from the back of the eye to the back of the ear is about the same as the distance from the bottom of the eye to the bottom of the chin. (Babies' proportions are different, so just use this rule of thumb for children.) The ears have a similar angle to the jaw. That is, if you drew an imaginary line up the back of the jaw, it would have the same angle as the ears. The front of the ears are in front of the line of the jaw.

Drawing Ears

Ears are not very difficult to draw. Use white plaster casts to become familiar with where you might expect to see lights and darks on a real face.

1 **Draw Half a Heart**

From the front of the face, the outside of the ear looks a bit like half a heart.

2 **Draw Another One**

Starting below the original line, create the bottom of the helix. The helix folds itself into the lobe toward the bottom quarter of the ear.

3 **Draw the Triangularis Fossa**

Draw a shape roughly like a triangle, turned upside down and slightly melted.

Psssssst!

Having trouble completing the steps? Cut a small opening in a piece of blank paper and use it to just look at one tiny part of the ear at a time.

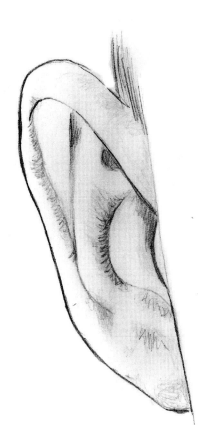

⑤ Add Shading

Use the plaster casts as reference as you add shading to the ear. Use a B pencil to apply graphite to the paper, then blend using your paper stump. The top of the ear will be lighter, as will the center of the lobe. Squint at the ear casts to see the shading more clearly.

④ Add the Bumps

Add both the tragus (pointing into the center of the ear) and the antitragus (pointing upward and often slightly forward).

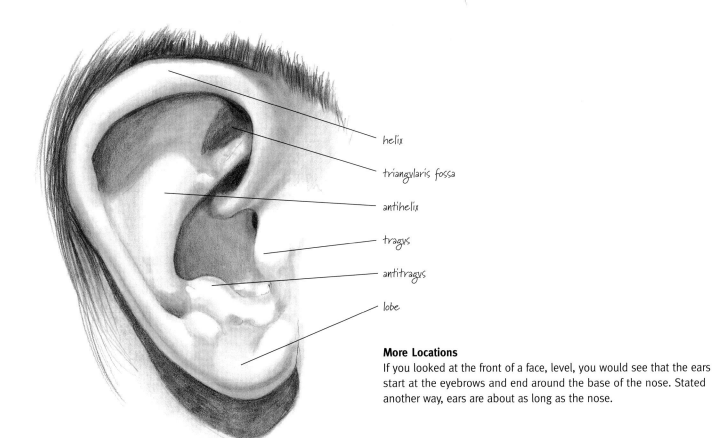

helix

triangularis fossa

antihelix

tragus

antitragus

lobe

More Locations

If you looked at the front of a face, level, you would see that the ears start at the eyebrows and end around the base of the nose. Stated another way, ears are about as long as the nose.

Drawing Hair

The items that seem to create the most difficulty, whether drawing an adult or child, are shading and hair. I find the biggest secret to drawing hair is that it takes time. You should plan to spend a lot of time on the hair because there really aren't any shortcuts.

Sharpen several pencils, because hair is fine (especially children's hair) and requires a sharp point.

- **Straight hair.** Even though the hair is "straight," make sure it conforms to the roundness of the head. Your pencil marks should follow the direction that the hair grows.
- **Curly hair.** Curls shouldn't just look like pencil squiggles. Each curl is made up of many hairs; therefore, many pencil strokes are required to make it look real.
- **Thick hair.** Where hair is thick, your pencil needs to make many, many lines to indicate this. A few lines smudged together just won't cut it.
- **Thin hair.** The secret to creating thin hair is to shade the head before adding hair so that the head shows through the hair.

Curly Hair
Curly hair takes a long time to draw. You will be "combing" each curl in the direction the hair grows. You will also want the hair to look fine and not like thick, dark pencil strokes.

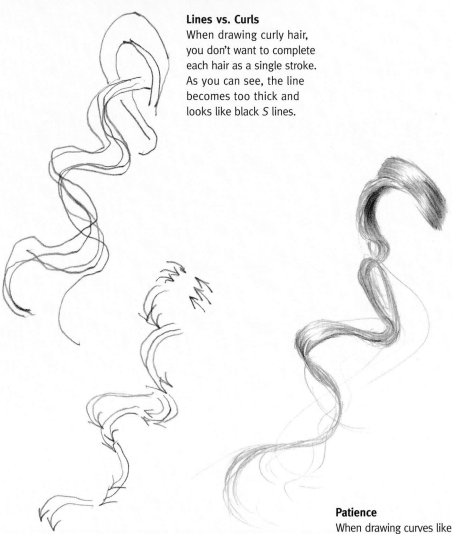

Lines vs. Curls
When drawing curly hair, you don't want to complete each hair as a single stroke. As you can see, the line becomes too thick and looks like black *S* lines.

Patience
When drawing curves like this, it will take several strokes to complete the curve to give it a hairlike appearance.

Creating Different Types of Hair

Hair may be fine, coarse, thick or thin, straight or wavy and a host of other appearances. You can draw many of these variables by varying the thickness of the pencil lead and using different grades of lead. Draw thick, coarse hair with a blunt 6B pencil. Use a sharp HB lead for fine hair. Children's hair is usually fine, so make sure your pencil point is sharp.

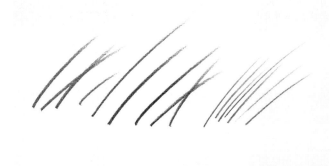

Pencil Lines
A pencil stroke is like a hair—fat at the beginning and fine toward the end.

Psssssst!

There is no secret shortcut to drawing children's hair. Just remember to:

- *Have a lot of sharp pencils on hand.*
- *"Comb" the hair in the direction it grows.*
- *Be patient.*

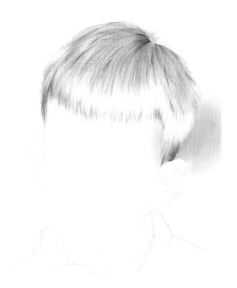

Shine
Although you can erase a shine into hair, a far better way to create shiny hair is to leave it white.

Create Feathered Ends
Lift your pencil at the end of straight hair strokes to create "feathered" (that is, hairlike) ends.

Creating Long, Dark Hair

As shown in this series of steps, use your pencil to "comb" the hair. Lay your pencil strokes the direction the hair would be growing or combed.

Once you establish the direction, start to fill in the strokes. If the hair is fine, do not try to get dark in a single layer of pencil lines. Build the darks by continuing to place more lines in the same place. Start with a very sharp 2H or HB pencil. Progressively move to darker leads (2B-6B).

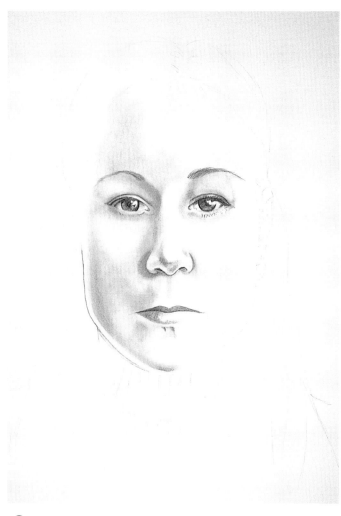

① Establish an Outline

Start by getting the basic information down on paper.

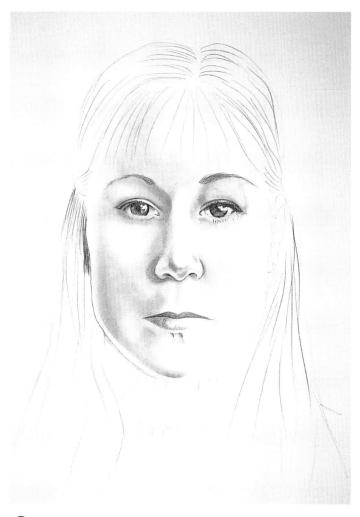

② Start to Form the Hair

Lay your pencil flat and begin to establish the direction of the hair.

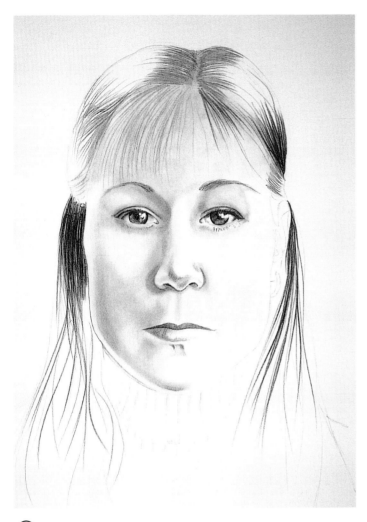

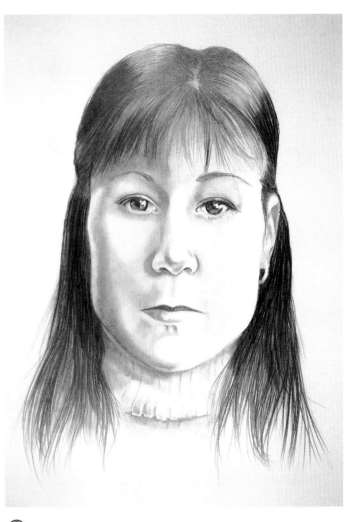

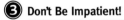 **3 Don't Be Impatient!**

Keep building up the smooth strokes. Hair takes time to accurately render.

4 Ahh... Finally Done!

The end result was definitely worth the wait! Just remember to keep building up your strokes until your hair looks complete.

GINA GAROFANO
14" × 11" (36cm × 28cm)

Building Highlights

It's better to leave space for the highlights in the hair rather than to try and erase them out. The highlight in the hair should have the end stroke of the pencil coming into it. This means you need to place your pencil lines "backward" into the highlight on the top, as shown in the next four images. Don't leave the highlight a large, white area. Place a line or two completely across the white highlight area.

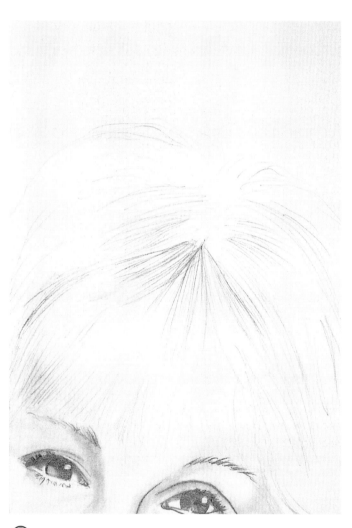

❶ Begin the Highlights

Establish the outline of the hair and highlights. Begin to place your pencil strokes back into the highlight. Remember, the end of the stroke should reach into the highlight.

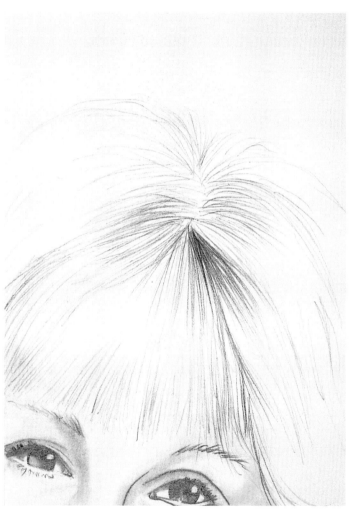

❷ Continue to Build

Keep layering the strokes and begin to establish the dark and light areas.

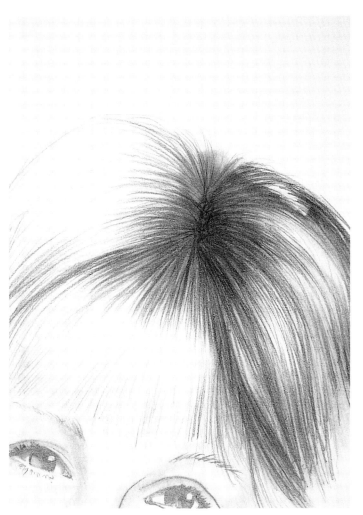

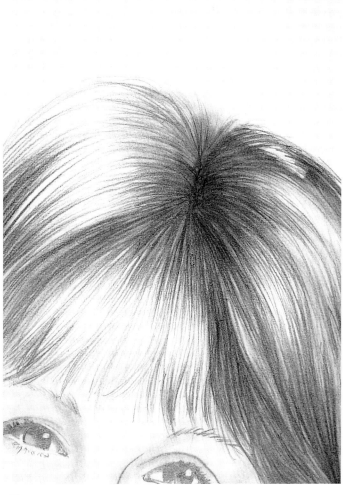

③ Don't Forget the Light Areas

As the hair becomes more defined, check and make sure you are leaving lighter areas for the highlight.

④ Anchor Your Highlights

Place a few strands across the light areas to blend them into the rest of the hair. This will help save the hair from looking like it has floating white spaces.

Drawing a Child's Shiny Hair

Let's practice by creating the shiny set of bangs shown at right.

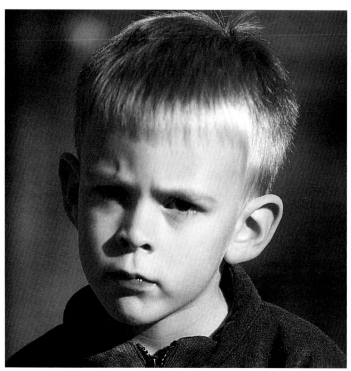

Reference Photo
Notice that the hair isn't flat on the head, but follows the curve of the head. The shine is white, so we want to preserve that as white paper. Keep your sketch light, because it's difficult to erase unnecessary lines.

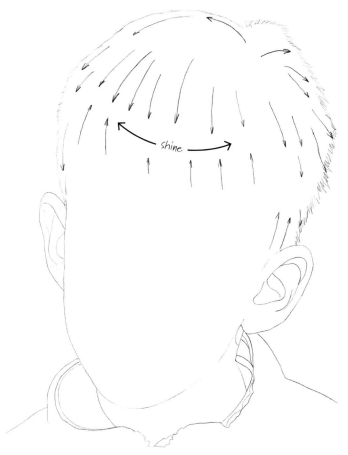

shine

① Identify Hair Direction

Decide on the direction that the hair is combed and the location of the shine.

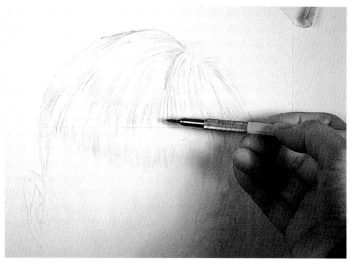

② Start Combing

Start combing the hair from the crown, lifting your pencil when you reach the area that will become the highlight.

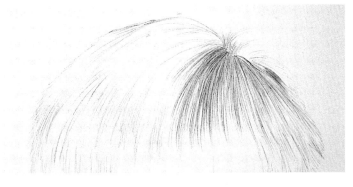

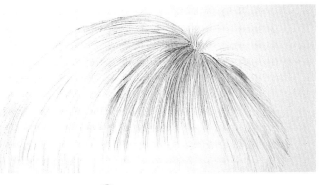

③ Keep Going!

Keep your lines smooth and close together to create a combed look. If the hair is messy, your lines don't need to be as neat. "Bury" one side of the stroke. That is, make sure you can't see both ends of your line, or it will look like a loose hair floating across the head.

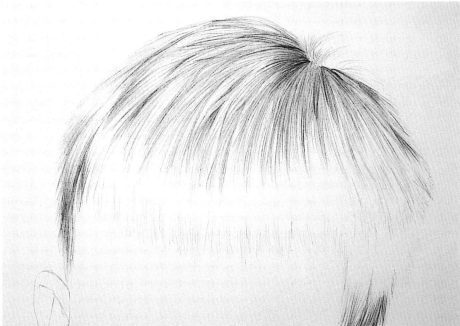

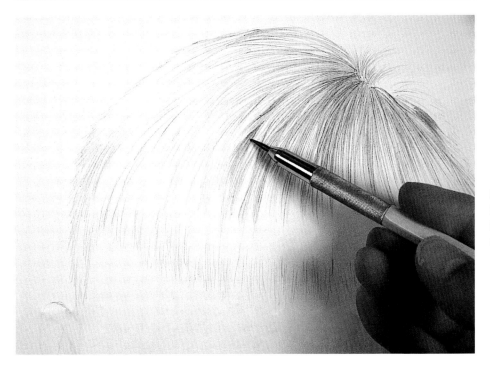

Create Depth as You Comb

Look for places where the hair crosses, forming two sides of a triangle. These areas may be darkened to create more depth in the hair.

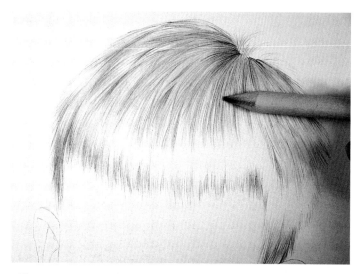

4 Blend

Fill in the white between the hairs to make the hair darker by smudging using a paper stump, chamois or cosmetic sponge. Be sure you don't lose the hair lines.

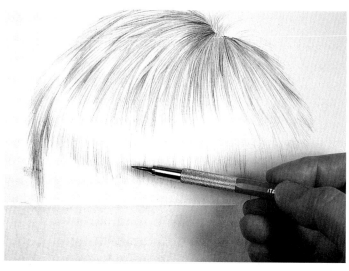

5 Reverse Direction

Reverse direction, creating the other side of the shiny area, and bring the feathered pencil stroke into the shine from the bottom.

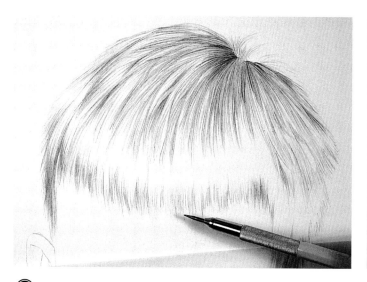

6 Reverse Direction Again

The ends of the hairs need to be softer, so bring the hair onto the forehead with yet another feathered stroke.

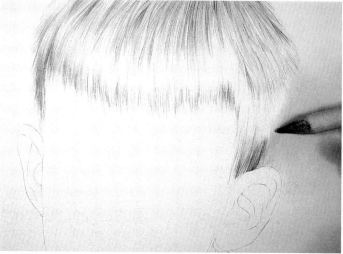

7 Darken the Background to Show Whitest Hairs

You can't make your drawing whiter than the white of the paper, so add a darker background to show white hairs. Hold the stump so that the tapered side is flat against the paper, not the tip. If you use the tip, you're putting too much pressure in too small an area, resulting in unattractive streaks. The darker the background, the more white the hairs look.

Another Technique for Creating Highlights

You learned to create the shine of bangs by leaving the shiny area white. But there's more than one way to create a highlight (though for large areas, it's generally better to use the white of the paper). You can also use a sharpened eraser to lift out hair, or you can get the exact highlight shape you want by creating a template from acetate.

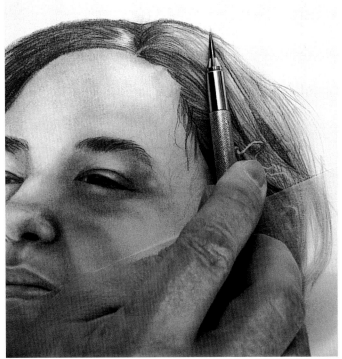

 Cut

Cut out the shape of the highlight from acetate with a craft knife. While you've got the craft knife and acetate out, cut more than one shape—fat hairs, thin hairs, straight hairs and curly hairs.

Creating Highlights and Dull Areas
This hair proved challenging because it had shiny areas as well as fuzzy hairs. To resolve the fuzzy-hair challenge, Rick used the side of his 6B pencil rather than the tip. This created less crisp, but smooth, defined hair.

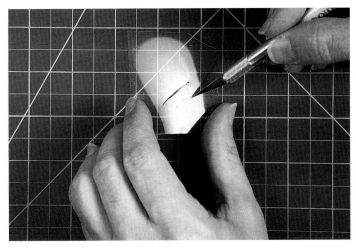

2 Erase

Place the acetate shape over the hair and erase through it. The template may be reused or used as a positive-shape template (a template where the cut out area forms a shape, such as a hair).

Sources of Acetate to Make a Template

- *Clear, thin report covers*
- *Transparency film for overhead projectors (the thick kind)*
- *Presentation sheet protectors*

Clothing

I confess: I like to draw faces, but I don't like drawing clothing. OK, I've said it. It's probably because my college instructors placed white sheets, artfully draped, on a table and told us to "draw!" Sheets are something you sleep on, not draw. Having said that, it's still something you need to learn to draw—clothing, that is, not sheets.

In all fairness, the white sheets taught us to see subtle shading while they were draped over various forms, giving shape to the form they draped. Let's look for a moment at what these white sheets can teach us.

Shading Sheets
Like the pattern found on the white shapes described in chapter four, fabric has a light-dark-light-dark pattern that gives it roundness.

Form and Texture
Clothing drapes on the child's body, giving form to the shapes underneath. Pay close attention to the direction of the folds of clothing.

Another factor to consider in drawing clothing is the texture of the material. The texture of wool differs from that of denim. Keep in mind that you can simplify a pattern found on clothing if you choose. Just because the fabric has teddy bears or small flowers on it, doesn't mean you have to draw it.

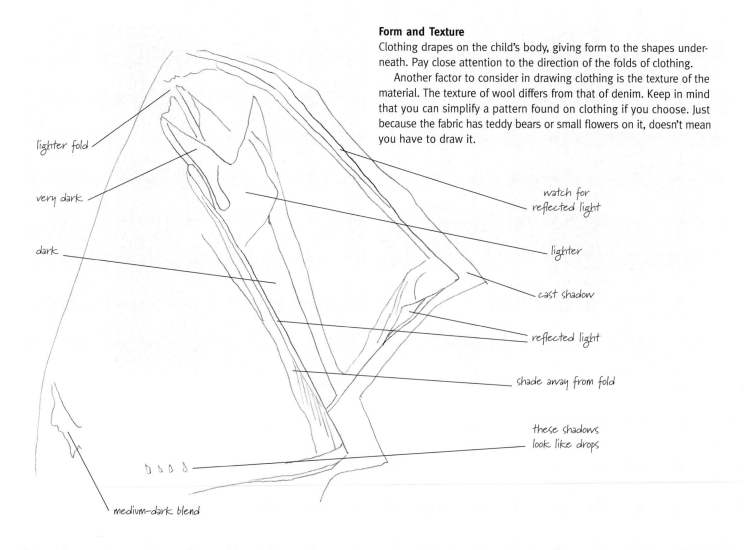

lighter fold

very dark

dark

medium-dark blend

watch for reflected light

lighter

cast shadow

reflected light

shade away from fold

these shadows look like drops

Using Props

You can draw any photo you already have, sketch from life or stage a photo you'd like to draw. In creating this book, we used a few photos sent to us by friends, but we snapped most of the photos ourselves. The older children were wonderful to work with, but there were some challenges with the young ones. One way to get a young child to relax is to have them interact with a prop—maybe hold their cat or dog, or smell the flowers in the garden. Here we share with you a few of our prop disasters.

Cole and Skylar Lindsey
This seemed like a good idea, but they look like they're behind bars.

Renee Ortega
The cat was fine for a bit, but grew tired of holding his smile. A people-friendly pet is the best choice for posing.

Cole Lindsey
Cole is watering a plant. Those are his fingers.

Shadows and Light

It took two rolls of film and a lot of screaming at my camera to come up with this photo. My nieces were either posing like deer in headlights or were a blur of activity. When I finally got the shot I wanted, the lighting was very dark. That meant that the area below Shilo's face was dark, as was her hair on one side.

When drawing a darker subject, the secret is to draw what you see. That is, if you don't see a detail, don't guess, just draw it as a dark shape. You can't be more "real" than the photo.

Reference Photo
Let's practice drawing the hair and face. Always check the proportions of your drawing before starting on the hair.

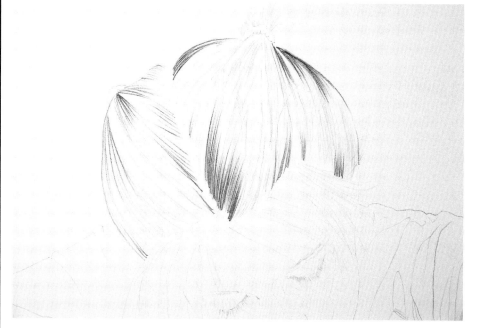

❶ Establish the Direction of the Hair

Before I begin the hairs, I need to establish where the hair is going. I've drawn some lines to indicate the direction I'll be "combing" the hair.

Pssssssst!

Sharpen several 6B lead pencils before you begin a drawing so that you don't have to stop.

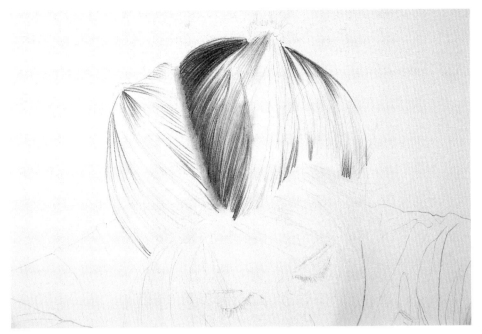

② Add the Darks

I like to see some darks as early in the drawing as possible. Because Shilo's hair is darker than her shirt, I've used it as a working value scale. (A value scale is where the lightest lights to darkest darks are laid out side by side.) Create a working value scale by placing a dark midtone in your drawing, and leaving another area white on your drawing. Now you can easily see the full range of shades you'll need to have to make an interesting drawing.

Although my drawing has gotten dark, my pencil is kept sharp. The shine of her hair is from leaving the lights, not from lifting them out.

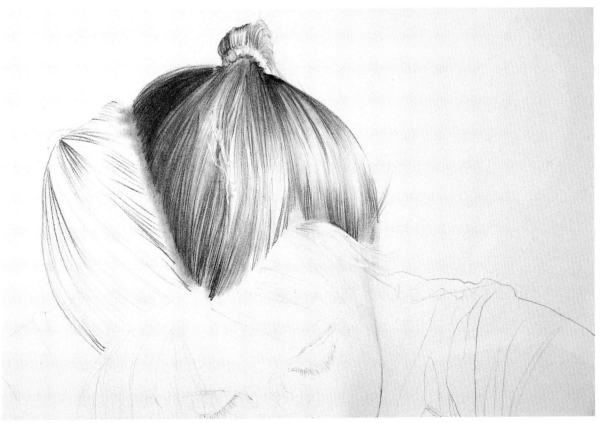

③ Blend the Darks

I've completed one side of Shilo's hair and blended the darks at the base. It's important that the lines remain lines and are not blended together—otherwise the hair will have a flat, decidedly "unhairlike" appearance.

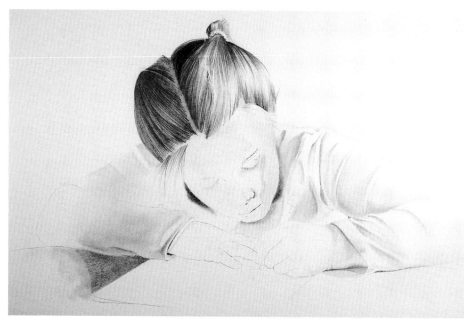

4 Shade Lightly

Lightly shade Shilo's face and clothing. On the original photo, there's a large dark area next to her face. Wait to smudge it later. If you were to work on this larger area, making it dark, you would have the potential of accidentally dragging some of the dark graphite into an area you want lighter. The drawing has a large range of values in it because of the darks in her hair. You want to have some lights, midtones and darks throughout the sketch.

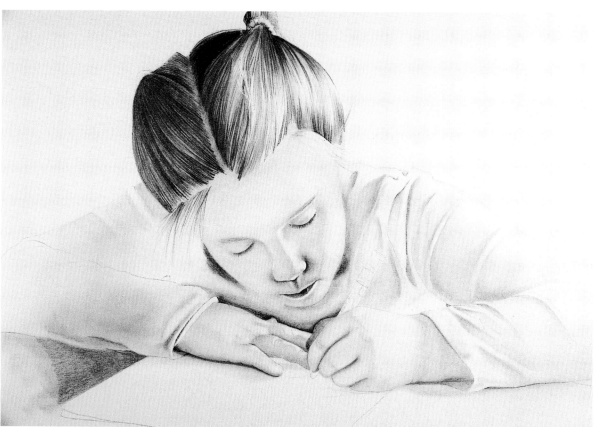

5 Work on the Entire Face

Shilo's face is taking form in an overall manner—that is, one facial feature is never completely finished before another.

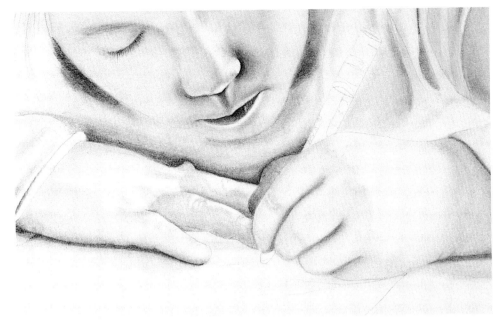

⑥ Draw the Hands

The lights and darks on the hands add dimension and make them believable. Hands should be no more difficult than faces. Use the same light-dark-light-dark pattern you've employed to create faces and fabric.

⑦ Keep Going!

Once you have darks, midtones and lights, you'll want to look at each part of the drawing to be sure it's correctly shaded. Rick and I often look at smaller details with a magnifying glass.

SHILOH STUART
Graphite pencil on smooth bristol board
12" × 14½" (30cm × 37cm)

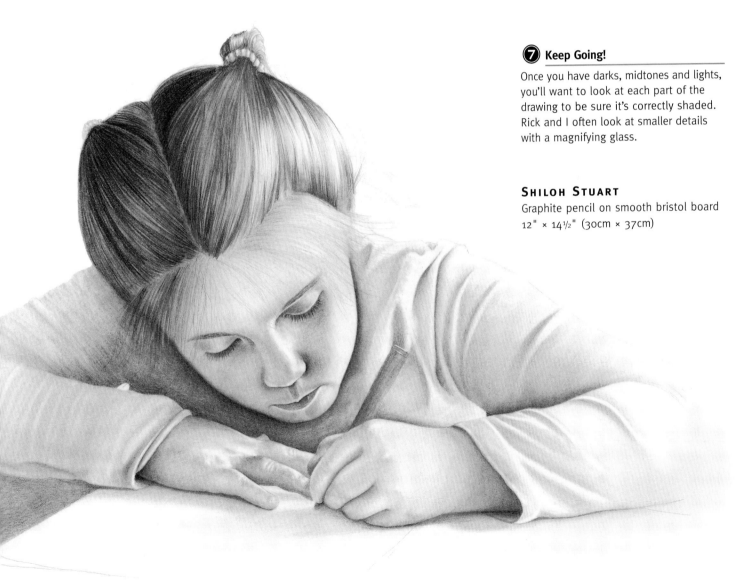

The Smallest Details

Cortney Lindsey is Rick's niece and a beautiful girl. Rick and I worked together to create this drawing. When we work together, Rick does the initial sketch, then passes the line drawing on to me. I place the working value scale (a full range of lights to darks) on the drawing and work on the hair. Then it goes back to Rick to refine the drawing. Here's what he did to make the drawing look more childlike.

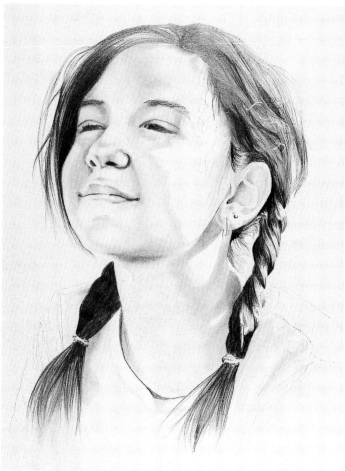

❶ Complete the Basic Drawing

Lay in the overall shading and hair. The remaining work is refinement.

❷ Refine the Eyebrows

Thicken Cortney's eyebrows, correct the shape and darken the drawing overall. It's common to avoid the eyebrows, but they can really make a difference in capturing a child's likeness.

❸ Darken the Mouth

Although her mouth is correct in shape, it requires more darks. Further define and darken the nose and chin.

④ Soften Harsh Edges

Using gentle pencil strokes, paper stumps and a kneaded eraser, soften the harsh edges. With a kneaded eraser, lift out any areas that should be lighter.

⑤ Define the Ear and Create Wisps of Hair

Darken the ear to create shadows. Notice how the contrasting values make the drawing more interesting. Create the wisps of hair on her face using a sharp HB lead pencil. Keep defining and blending tones around the ear.

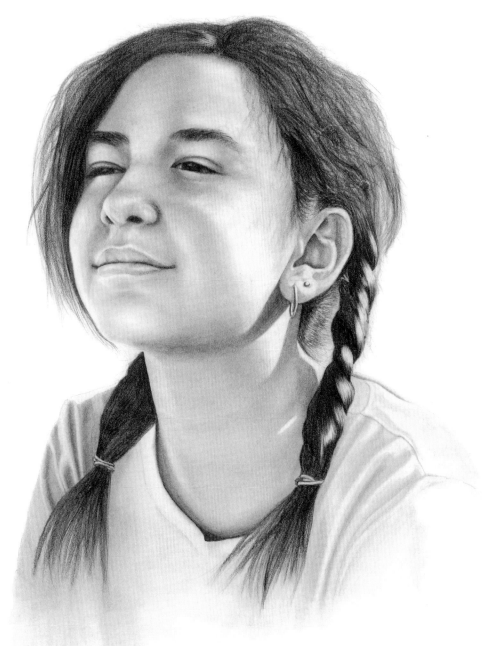

CORTNEY LINDSEY
Graphite on smooth bristol board
16½" × 11" (42cm × 36cm)

Capturing Character

Capturing Orion's expression was the goal of this drawing. The challenges were making sure it was an accurate depiction, not a caricature, and also finishing the top of his head that the photo didn't show.

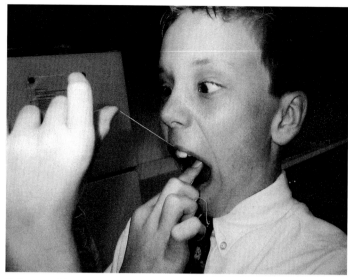

Reference Photo
Nadeoui Eden sent us this wonderful photo she took of Orion flossing his teeth. It made us laugh, and we loved it. We asked for permission from both Orion's parents and the photographer to use it in this book.

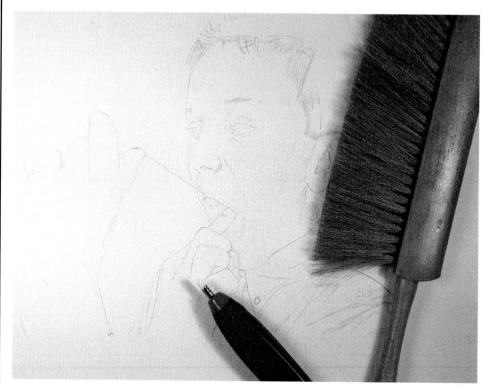

❶ Erase Any Unnecessary Lines

Before you begin to shade any drawing, all extra lines must be erased including guides, unneeded sketch marks and grids. It's difficult to remove them after the shading process begins.

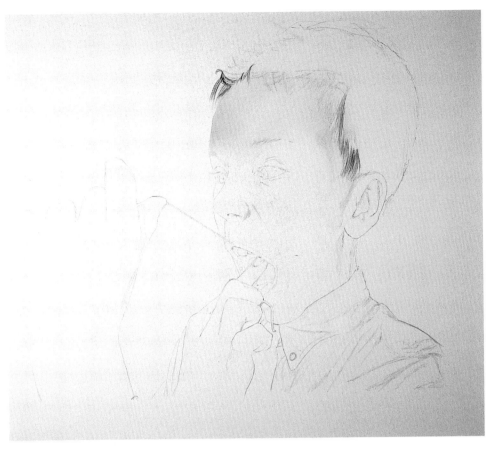

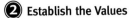 **Establish the Values**

Start the hair and add shading to his forehead. It is good to establish some values (relative lights and darks) early on in the drawing.

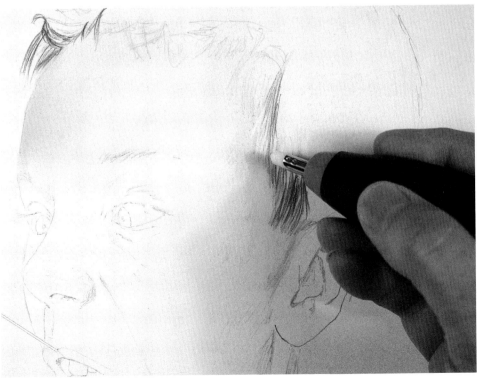

③ Lift Out Light Values

This subject has white hairs as well as dark. You can't "draw" white hairs, but you can lift them out of a darker background with your eraser.

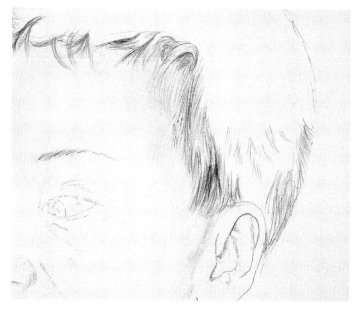

4 **Randomize the Hair Strokes**

Pencil strokes should be about as long as the length of the hair strands. Take care to keep the strokes random, rather than in rows, unless you're drawing a hair part in the scalp.

5 **Continue Shading**

Work your way down your subject, softening the shadows and shading. I don't begin in any particular formula—sometimes I start with the eyes, sometimes the hair, sometimes the nose. As long as your underlying drawing is correctly proportioned, you have the freedom to choose where you begin.

6 **Hone the Drawing**

Add an overall light shade to the entire face.

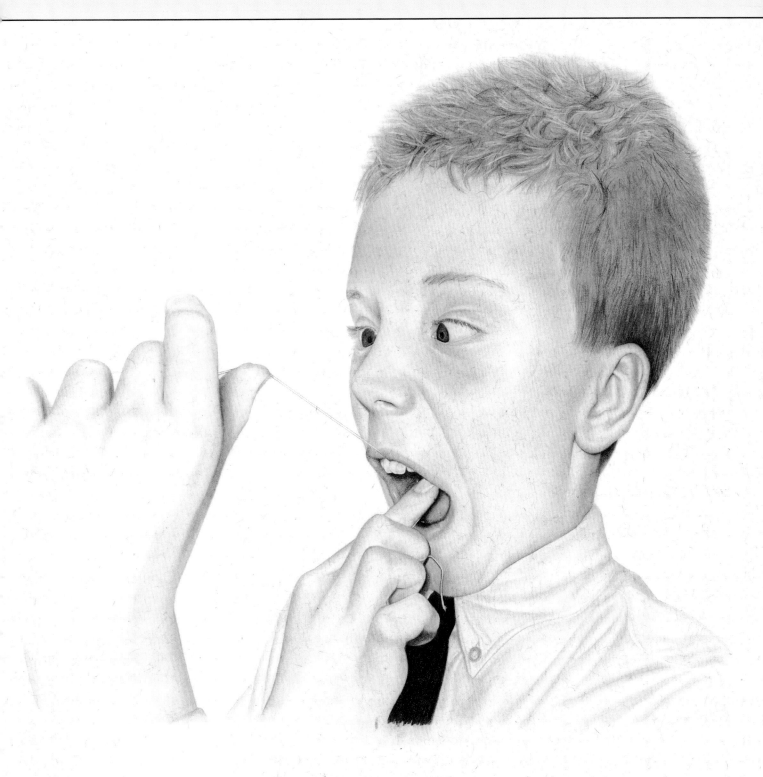

7 Add More Dark Areas

The darks in a drawing make it pop, but be sure they're in the right place before digging into that 6B lead! (It's horrible to erase.) Add some dark areas with a 6B lead pencil.

The drawing now has some of the subtle details that make it alive. For example, his teeth aren't just white—they have detail lights and darks that are visible in the photo.

Rick improved my finished drawing by straightening the hair and removing some of the highlights.

Index